EMBRACING CUBA

UNIVERSITY PRESS OF FLORIDA

Florida A&M University, Tallahassee
Florida Atlantic University, Boca Raton
Florida Gulf Coast University, Ft. Myers
Florida International University, Miami
Florida State University, Tallahassee
New College of Florida, Sarasota
University of Central Florida, Orlando
University of Florida, Gainesville
University of North Florida, Jacksonville
University of South Florida, Tampa
University of West Florida, Pensacola

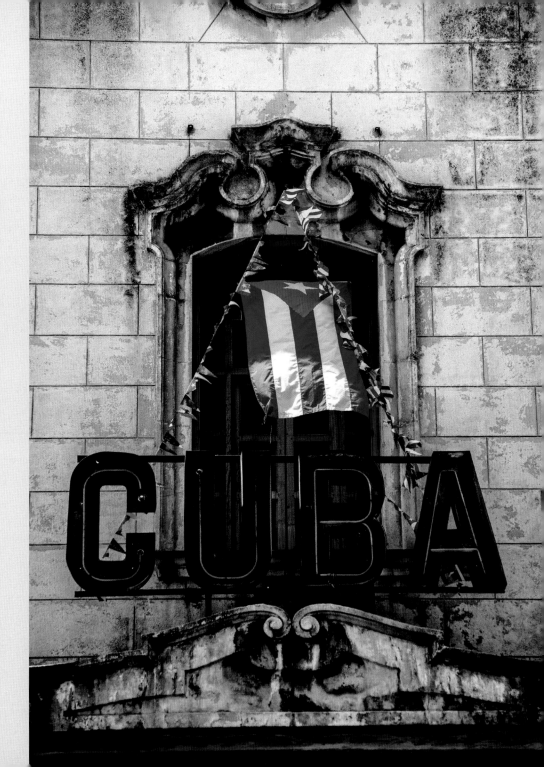

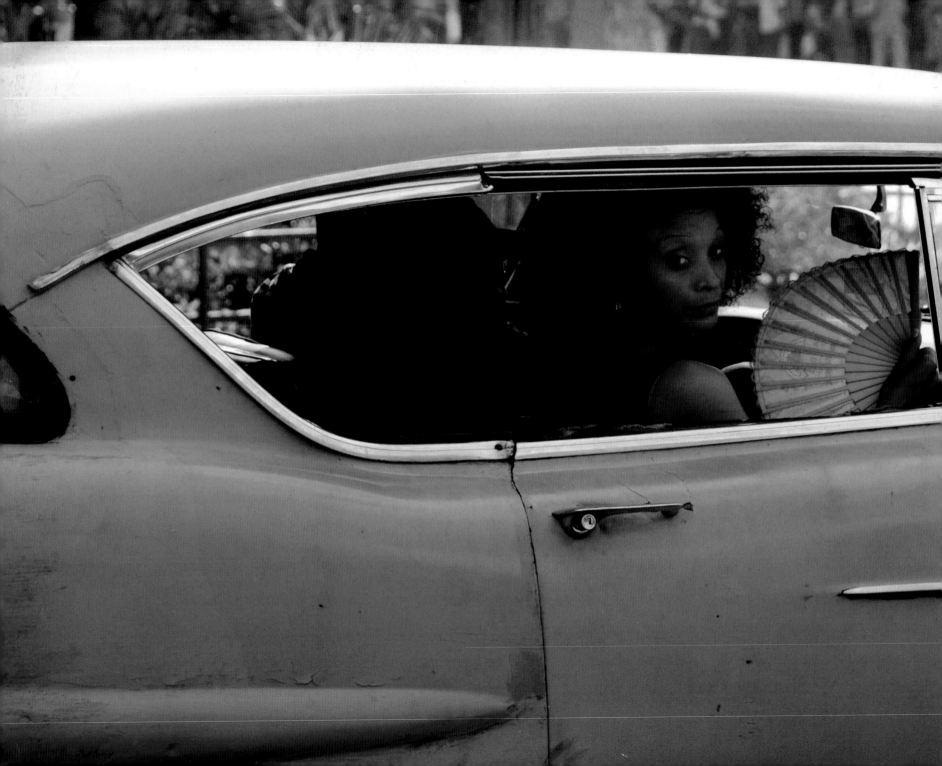

EMBRACING CUBA

BYRON MOTLEY

Foreword by Dr. Mariela Castro-Espín

University Press of Florida
Gainesville · Tallahassee · Tampa · Boca Raton
Pensacola · Orlando · Miami · Jacksonville · Ft. Myers · Sarasota

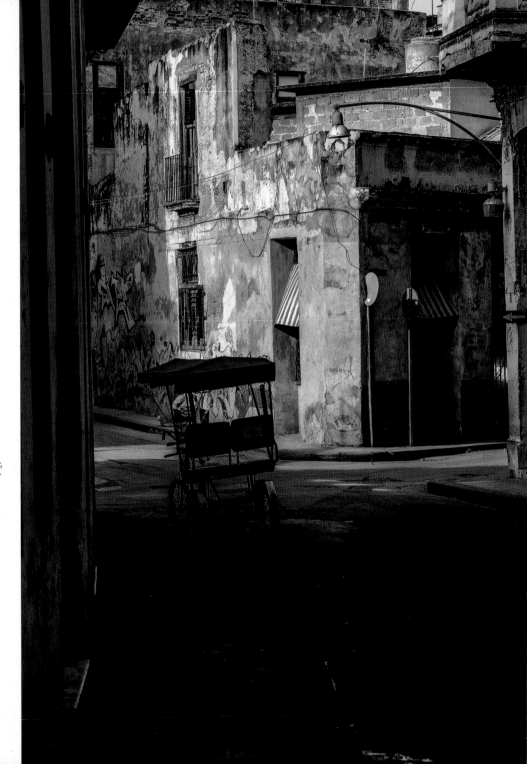

Page i: Cuba Marquee, Centro Habana, 2011
Page ii: Lady with Fan, Vedado, 2009
Right: Bicycle Taxi on Street Corner, Habana Vieja, 2008
Following page: Start of a New Day, Trinidad, 2013

This book may be available in an electronic edition.

20 19 18 17 16 15 6 5 4 3 2 1

Library of Congress Control Number: 2015930917
ISBN 978-0-8130-6115-3

The University Press of Florida is the scholarly publishing agency
for the State University System of Florida, comprising Florida
A&M University, Florida Atlantic University, Florida Gulf Coast
University, Florida International University, Florida State University,
New College of Florida, University of Central Florida, University of
Florida, University of North Florida, University of South Florida,
and University of West Florida.

University Press of Florida
15 Northwest 15th Street
Gainesville, FL 32611-2079
http://www.upf.com

For Momma and Daddy, who bought me my first camera and, more important, took me on my first trips abroad, awakening my eyes, heart, and spirit to the wonders of other cultures, sights, and peoples and the world. *I love you!*

Every moment is an adventure here, and every day is full of surprise. I never want to sleep in Cuba. And even after I have returned home—and the place has disappeared entirely from view—I find that it haunts me like a distant rumba.

PICO IYER

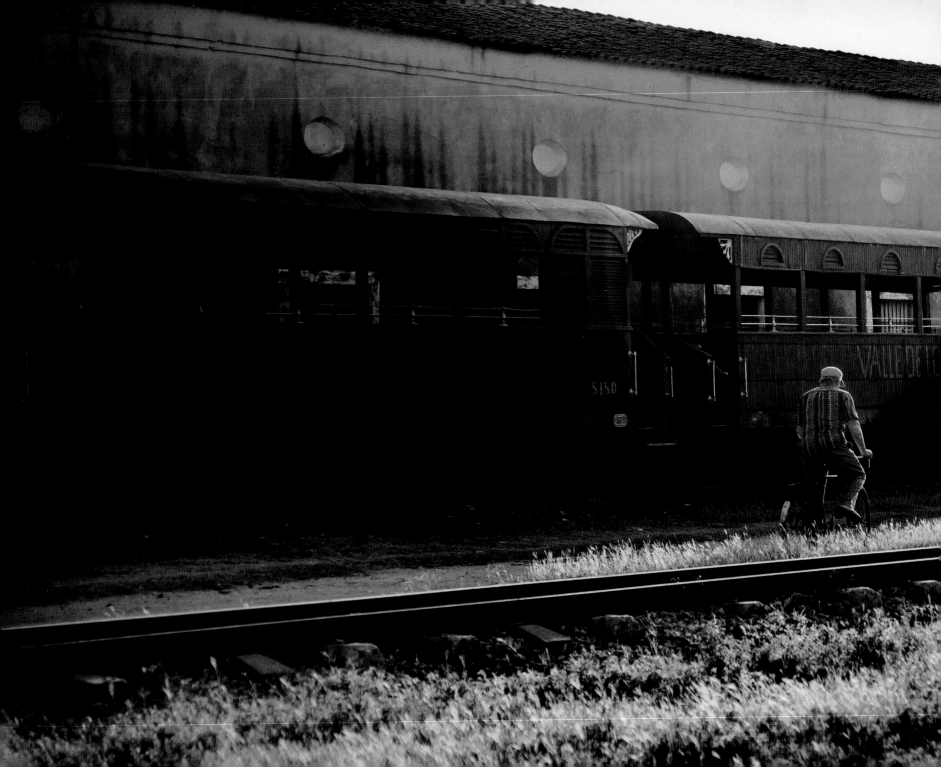

CONTENTS

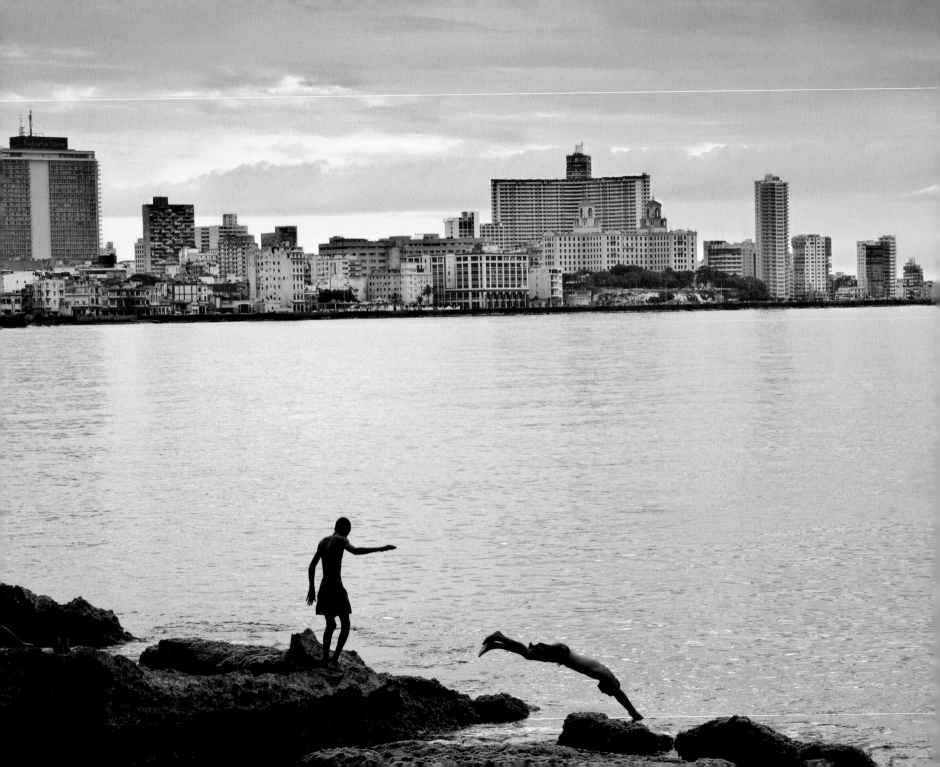

FOREWORD

I first met Byron Motley during an interview and photo shoot for the *Advocate* magazine in March 2009. From the moment we met there was an immediate bond and kinship. In 2010 he attended the third annual Cuban International Day Against Homophobia (IDAHO), of which my group, CENESEX, leads activism in LGBT rights and issues.

Since then Byron has become a part of our circle of social activists, artists, and close friends. In May 2011 we presented Byron's first exhibition of photographs showcasing his experiences from the 2010 IDAHO event, which was held in Havana and Santa Clara, with unforgettable memories in the iconic El Mejunje cultural center.

It was during preparations for our 2011 program when I realized that Byron had already been chronicling our IDAHO event in a comprehensive way as no other photographer had ever done. That was when we decided to begin exhibiting his work in Havana's International Press Center. To this day Byron continues to be the main photographic chronicler of our annual IDAHO event.

Strong emotions emerge between heterosexual and LGBT communities in this process of learning and discovery, emotions of joy and sadness, of forgiveness and recognition, culminating in spiritual healing. And Byron has the ability to capture those moments. When I scan through the crowds and do a visual journey to try understand what people are feeling in their hearts and minds, I see Byron with his camera in hand and I have the security of knowing that he's capturing all those moments for the collective memory, and to honor the brave individuals who have stood up for equal rights and continue to do so.

I would very much like to thank you, Byron, for this graphic history of the Cuban Days Against Homophobia with its different nuances of light and colors, faces, bodies in motion, streets overtaken by flags of the rainbow, joy, hugs, dialogues, songs, and humanity. I am impressed by the strength and intensity with which each image conveys the essence of these moments.

This is why Byron is my friend and also my colleague in the difficult work we face on cultural resistance to the domination of ancestral archetypes that still persist in all societies.

I am delighted to tell you that Byron is not only an artist of the image; he is also a very soulful singer. He has performed at our annual Havana Jazz Festival, which has expanded his understanding of Cuba's great affection for the arts and culture. It is because he is a gentle spirit that Byron sings as beautifully and movingly as he does.

Byron is a fan of baseball, and has also been able to capture what no American photojournalist has been allowed to access on-field and alongside some of Cuba's most popular players.

With his grace and dignity he has many charms that enable him to relate to the Cuban people, live alongside them, and capture their essence. When he strolls through

Diving In, El Malecón, 2012

our streets, doors open to him easily and nothing escapes his lens. He transforms the everyday life of the city into art; the work of the watchmaker, buildings that reflect in the windshields of old cars circulating as relics in Havana, the musicality of a boy playing his trumpet on the sidewalk, the making of bread, the joyous enthusiasm of a spectator in the stadium, and even a man and his child on a bicycle.

There is no doubt that the camera captures all Byron perceives: the pulsations of existence.

Dr. Mariela Castro-Espín

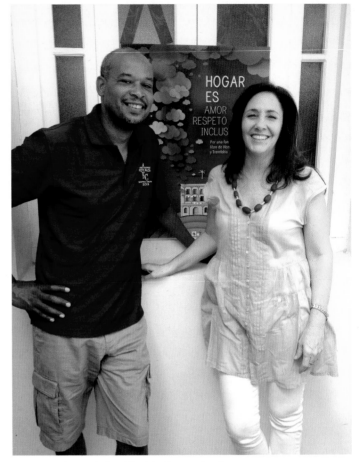

Byron Motley with Dr. Mariela Castro-Espín, 2013

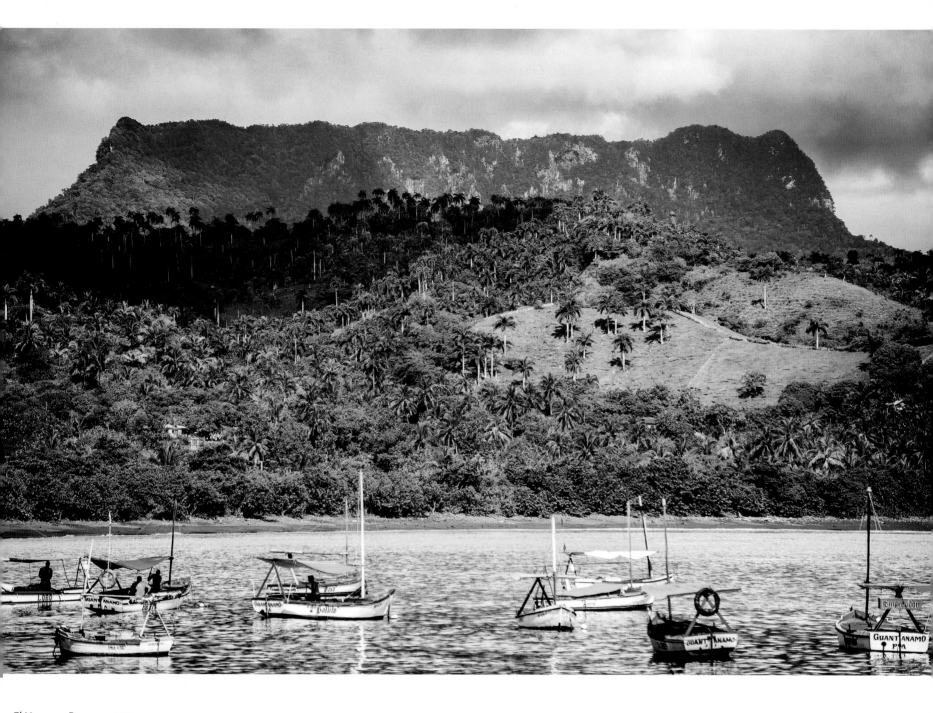

El Yunque, Baracoa, 2014

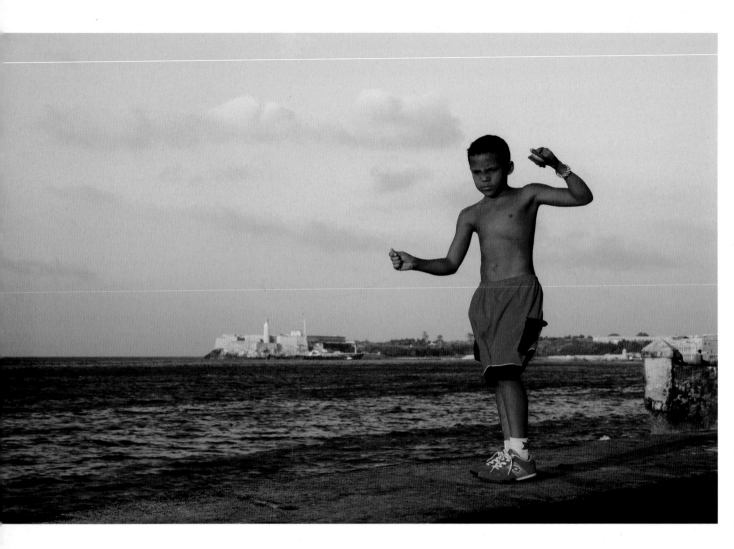

xii | Boy Fishing, El Malecón, 2008. *Right*: Rushing Waves, El Malecón, 2013.

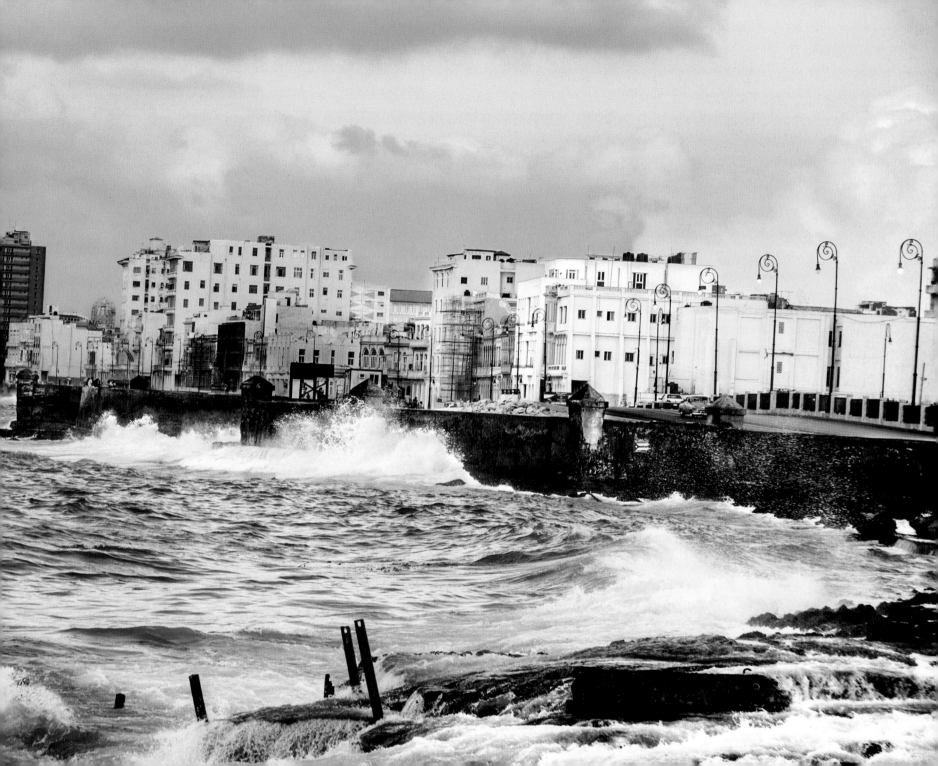

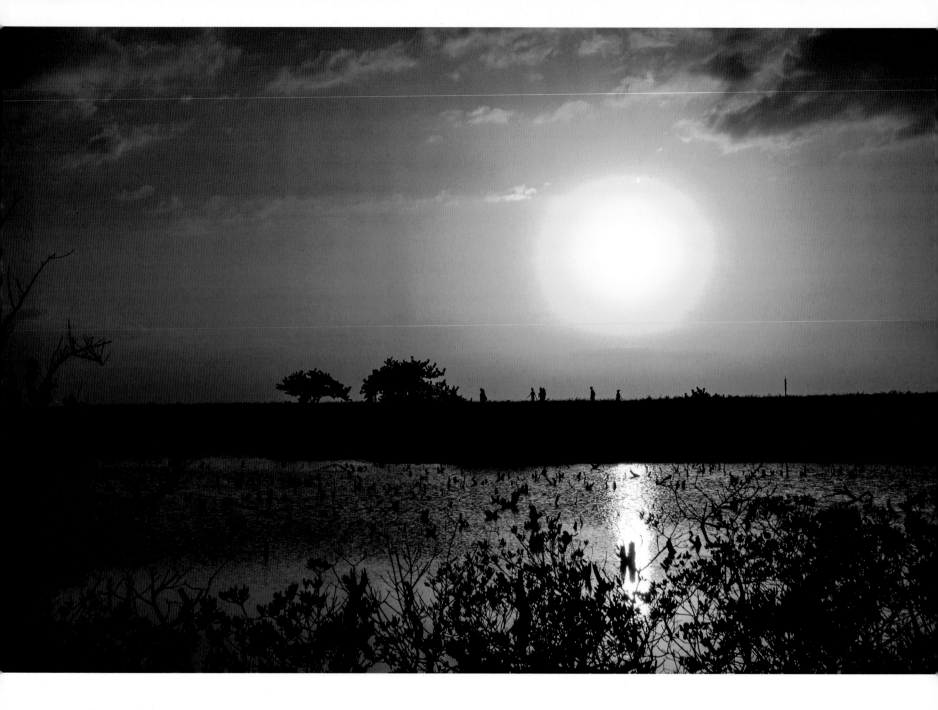

Sunset Stroll, Trinidad, 2013

PRESENTANDO CUBA

Because most visitors have only the vaguest idea of Cuba's troubled history, I am going to review it as briefly as I can, and if you are not interested, you can skip to the part about cocktails.

ELEANOR EARLY, TRAVEL WRITER

How does one paint a picture with words when words are not enough? Upon sitting down to write the manuscript for this book, I could not shake that gnawing question.

I think about the gifts this magical island, Cuba, has given me; the appreciation, if not longing, for a simpler time; the deep understanding of the importance of embracing and protecting one's cultural heritage, especially in a time of rapid globalization; admiration for the optimism and generosity of its people despite a lack of amenities that most Westerners, myself included, often take for granted; how the island has awakened my senses with its utterly unique vivid sights, vivacious sounds, and victorious spirit.

Thirteenth-century Persian poet Jalāl ad-Dīn Muhammad Rūmī, commonly known as Rumi, once wrote: "Respond to every call that excites your spirit." Having adopted this sentiment as one of my own personal mantras, I have followed the call of my heart by embracing Cuba as a place that feeds my soul like no other place on earth.

My relationship with Cuba began before I was even born. My father, having just graduated at the top of his class from the Al Somers Umpire School in Daytona Beach, Florida, was invited to "try out Cuba," since the major leagues were not yet accepting Negro umpires. Intrigued by the possibility, my parents, with my then six-year-old sister in tow, paid ten dollars a ticket and boarded an Aerovías Q Airways flight from Key West to Havana. In thirty minutes they were in pre-revolutionary Cuba, investigating what opportunities my father might have for an umpiring career in the Cuban leagues. After spending a week on the island, and falling in love with everything that is Cuba, they returned to their home in Kansas City, Missouri, dreaming soon to revisit the land where they could live and raise their growing family in a culture that was clearly more accepting of skills provided by people of color.

My father indeed found opportunities to umpire professionally in Cuba, but two circumstances prevented him from ever returning to the island to do so. First, he unexpectedly got an offer from the Pacific Coast League (one level below the majors), making him only the second black umpire in a top-tier minor league. Second, and even more unexpected, a charismatic yet controversial figure by the name of Fidel Alejandro Castro Ruz rode into Havana with his Revolution, overthrowing Cuba's dictator and U.S. ally Fulgencio Batista, changing the direction of the country's future nearly overnight.

Since my parents' trip in 1958, Cuba has held a special place in the hearts of my family. I grew up listening to them reminisce about their fun-filled, adventurous, and eye-opening week of discovering what was wholly exotic to them at that time—foods such as plantains, malanga, and yucca, and the freshest seafood ever; the pristine beaches, salacious nightlife, the rich and rhythmic music, nightly costumed midnight parades through the streets of Havana, and some *damn good baseball.*

As I got older and began to do the math, I ultimately realized that I had actually been conceived during my parents' Havana adventure. Well, that did it. Now I felt even more of a connection to the mysterious island and dreamed that someday I could "try out Cuba" for myself. Finally, in 2005, traveling under a General License, as sanctioned by the United States Department of the Treasury's Office of Foreign Assets Control (OFAC), I ventured to Cuba to do research for a television documentary I am producing about players from the Negro Baseball Leagues, who for decades, because of Cuba's balmy weather, played on the island during the winter months. It's a rich and unexplored history that connects our countries through a shared national pastime, baseball. Expecting to immerse myself in research, I found myself totally captivated by the island's charm, beauty, and warmth. Like my parents had done more than forty years before, I too immediately fell under the spell of this "jewel of the Caribbean."

The moment I stepped out of Havana's José Martí International Airport and walked toward the waiting tour bus, I felt a strange, unexpected, and overwhelming sensation that is difficult to put into words. I distinctly recall hearing a voice inside me whisper, *"I'm home."* Having traveled to many different and fascinating lands since I was a child, I dismissed the voice as simply the overwhelming excitement at having finally arrived in the one place I had dreamed of for so long. But the whisper persisted, and by the end of my inaugural visit, I began to sense just how prophetic that whisper would actually become. Ten years later I count it as a blessing that my curiosity, my research, my newfound *amigos y familia*, and the love I feel for *my* Cuba (as I now affectionately call her) continue to call me back to the island

time and time again. I certainly understand Ernest Hemingway's desire to "want to stay here forever." I know I do.

Everything about Cuba fascinates me. It is a proudly patriotic island that, like nowhere else in the Americas, draws Madrid and West Africa and the Antilles together. The prerevolution midnight parades and clubs of my parents' Cuba may be no more, but culturally and socially many things remain. Add to this the tantalizing rhythms and harmonies of the *bolero* and *changüí*, seducing and pulsating dances of the mambo and rumba, the tranquil beaches and balmy turquoise waters, the whimsical leisurely mood of the Malecón; the nostalgic aura of classic cars breezing by; and the genteel beauty of decaying colonial structures with their eye-popping colors and multihued textures and patinas. Yes, all of these things infused with the genuine warmth of the Cuban people, their generosity, their resilience and spirit; throw in some "damn good baseball," and you have all the ingredients that make me feel so alive and at home on this charming isle.

And if the truth be told, the mojitos ain't too bad either!

If I had to choose a spot that best defines my personal favorite place in Cuba, if not the planet, it would have to be Havana's storied El Malecón. Built in 1901 to serve as a seawall to protect the city from damaging ocean waves, the expansive esplanade stretches four miles in length and is lined with residences, hotels, restaurants, and other buildings, a few abandoned and decaying like ghosts of an extinct era and others elegantly restored. Somewhat ironic however, is the placement of the starkly designed American Embassy

(formally the American Interests Section) right next to the José Martí Anti-Imperialist Plaza.

The six-lane roadway of the Malecón and accompanying pedestrian walkway snake from the mouth of the city's harbor and colonial core in Habana Vieja (Old Havana) past the northern border of the Centro Habana (Central Havana) barrio to the far edge of the neighborhood of Vedado.

Often referred to as "the soul of Havana," the Malecón is a teeming river of diversity, of individual and communal activities. At all times, day and night, the area thrives with *habaneros* (residents of Havana) hanging with friends, families picnicking, and lovers cuddling. Musicians jam, artists paint and sketch, writers and poets compose, kids dive off the seawall for a dip in the cooling ocean below, vintage cars zoom by, fishermen cast lures to reel in their fresh catch of the day, followers of Santería serve up offerings to Yoruba gods, and locals and foreigners mingle while sipping rum and swapping tales.

The breathtaking sunsets are mystical and magical. And despite the almost constant bustling atmosphere, a tranquil spot of solitude for reflective introspection and thanksgiving can always be found. Yes, for me, the Malecón is the place where Havana's soul and mine are in complete harmony.

To say that Cuba is a photographer's paradise is an understatement. Practically everywhere you look a photographic moment presents itself. Life moves fast on the island, so the camera has to be ever ready to snap at a moment's notice.

As I stroll the streets from sunup to sundown on the hunt for the next inspiring photo op, I always encounter inquisitive people. Because I "look Cuban," I usually blend in. That is, until my camera or my less-than-stellar attempts at Spanish serve as a dead giveaway. A split second later I'm on the receiving end of curious double takes and a quick head-to-toe eye scan. With the cat out of the bag that an *extranjero* (foreigner) is at hand, the questions rapidly come: "*¿De dónde es usted? Que país? Canadá? Inglaterra? Francia?*" (Where are you from? What country? Canada? England? France?).

Unprepared for my reply, "Los Estados Unidos" (the United States), Cubanos are always taken aback. But only momentarily. Then, without fail, a wide, warm, inviting smile washes across their once confused faces, followed by an enthusiastic handshake, a bear hug, or both. "*Ahhhhh, United States!*" they'll joyously acknowledge in English. "You are my friend. You are my brother!" It never fails. They will then proceed to tell me of an aunt, uncle, cousin, brother, sister, or other relative living stateside. Our kinship is immediate. Without an ounce of wariness, mistrust, or intimidation—just genuine interest, respect, admiration, and love.

Sometimes the conversation leads to an offer of some sort: home-brewed coffee (for free), an invitation to a rumba or to hear a knock-off version of the Buena Vista Social Club at a nearby hangout, a recommendation of a *paladar* (restaurant), cigars (for sale), or even perhaps a proposal of marriage. It is all good-natured fun that often interrupts the flow of my photographic quest, but these lively exchanges are cherished moments that enrich my connection to the spirit of the Cuban people, which breathes life into my photographs and spirit. What's more, some of these conversations and chance meetings on the streets, in taxis, buses, or other far-reaching places around the island have led to enduring friendships and a deeper appreciation

for the moments I have been fortunate enough to capture photographically.

One of the most cherished lessons my parents taught me, from a very young age, is that when you open yourself to opportunities to engage and interact with people from all walks of life and cultures, regardless of differences, beliefs, status, or background, that is life's greatest education. In my life this teaching has been and continues to be invaluable. Because I particularly adhere to this advice when in Cuba, it has led me to some of my most inspired, treasured, and life-affirming moments.

Words alone do not do Cuba justice. They depict only fragments of her mystery and beauty, her strength and fragility, her spirit and song. And so I turn to my cameras to capture the Cuba I love through the lens of both camera and soul. I am honored to have this opportunity to take you with me on this photographic journey, to share my scrap-book of memories and moments. In my heart I have adopted Cuba as my home away from home, or should I say she has adopted me. Whichever the case may be, I look forward to returning to *my Cuba* time and time again, armed with my cameras and lenses, to experience more reflective strolls along the Malecón, the sensuous red-golden Caribbean sunsets, the melodious serenades of *boleros* and *son*, some damn good baseball, and to hear again those whispers deep in my soul: *"I'm home."* Responding to Rumi's thought provoking words will inspire me to continue filling my heart and photo album with memories as I continue *Embracing Cuba*.

Byron Motley Self Portrait on the Malecón, 2012

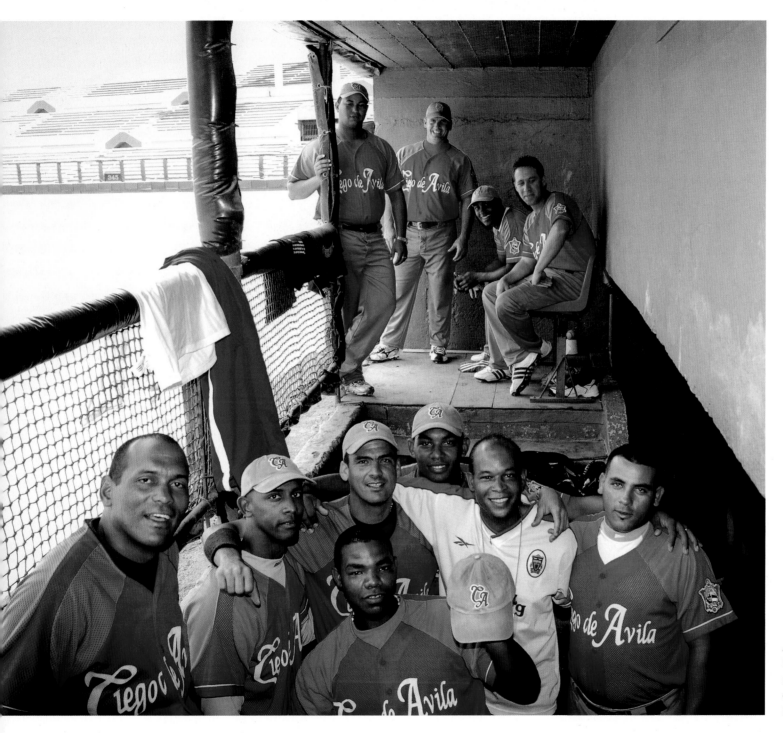

A Moment of Inclusion:
Byron Motley Sur-
rounded by Members
of the Ciego de Avila
Baseball Team, 2009

LA ARQUITECTURA

So much has been written about Cuba's sugar mills and tobacco plantations that most people haven't an inkling of the country's most flourishing natural industry. It is charm!

CONSUELO HERMER AND MARJORIE MAY,
CUBA TRAVEL WRITERS

Teatro Manzanillo Ceiling, Manzanillo, 2014

CUBA'S FIVE-HUNDRED-YEAR HISTORY is evident in the array of eclectic architectural styles that span the entire breadth of the island. From the palatial estates of Havana to the picturesque colonial town of Trinidad, with its endless rows of red terracotta tiled roofs, frescoed walls, multicolored painted facades, and antiquated cobblestone streets, to the vibrant city centers of Camagüey, Santiago de Cuba, and Cienfuegos, laden with an assortment of stunning churches and ornate structures, the island boasts spectacular architecture.

A wide spectrum of cultural influences is represented in Cuba's diverse architectural styles, the most widespread reflecting its illustrious Spanish colonial past. Throughout the island Moorish, Italian Renaissance, Greek, and Roman motifs are harmoniously juxtaposed among a myriad of Baroque, Neoclassical, Art Nouveau, Art Deco, and modern designs.

As the largest city in Cuba, Havana offers the most eclectic and diverse collection of architectural treats. Spectacular in its ambition, the architecture speaks poignantly of Havana's former place as one of the world's most elegant and cosmopolitan cities. Once known as the "Paris of the Western Hemisphere" and coined the "the city of columns" by novelist Alejo Carpentier for the Neoclassical-style pillars that front thousands of stately homes and buildings, Havana showcases a multitude of opulent villas, splendid cathedrals, ostentatious mansions, and broad buildings. Interlaced with these impressive structures are dramatic accents of squares, parks, fountains, and statues.

Emerging relatively unscathed from the turmoil of three separate revolutionary wars, Havana has survived into the twenty-first century with the bulk of its original colonial features remarkably intact. In 1982 Habana Vieja (Old Havana) the historic core of the city, became the first of Cuba's nine designated UNESCO World Heritage sites. Constant and painstaking efforts continue to be made to protect and preserve many of the historical structures, especially in Old Havana.

The quaint atmosphere of Old Havana with its ancient structures and narrow walkways feels remarkably modern and is a treasure. Bustling with businesses and extremely popular with tourists, the district pulsates with lively activities and events and contains more than nine hundred buildings of historical significance. Highlights include the Catedral de la Virgen María de la Concepción Inmaculada de la Habana (Havana Cathedral), El Capitolio (National Capitol Building), Basilica Menor de San Francisco de Asis (Plaza of San Francisco), Museo de la Revolución (Museum of the Revolution—the former Presidential Palace), Museo Nacional de Bellas Artes de la Habana (National Museum of Fine Arts of Havana), and the striking Plaza Vieja (Old Square). Also a UNESCO-designated site, the Plaza Vieja is Havana's most architecturally eclectic quadrate, where Baroque, Neoclassical, and Art Nouveau themes nestle together in a homogenous composition of styles, making it uniquely Cuban.

Serving as a dividing line between Central and Old Havana, the storied Paseo del Prado Boulevard remains an elegant, terrazzo-floored promenade, lined with hotels, restaurants, museums, and residences, and was once Havana's answer to New York's Fifth Avenue. The five-block-long, tree-covered walkway now serves as a social gathering

place for artists, families, friends, lovers, and kickball-playing children. Designed in the eighteenth century and remodeled in the 1920s, its marble benches, bronze lion statues, and ornate light fixtures harken back to the Victorian age of parasols, petticoats, top hats, and walking canes.

Although popular Obispo and O'Reilly streets now bustle with bars, shops, galleries, restaurants, and hotels, probably few sightseers realize that these boulevards of opulent buildings, with vendors selling every imaginable touristy trinket and tchotchke, were once known as "little Wall Street," Havana's financial district. If concrete and marble could speak, they would surely tell tales of Cuba's bourgeois high society who cornered the market on the riches and financial wealth that flowed into the country during the latter part of the nineteenth century.

The Neoclassical style of design perhaps exemplifies the most influential form of design in nineteenth-century Cuban buildings. With their dramatic use of French-inspired interiors, elegantly appointed to complement a lavish and spacious courtyard outlined by prodigious marble columns and imposing doors, many of these structures eventually became private homes of Cuba's elite.

The twentieth century ushered unprecedented wealth into the Cuban capital with monies from its booming sugar, manufacturing, and construction industries. As the country prospered and its economy flourished, Cuba's tycoons who wanted to flaunt their fortunes built opulent mansions. Havana's once affluent districts of Vedado and Miramar are dotted with their estates. Today the majority of these former family and privately owned manors are state owned, utilized as government offices, businesses, and embassies.

As U.S. influence became more prominent during the early part of the twentieth century, the Art Deco style began to infiltrate the landscape of Cuban design. Boasting a more modernistic approach, its trademark stylized geometric shapes, symmetrical and asymmetrical motifs, and polychromatic tints of color also influenced Cuban fashion, sculpture, cinema, art, and graphic design.

Perhaps the island's quintessential example of the Art Deco genre is the stylish Edificio Bacardi—the Bacardi Building, former headquarters of the famous rum dynasty. Completed in 1929, the twelve-story masterpiece still holds its splendor. Interior details include blue mirrors, stucco reliefs, brushed and polished brass, mural paintings, mahogany and cedar paneling, stained and etched glass, and richly colored inlaid marble from Europe. It is arguably the finest archetype of Art Deco in all of Latin America.

Cuba's architectural designs, regardless of style influences, adapted to reflect its climatic environment. The inclusion of verandas, porches, patios, and courtyards in palaces, mansions, and public buildings reveals insight and creativity by both local and international designers, who created a potpourri of stylish structures that were conducive to Cuba's middle- and working-class lifestyles.

Every structure is unique. From minute to bold decorative nuances, the attention to detail each artisan has clearly devoted to the designs—the door handles, knockers, lampposts, light sconces, cornices, stained glass windows, marble inlays, wrought-iron fixtures, wallpapering, etchings, tiled floorings, hallways and walls—is obvious and notable.

After suffering decades of scorching sun, tropical storms and hurricanes, and lack of care, many of the country's

grand facades have fallen into disrepair. Many are decaying and crumbling with the passage of time, while some, with government funding or the assistance of foreign investments, have been meticulously preserved and brought back to their original essence.

From its sixteenth-century castles to modernistic high-rises, for a country of its size and relatively brief history, Cuba can claim bragging rights in possessing some of the world's most spectacular architectural jewels. Although the fusing of trends, periods, and forms from other nations has been key to influencing its style, Cuba has developed a character, style, and look that is uniquely its own.

As one steps back in time amid the weathered buildings, vintage automobiles, and storied history, the beauty of this charming island cannot be denied. Nor can the ingenuity and contributions of the discerning architects, designers, and builders who through the centuries created and transformed the island of Cuba into a living work of art.

Wrought Iron Bench, Cerro, 2013. *Right*: Street Scene, Trinidad, 2013.

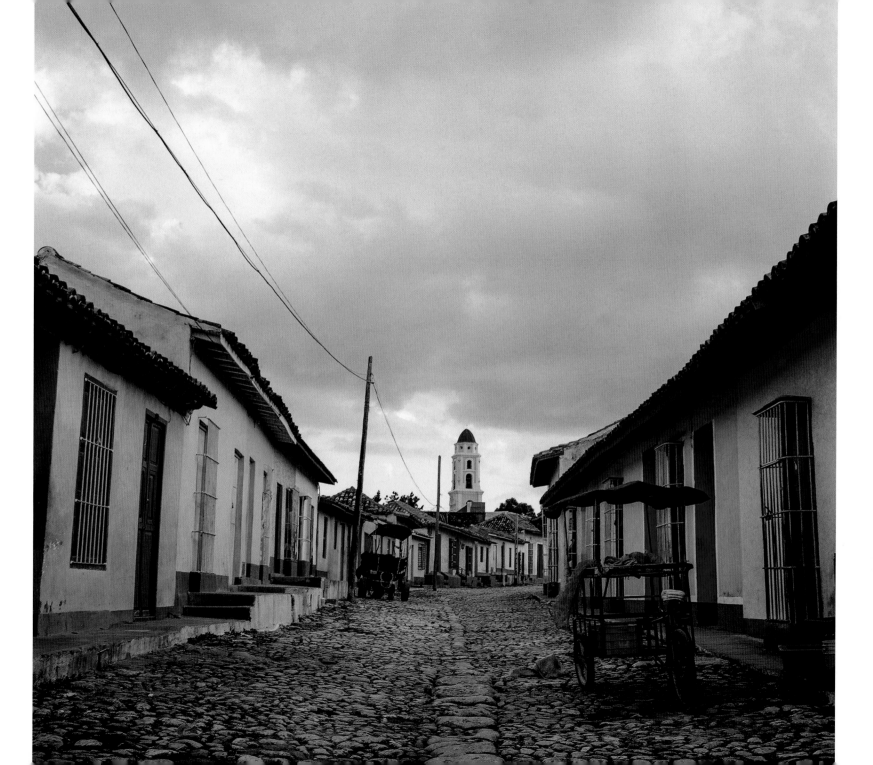

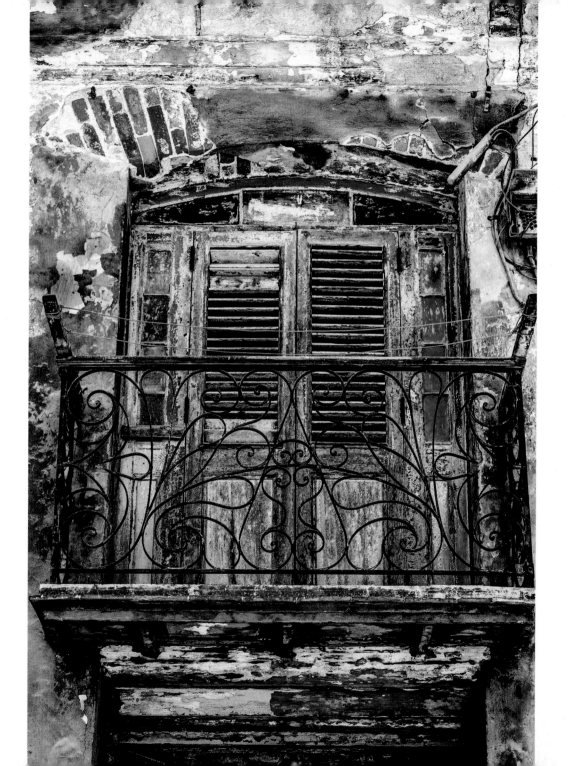

14 | Casa Simon Bolívar Staircase, Habana Vieja, 2013

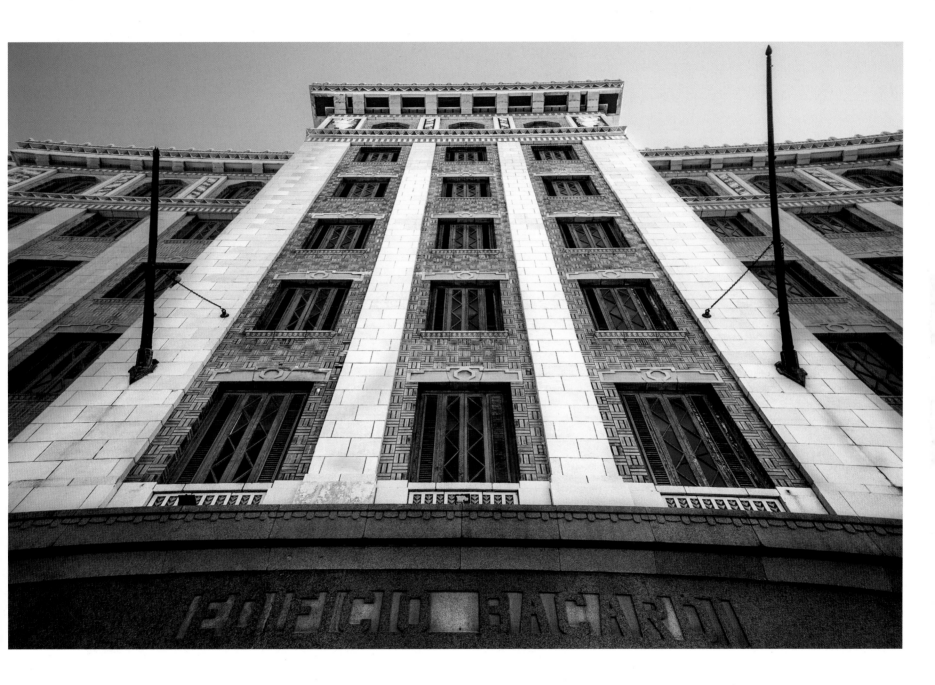

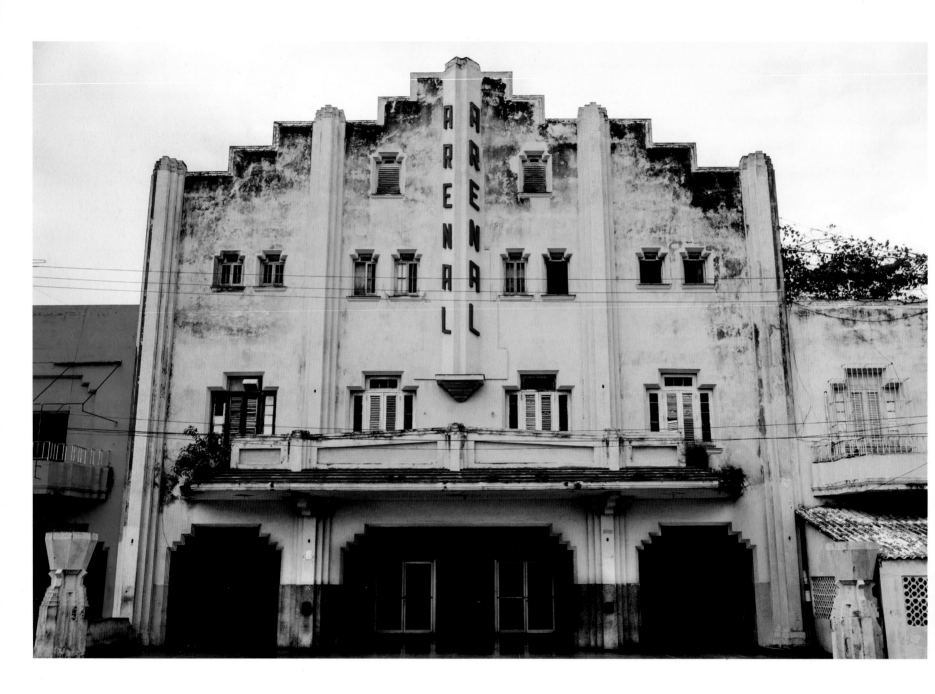

| Arenal Theatre, Vedado, 2013

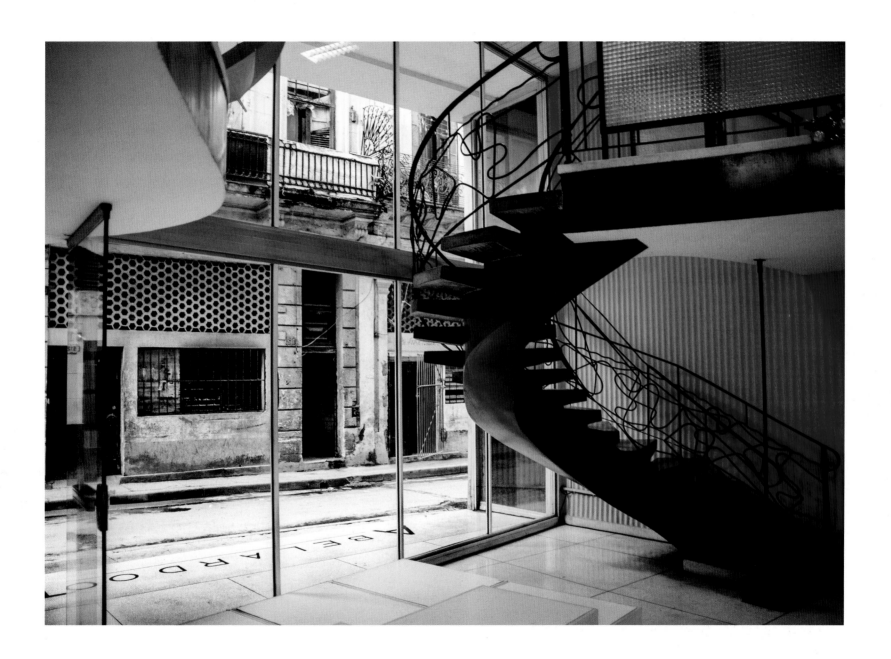

Abelardo Tous Interior, Habana Vieja, 2013 | 17

18 | El Morro, La Habana, 2012

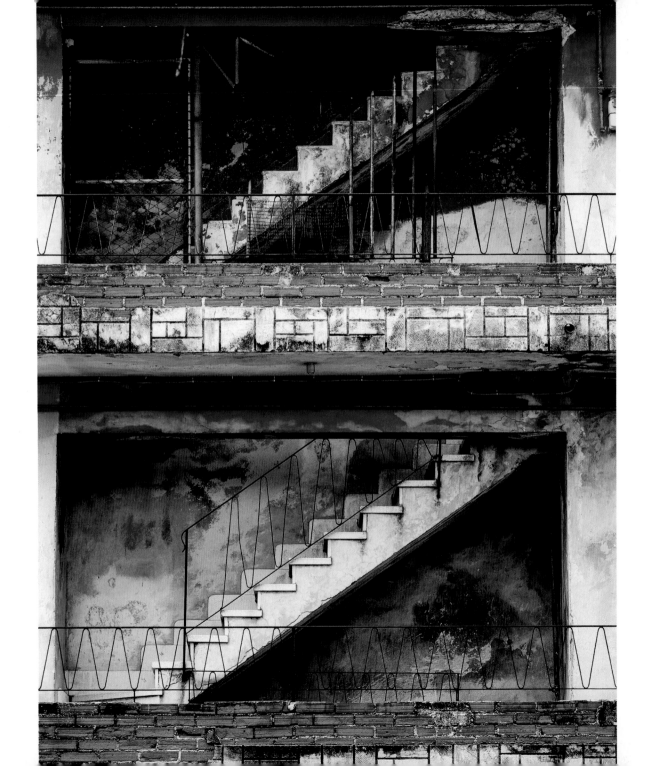

20 | Double Staircase, Vedado, 2008

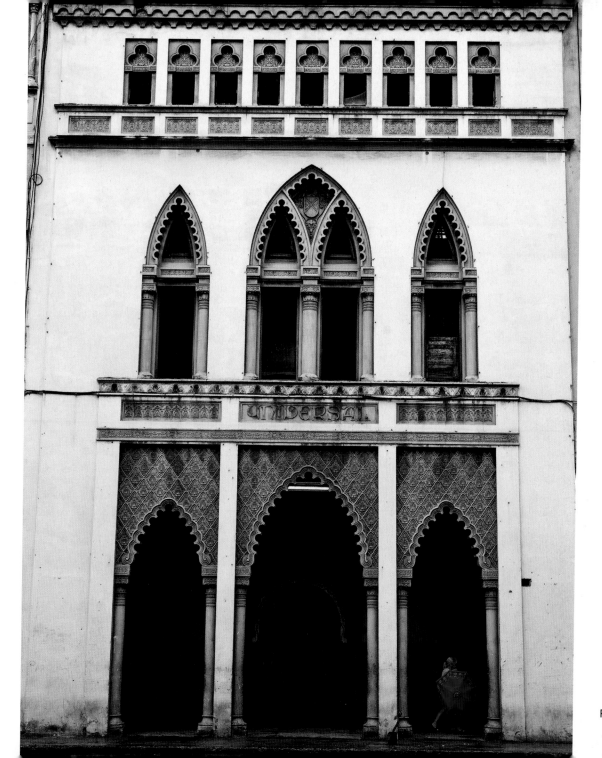

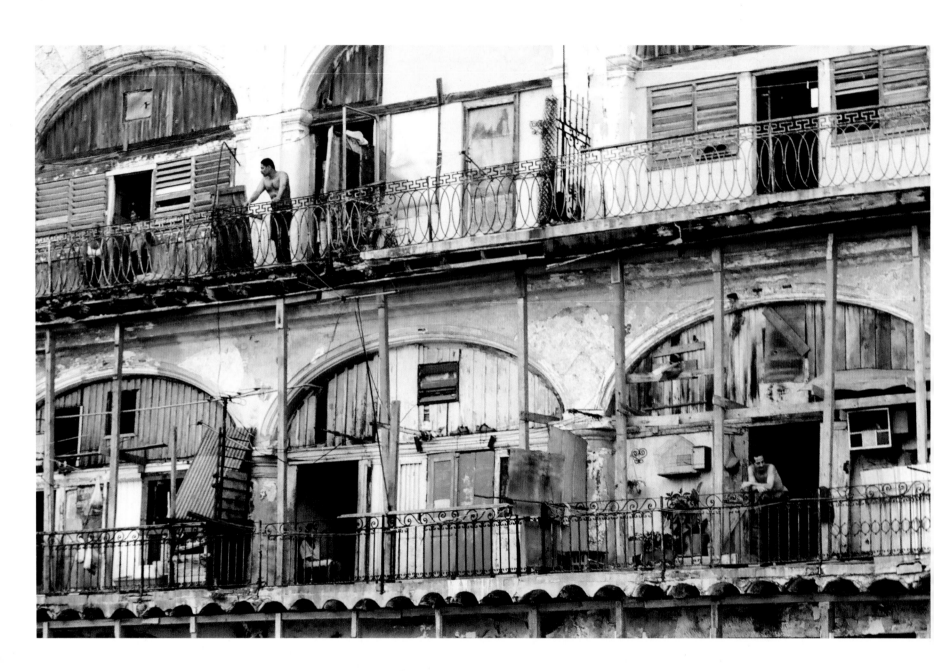

22 | Plaza Vieja Living, Habana Vieja, 2005, before restoration

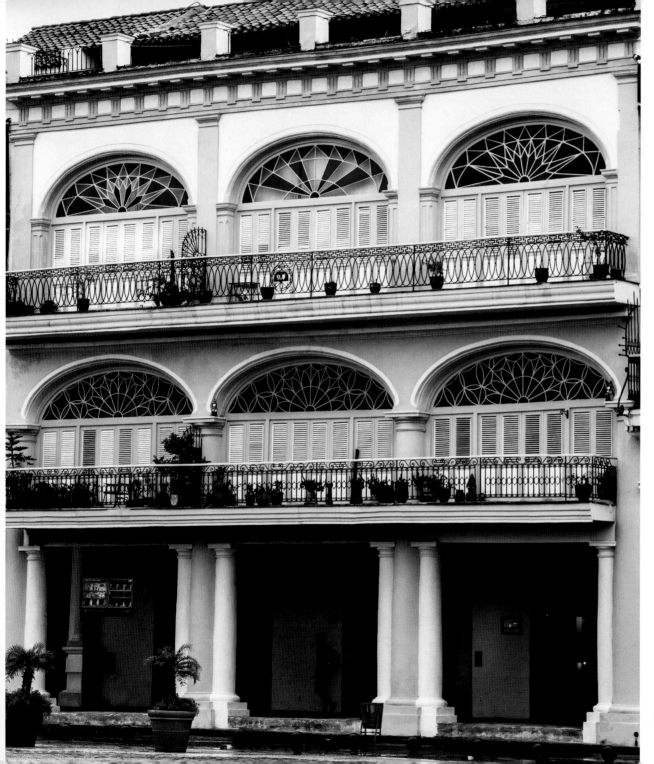

Plaza Vieja Restoration, Habana Vieja, 2013 | 23

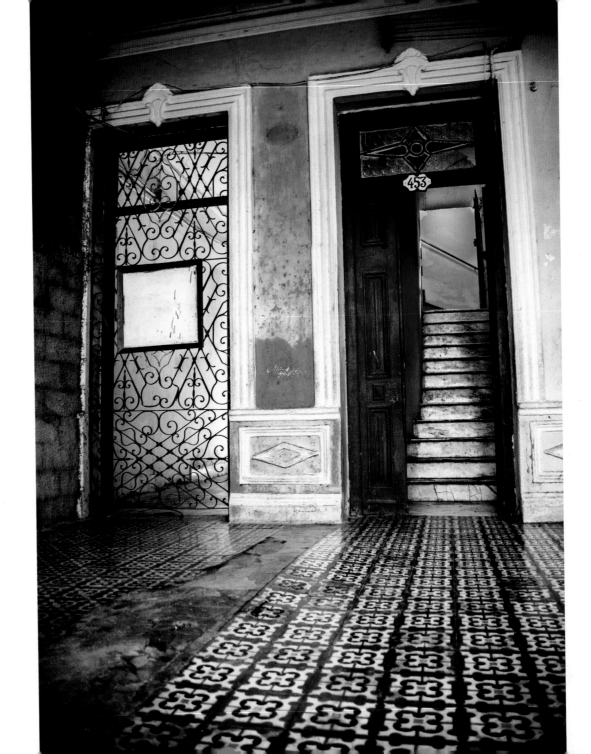

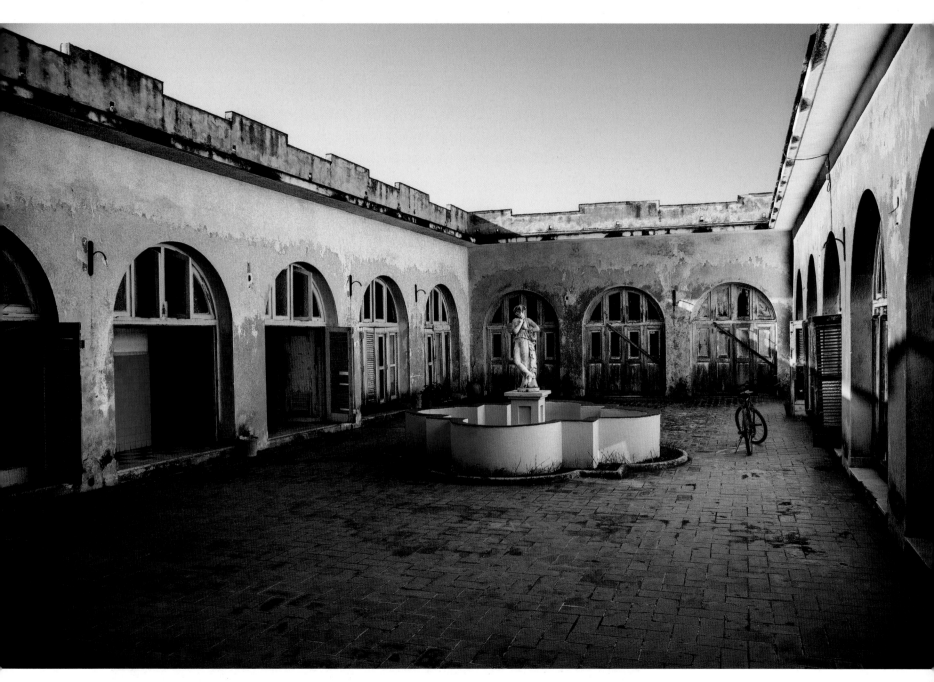

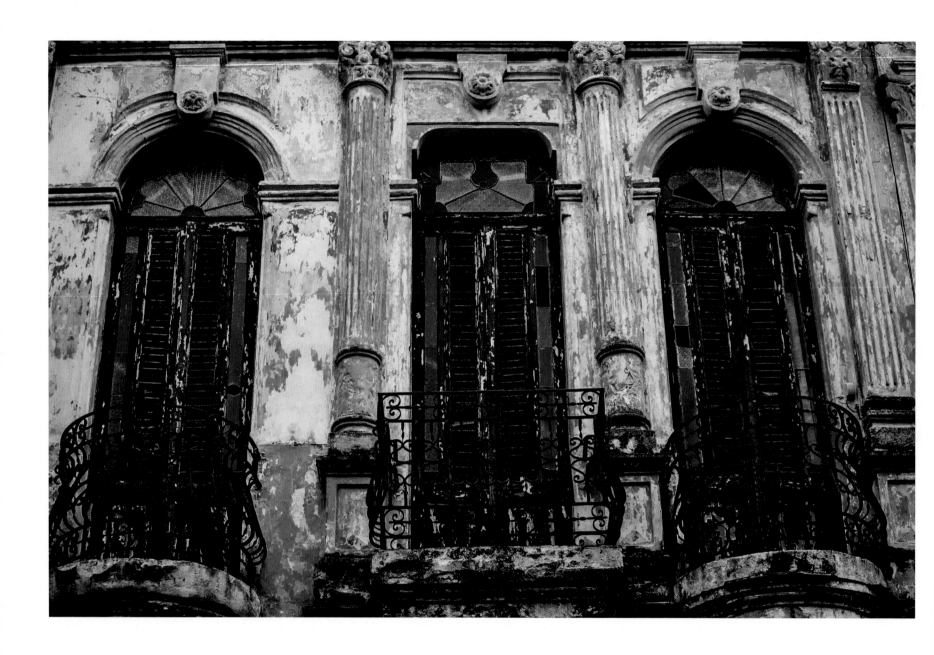

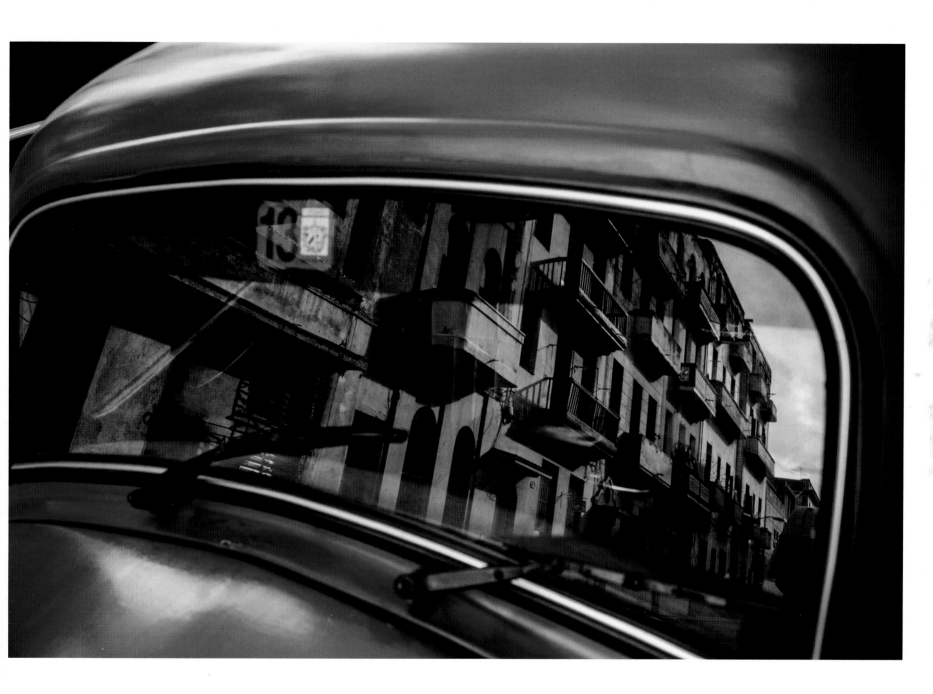

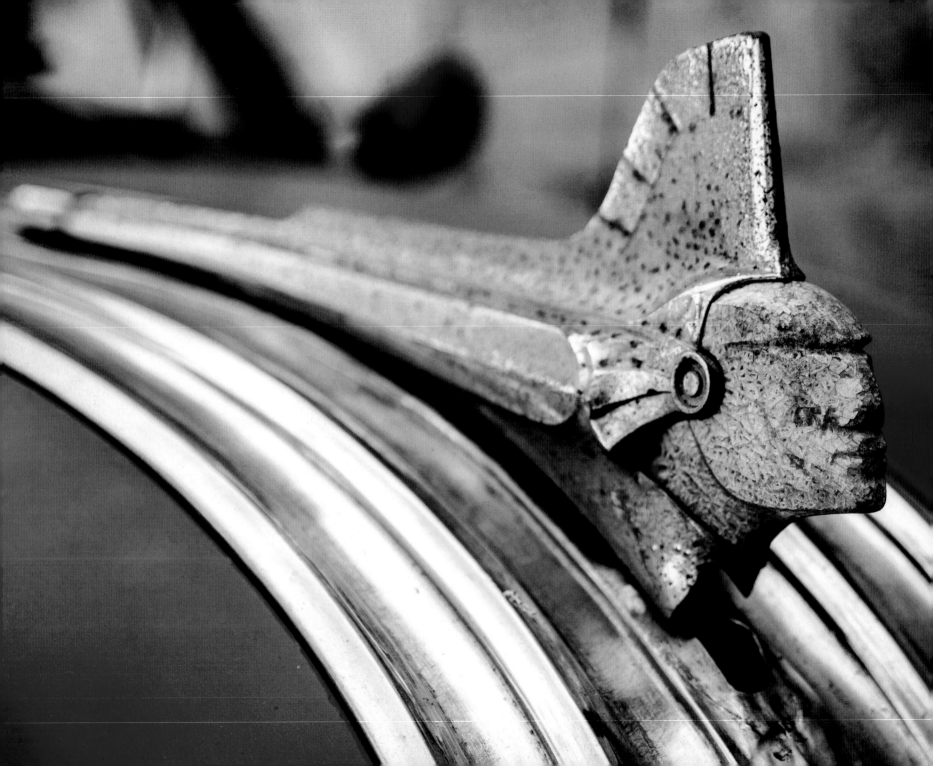

LOS CARROS ANTIGUOS

The streets of Havana reminded me of my high school parking lot.

ROBERT AMES, LIFELONG CAR COLLECTOR

Chief Poncho, La Habana, 2013

These are your father's or perhaps even your grandfather's Oldsmobiles. Rumbling up and down the boulevards and cobblestone streets of Havana, and throughout country roads across the island, are symbols that seem oddly antithetical to communistic ideas; old-fashioned American-manufactured automobiles of every imaginable make, model, and color. Chevys, Dodges, Fords, Buicks, Mercurys, Pontiacs, and Studebakers, most dating from the 1940s and 1950s, harken back to an era of milk shakes, Hula Hoops, Slinkies, James Dean, and rock 'n' roll. The *cacharras* or *bartavias* (as Cubans call them) have long been a unique attraction in Cuba, and they are everywhere. It has been estimated that one in ten cars in Cuba dates back to before 1959. In fact, unless one is a die-hard automobile devotee, after spending any amount of time on the island, the eye becomes immune to the ever-present sight of vintage vehicles chugging about.

Some of these "yank tanks" are in mint condition, maintained by proud owners who outfit and coddle their throwback era carriages with constant care and attention. Others are antiquated mechanical dinosaurs, barely kept running with a hodge-podge of jerry-rigged parts.

Whether the cars are in pristine or shoddy condition, many sport add-ons to express the personality (and budget) of the driver, such as chrome-plated hubcaps or matching candy-colored painted dashboards and steering. For those who can't afford automotive paint, a colorful coat of house paint to hide rust and imperfections of age will do just fine.

Some cars feature creative add-ons that could be considered works of art. A Chevy's rear light panel is turned into a bank of colorful brake lights that look like giant gumdrops. Chrome trim accents tail fins and sharp curves. And elaborate hood ornaments stab out from hoods like gleaming figureheads. Some, like the cars, are authentic antiques, while other hood ornaments are replicas or even homemade, crafted from a variety of metals, representing everything from eagles and swans to Art Deco symbols.

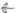

Cuba's relationship with the American automobile began to flourish in the 1930s and '40s, during the country's influx of U.S. organized crime figures. Using the island as a refuge from the law, mafia leaders brought their cars with them as well as the vices of drugs, gambling, drinking, and prostitution. Against a backdrop of glamorous nightclubs, beaches, beautiful women, and Hollywood stars, American-made roadsters roared through the streets of Havana and the Cuban countryside. Amazingly, more than a half-century later, they still do.

After the Revolution the mob fled, as did some citizens, but the cars remained. Through the years as trade relationships dried up between the United States and Cuba, the vehicles have gone from being regular old cars to collectable classics, making the highways and byways of Cuba feel like a traveling museum.

Some engines roar through the streets like airplanes, while others purr like sweet kittens. Sound quality aside, the most important thing about a car in a country where 90 percent of the people don't own an automobile is that it runs. With new parts available only at a bare minimum, even from non-embargo countries, most cars are kept running solely on the ingenuity and creativity of Cuban know-how. Because

for so many years they have had to make do with whatever parts, gadgets, and sheer ingenuity were on hand, Cuban mechanics are unquestionably among the world's best.

The old-fashioned American cars also play an important role in a charming tradition unique to Cuba. Brides are often escorted to their weddings in immaculate vintage convertibles that have been adorned with colorful and decorative laces, ribbons and bows. Riding atop the back seat of the car, much like the queen in a parade, the bride-to-be is whisked through Havana's streets by a dapperly dressed driver. As the bridal vehicle moves along the illustrious Prado and romantic Malecón, a celebratory horn alerts pedestrians, drivers, and onlookers to catch a glimpse of the smiling bride-to-be as she passes by with her white veil billowing behind her.

No one knows the numbers for sure, but it is estimated that nearly sixty thousand pre-1960s American cars are still in existence today in Cuba. Most are operational, but others sit rusting away on curbsides or in driveways and garages, the owners hoping someday to restore their former glory.

Over the past few decades Cuba's roadways have seen increasing numbers of newer makes and models of a variety of foreign-manufactured cars: Ladas from Russia, Kias and Hyundais from South Korea, Toyotas and Suzukis from Japan, Peugeots from France, Fiats from Italy, Jaguars from England, Mercedes and BMWs from Germany. They're all here with the gradual lifting of the fifty-year government restriction on car imports.

Museo del Auto Antiguo—the Old Car Museum, located in historic Old Havana, provides a glimpse into Cuba's transportation history. The museum displays include everything from late eighteenth- and early nineteenth-century horse-drawn carriages to an impressive array of beautifully restored Cadillacs, Rolls Royces, and Packards, the latter collection being reminders of Cuba's decadent past.

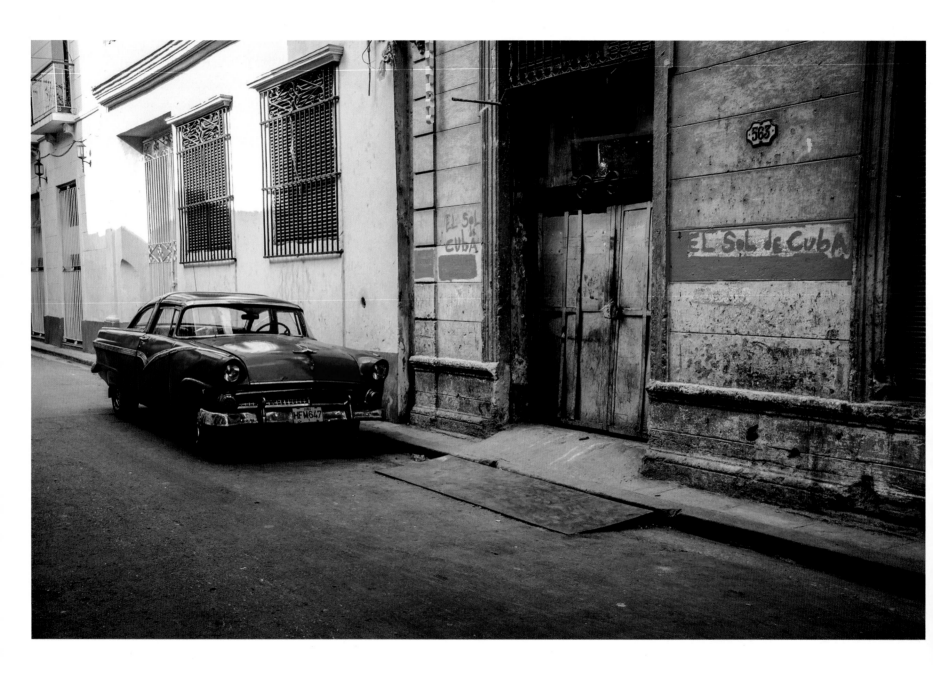

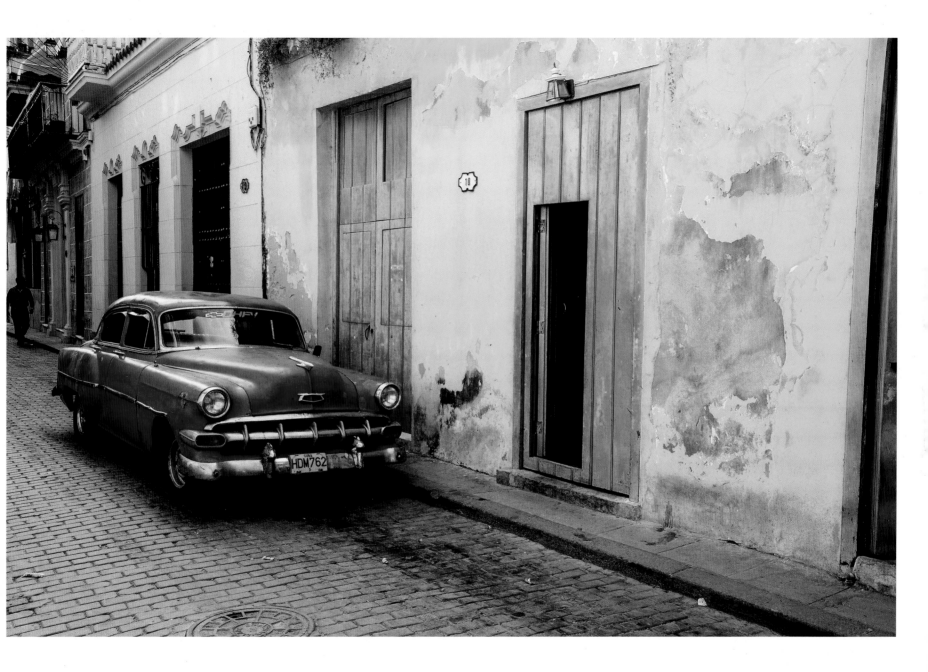

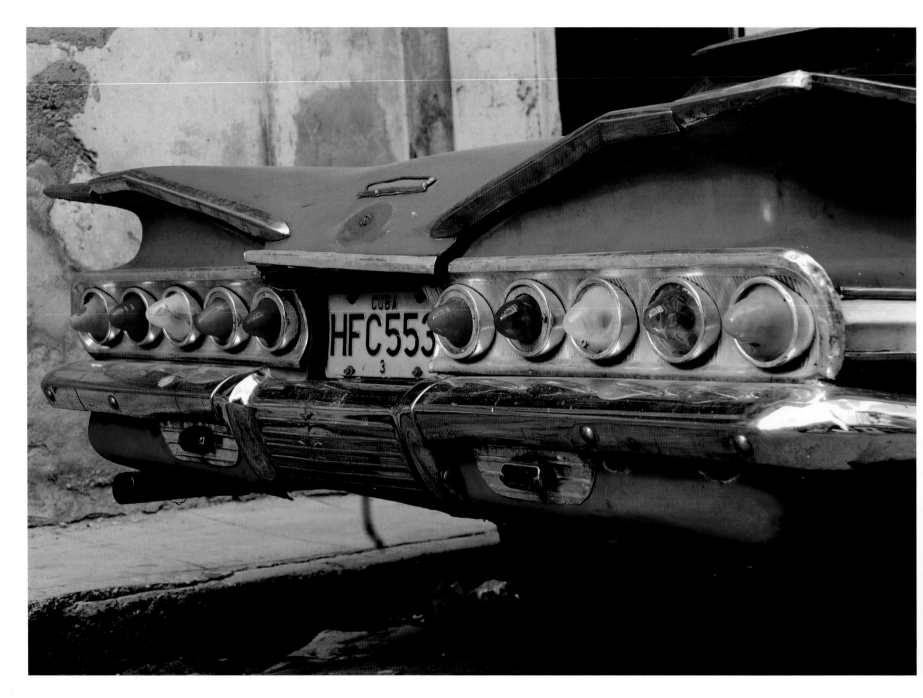

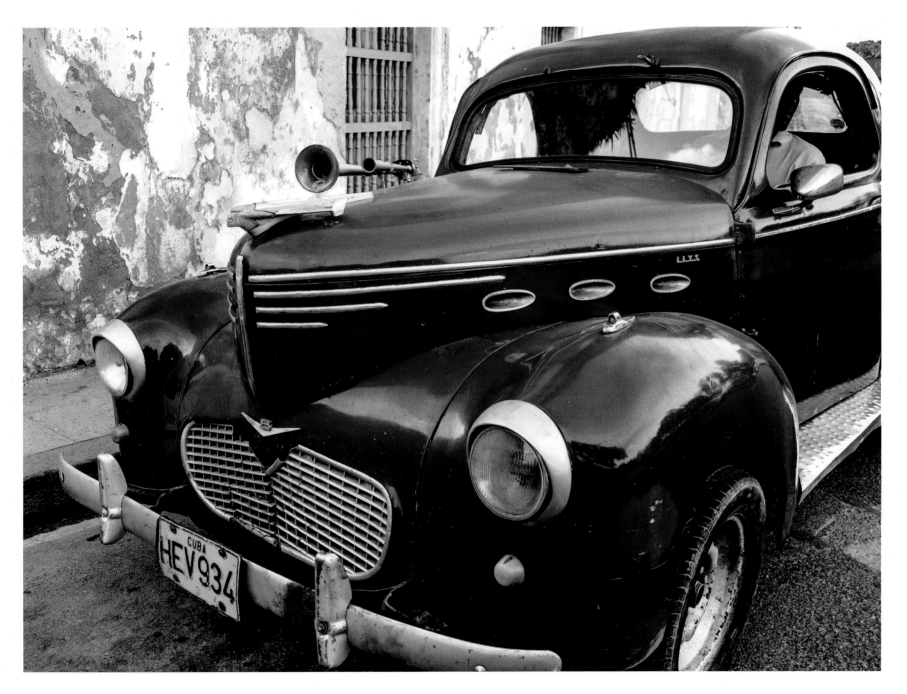

1940 Willys Pickup, Habana Vieja, 2008 | 35

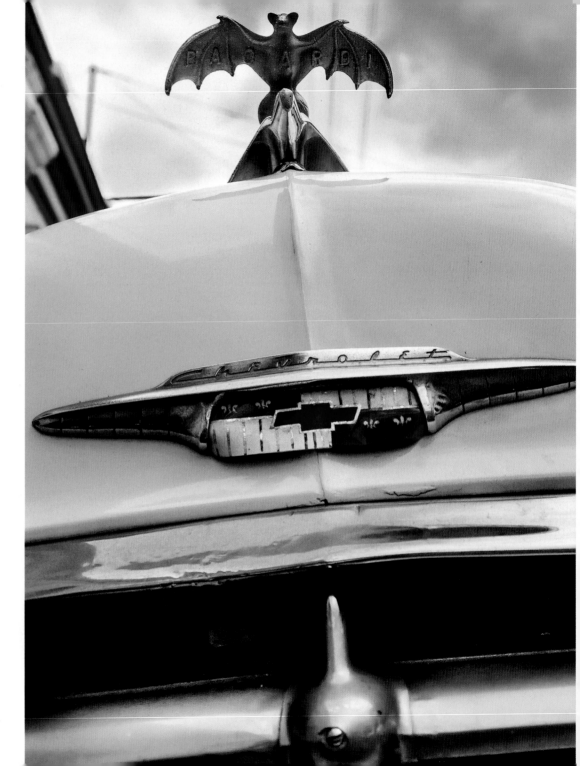

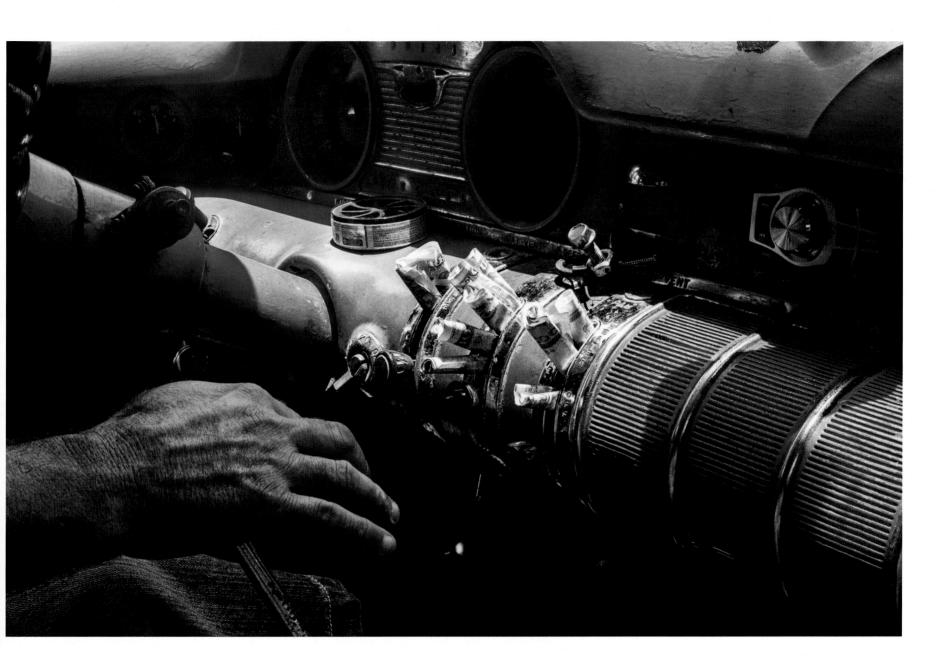

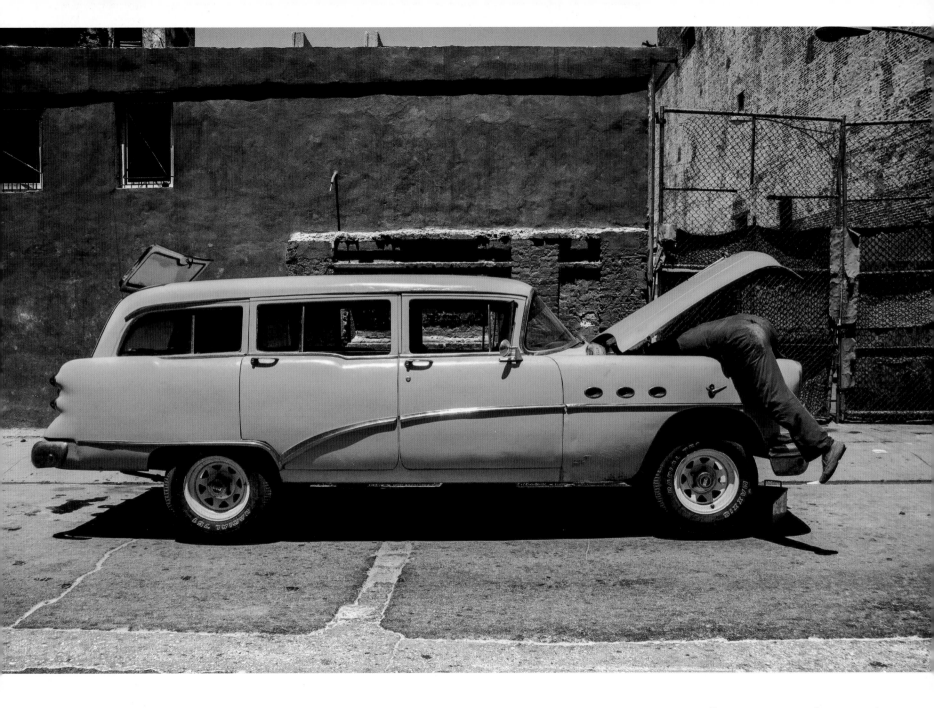

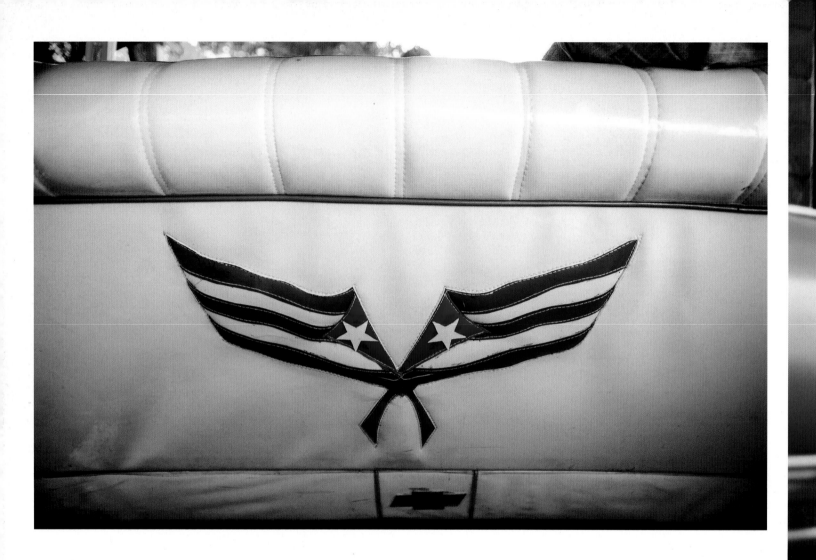

40 | Chevy Flag Interior, La Habana, 2013. *Right*: Mattress Car, La Habana, 2013.

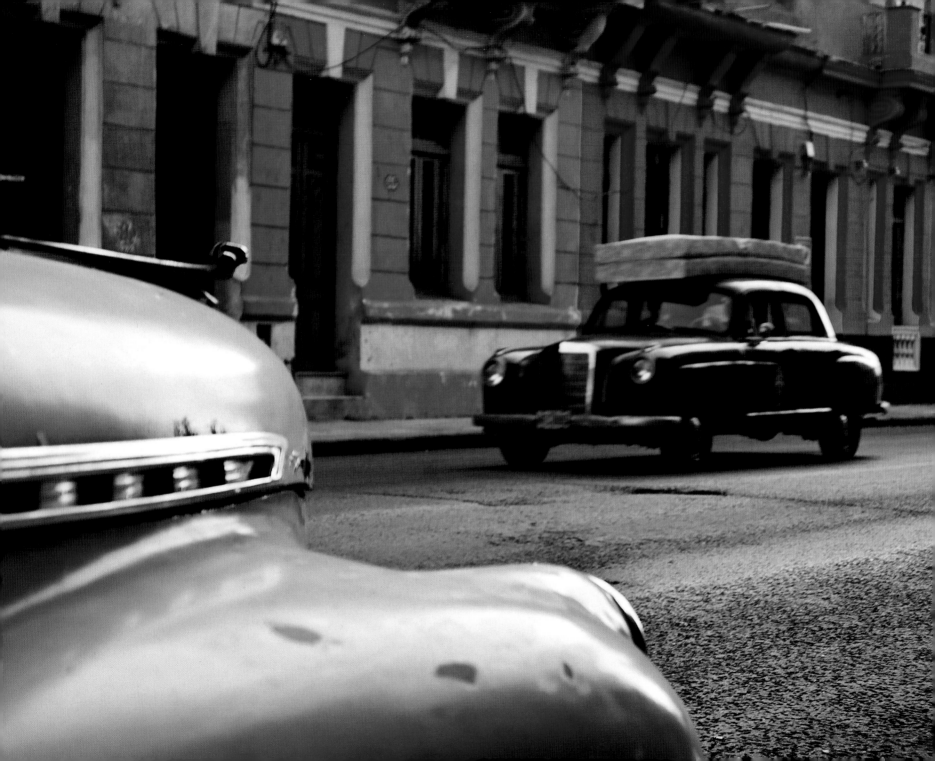

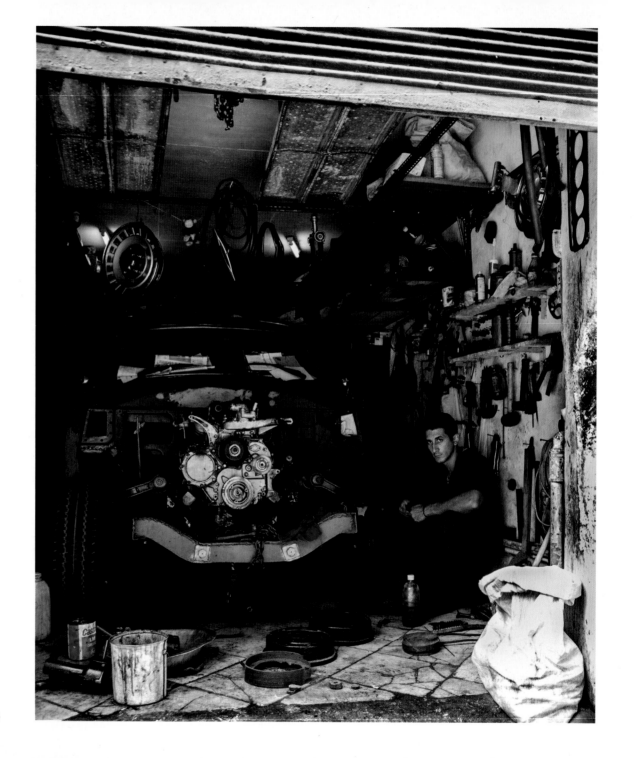

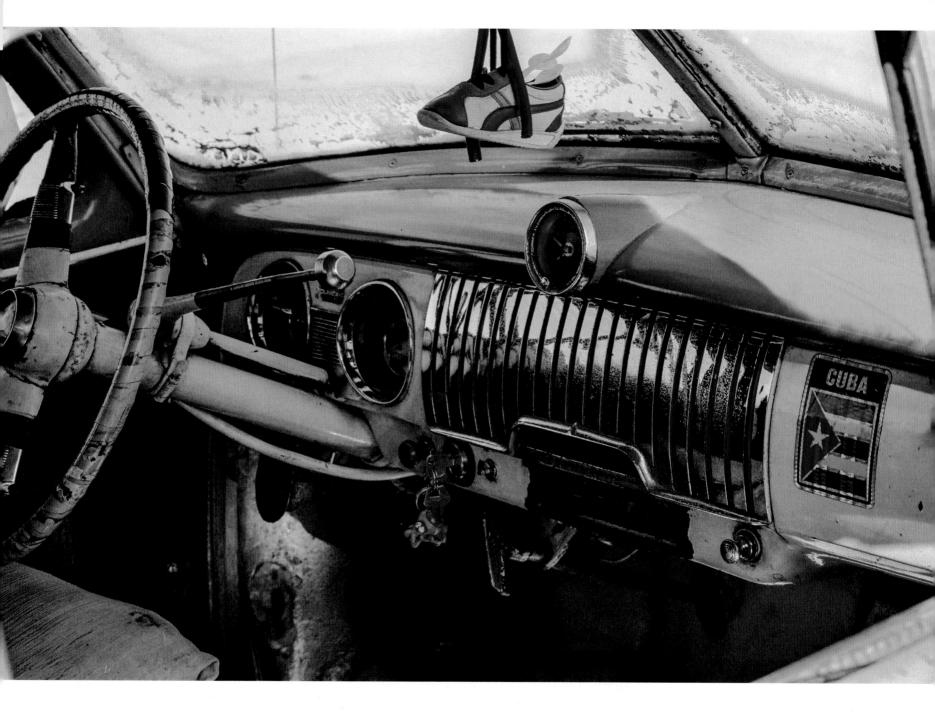

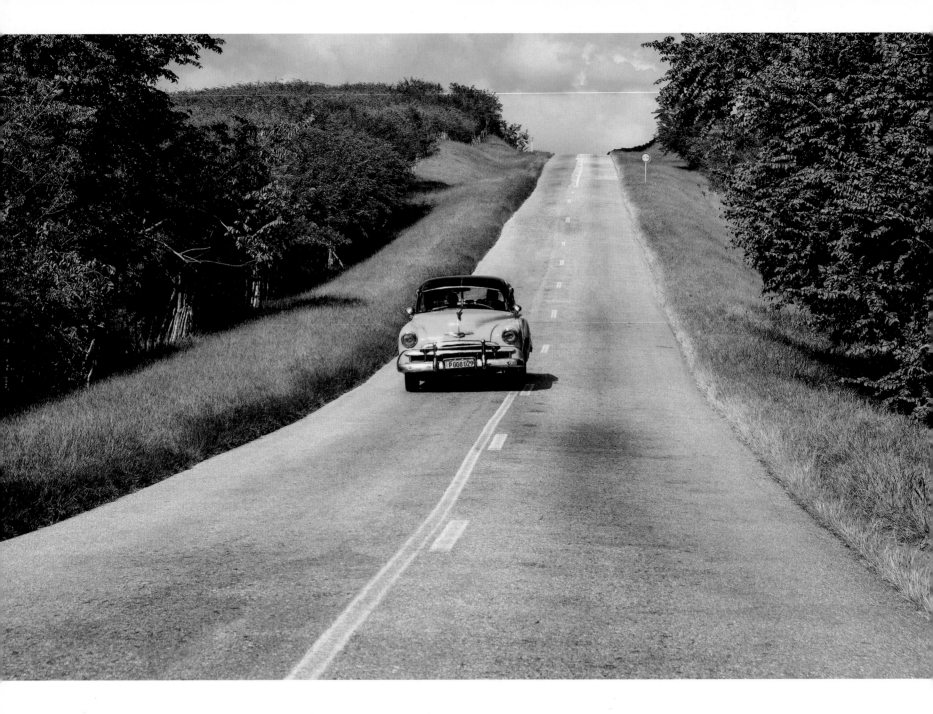

44 | Ease on Down the Road, Somewhere on the A1, 2013

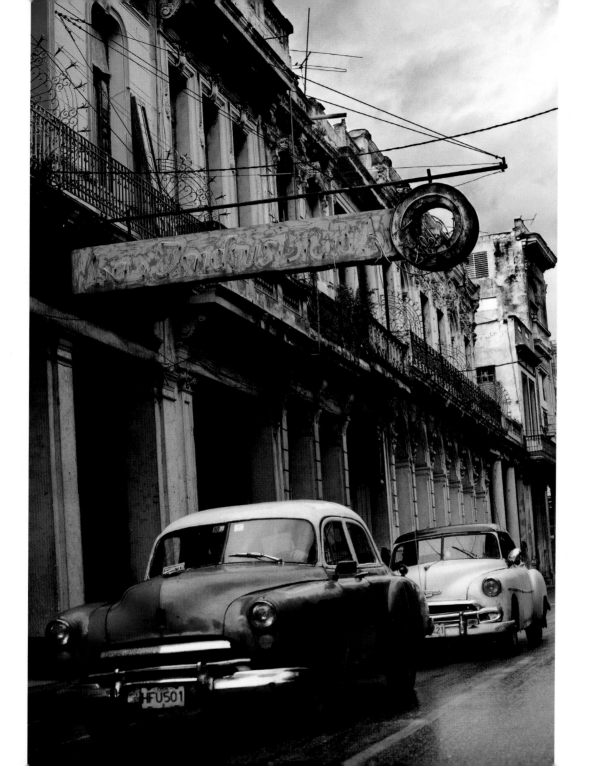

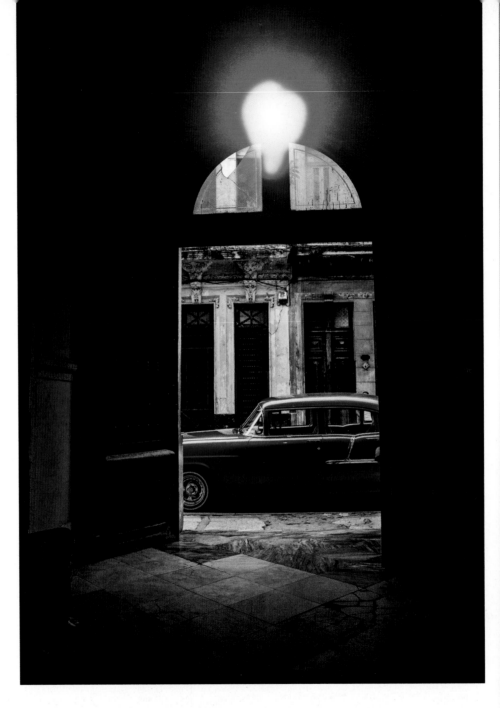

46 | Vintage in Doorway, La Habana, 2013. *Right*: Chevy Sunset Malecón Cruise, El Malecón, 2008.

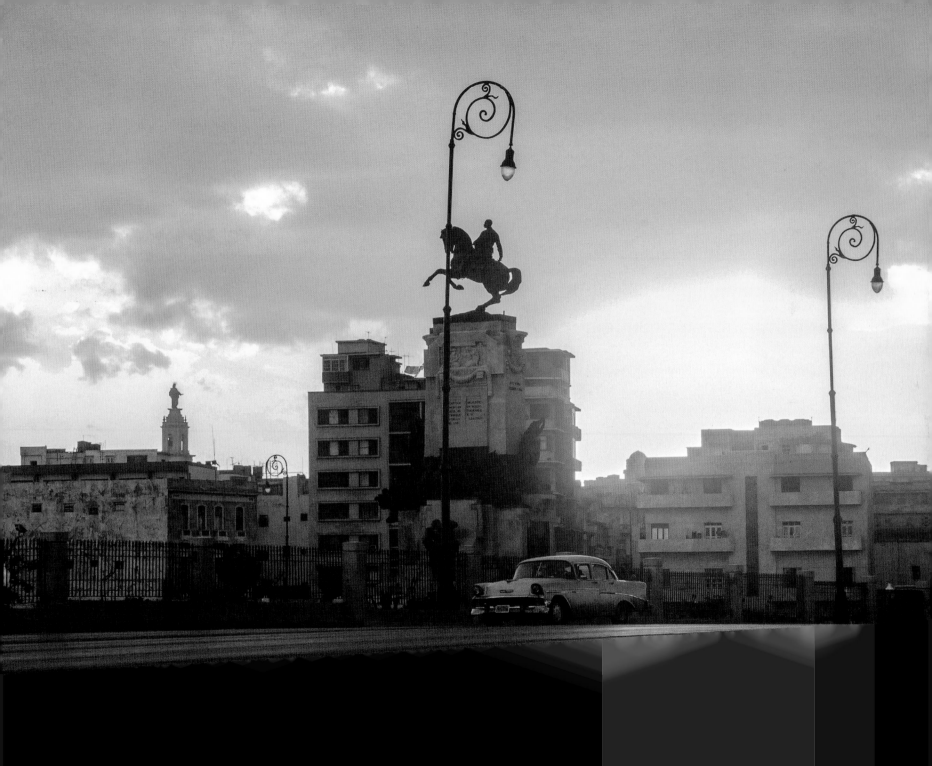

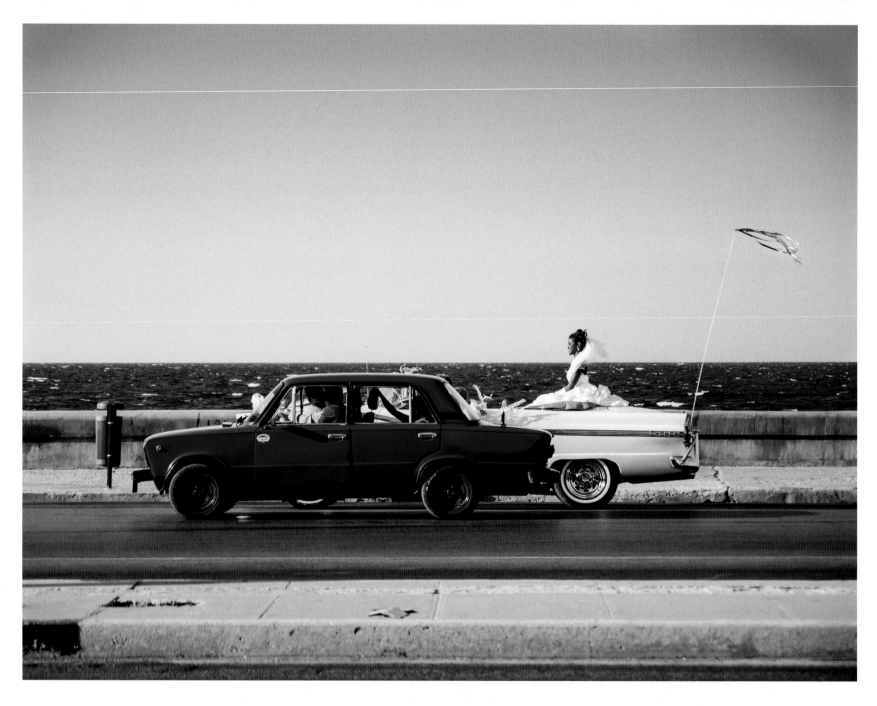

48 | Bride Ride, El Malecón, 2011

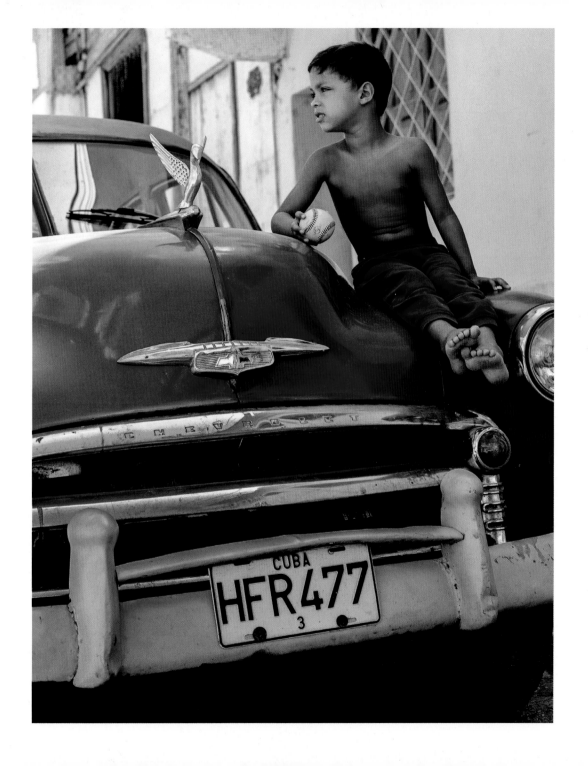

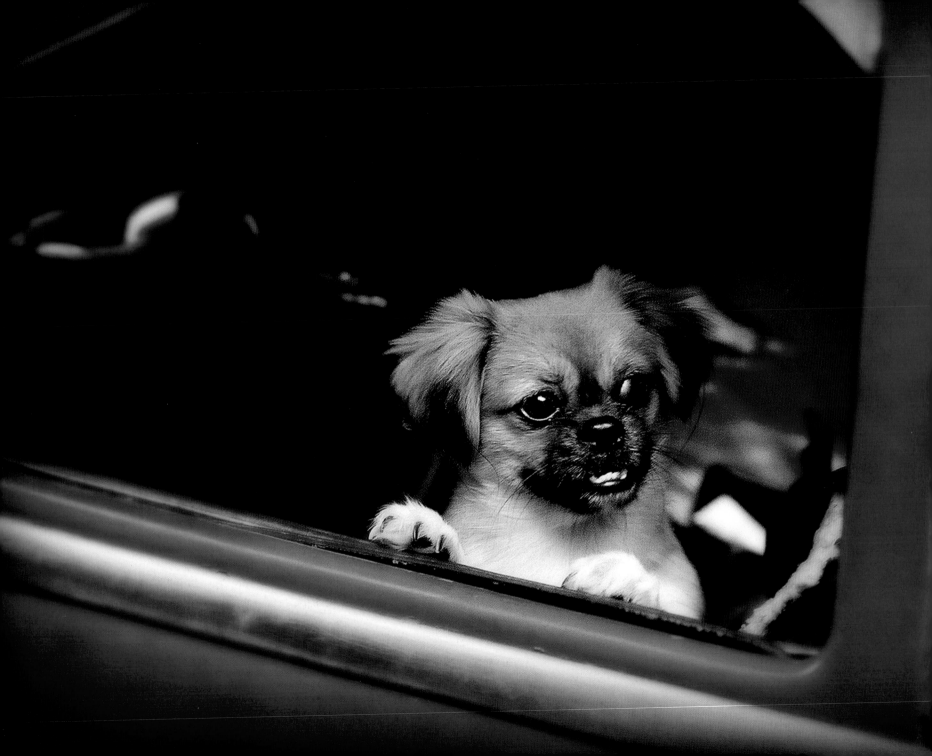

LOS PERROS

*Dogs are to Havana and Cuba as cats are to Naples and the Greek Isles—
a ubiquitous and lovable presence whose adaptability and resilience is as
charmingly a defining element of contemporary Cuba as are the island's
classic American cars.*

CHRISTOPHER BAKER, TRAVEL WRITER/PHOTOGRAPHER

Celli at the Wheel, Regla, 2006

THEY WANDER THE STREETS AT WILL, in and out of restaurants, homes, schools, and businesses, as if they have a schedule to maintain, business to address, and the right to go about as freely as any human.

Los perros de Cuba (the dogs of Cuba) are as much a part of society as people. Certainly more common than one might expect, hundreds of distinct breeds can be found throughout the island. Dachshunds in particular are popular, as are Dalmatians, Shih Tzus, Boxers, Beagles, Chihuahuas, Schnauzers, Cocker Spaniels, German Shepherds, and the quirky but adorable *perro Chino*, Hairless Crested Chinese dog. However, it is the street hounds of God-only-knows-what mixed breeds that tug at the heartstrings and represent the truest spirit of Cuba's dogs.

Because Cuba has no leash laws, uncollared strays amble freely through city streets and village roads as though they own the land. Possessing an uncanny sense of their surroundings, they instinctively seem to know when it is or is not safe to move through traffic, both automotive and human. Still, if necessary, cars come to a screeching stop, kids playing on sidewalks momentarily pause, and people step aside to allow their four-legged fellow citizens to go about the business of looking for scraps, schlepping about with other furry friends, or prowling for the next mate to propagate. Street dogs sleep on, in, and under stairways, cars, porches, benches—anywhere they can catch a snooze. Because they are not spayed or neutered, crossbreeding and inbreeding are common, resulting in some of the strangest and often comical-looking critters imaginable.

For an animal lover, witnessing the plight of the Cuban street dog can be disturbing, to say the least. Some of these creatures are so mangy and malnourished that it is heart-breaking. Unvaccinated, many carry fatal canine diseases such as parvo and rabies, while others suffer from severe bouts of flea, mite, and heartworm infestations. But true to the Cuban spirit of resilience, these lovable island canines carry on in an undaunted manner; many are looked after and fed by entire neighborhoods, and others roam freely from barrio to barrio.

On the flip side, house dogs receive thoughtful care and attention from loyal owners. And in return, the canines stay near and loyal. Some dogs trot along rooftops, keeping a protective eye over house and 'hood, while others lounge behind iron-barred windows and doorways, peering out at and greeting passersby. Typically, Cuban owners spoil pets and shower them with affection in the same manner as loving dog owners do the world over.

Having hosted its share of political summits, music and art festivals, international baseball games, car shows, and numerous other events, Havana has added a dog show to its impressive lexicon of international events. Known as the Campeonato Internacional de Belleza Canina (International Beautiful Dog Show Championship), the four-day experience organized by the Kennel Club of Cuba, held at the Eduardo Saborit Sports Complex (formerly Havana's dog track), hosts hundreds of dog lovers from around the island and other countries, proudly showing off their favored pedigrees.

Judges brought in from various Latin American countries evaluate the competitions in several breeding categories according to the rules of the Fédération Cynologique Internationale world canine organization, with its eighty-eight-nation membership governing dogs and dog shows, of which Cuba has been a member since 1987.

The winner receives no prize money or trophy. But the bragging rights of being recognized as "Cuba's best in show" are the stuff of a doggy parent's dream.

Regarding animal care, all of Cuba's provinces have full service veterinary clinics. Around Havana, trendy pet boutiques are starting to pop up, carrying a variety of supplies for dogs, cats, fish, reptiles, and birds. For extremely pampered pooches, a *tienda* (store) will carry everything from grooming supplies, flea control medications, and toys to fashion accessories for furry pals.

The Havanese (aka Havana Bichón) is the national dog of Cuba. Initially named the Havana Silk Dog, the Havanese remains Cuba's first and only homespun hound. In 1995 the American Kennel Club recognized it as an official breed in the "toy group." The Havanese breed is small but sturdy and is known for its springy gait as well as its playful, affectionate, protective, and intelligent temperament. Other distinctive traits include a long, wavy, silky coat, which comes in several colors, and a curled, fluffy tail.

In an effort to address the high stray population, the Asociación Cubana para la Protección de Animales y Plantas (ANIPLANT, the Cuban Association for the Protection of Animals and Plants), has implemented a new community project that provides homes for strays. Businesses, offices, and schools adopt and provide shelter, food, and veterinary care for stray dogs, which in turn become pets for these organizations. Collars and name tags (with photos) are provided for the adoptee, also bearing the name of the business entity sponsoring the dog. ANIPLANT hopes to expand its program and increase awareness by creating shelters, implementing neutering programs, eradicating canine abuse (such as underground dog fighting rings), and promoting adoptions.

Cuba's national passion for dogs extends back to the arrival of Columbus. When the Spanish first arrived in the Americas in the sixteenth century, they found at least twenty distinct breeds of dog, including the Mexican Hairless Dog (Xoloitzcuintli), one of the most popular pedigrees still found in Cuba today. Steeped in Yoruba traditions, which advocate that dogs are sacred and should not be mistreated, Cubans hold them, and all animals, in high esteem. This belief has been passed down and absorbed into contemporary social custom.

Whether navigating their way through the bustling traffic of Havana's classic cars, Coco taxi's, and bicycles carriages, or trotting alongside a dusty road in a rural village, or simply resting comfortably on the lap of a doting human companion, *los perros de Cuba* are without a doubt an integral part of the country's charm.

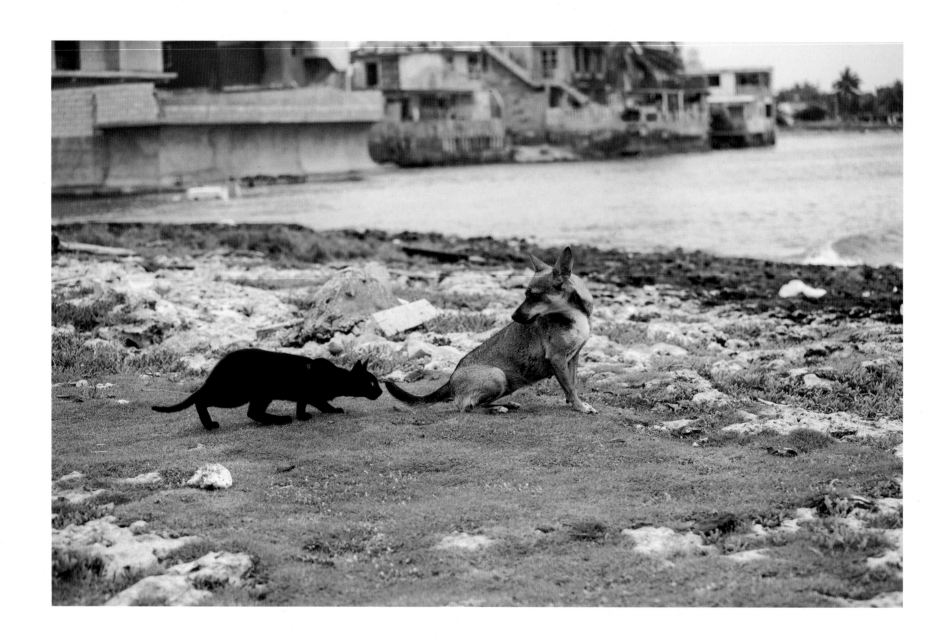

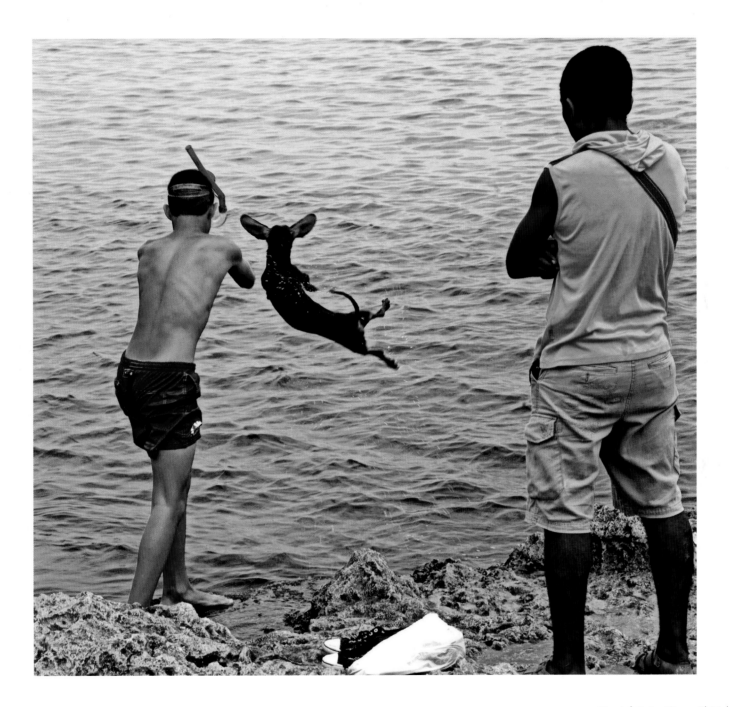

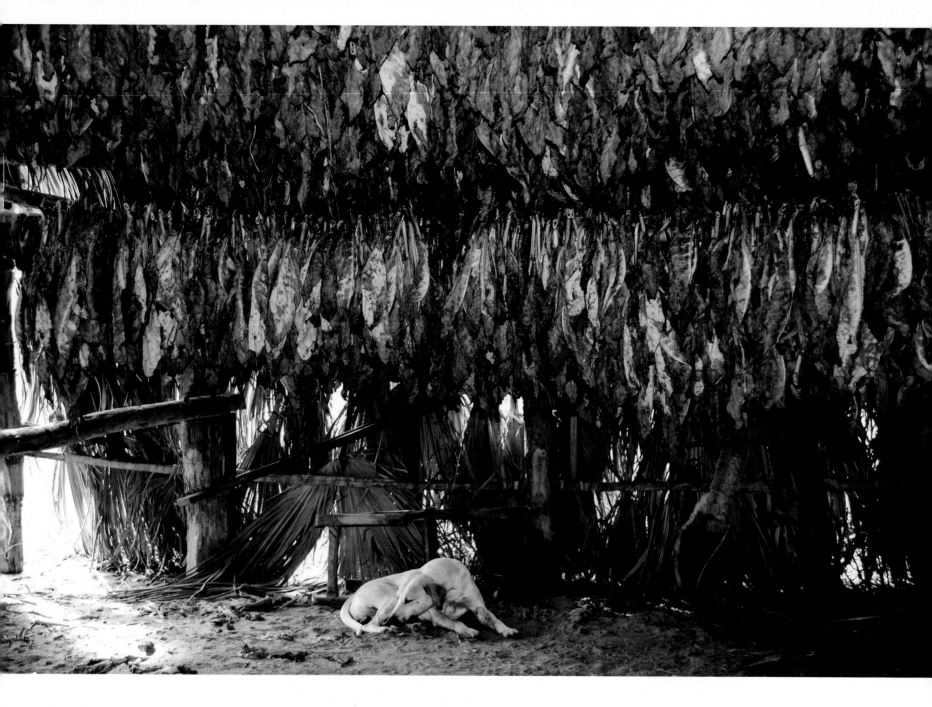

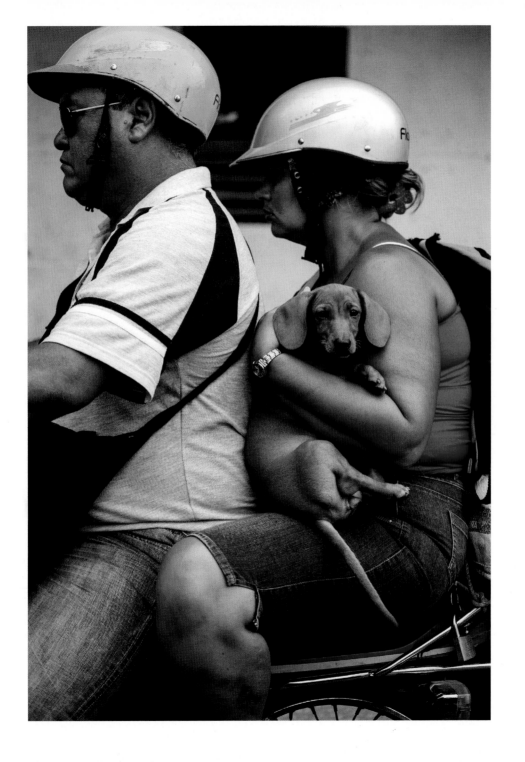

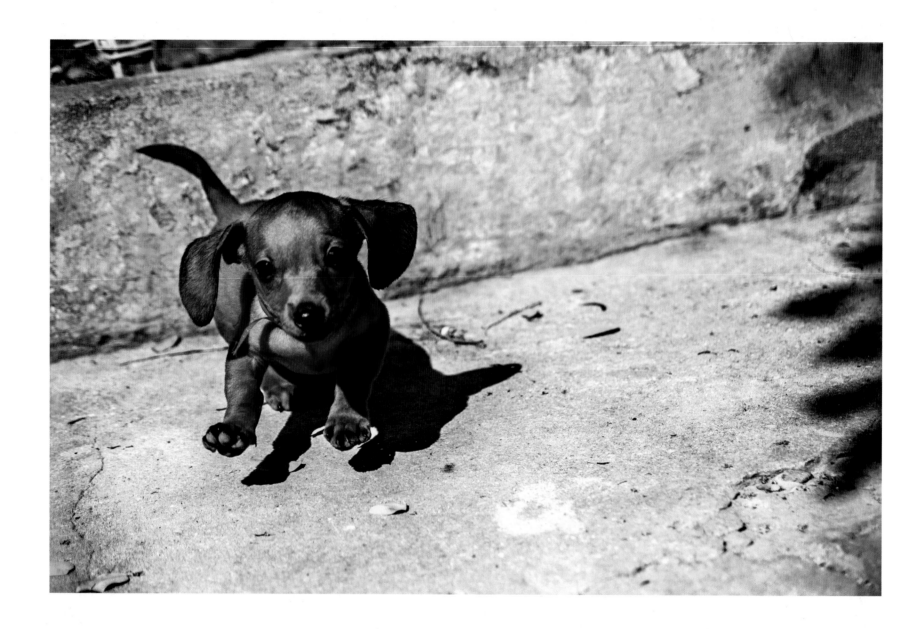

Dachshund Puppy, Vedado, 2011

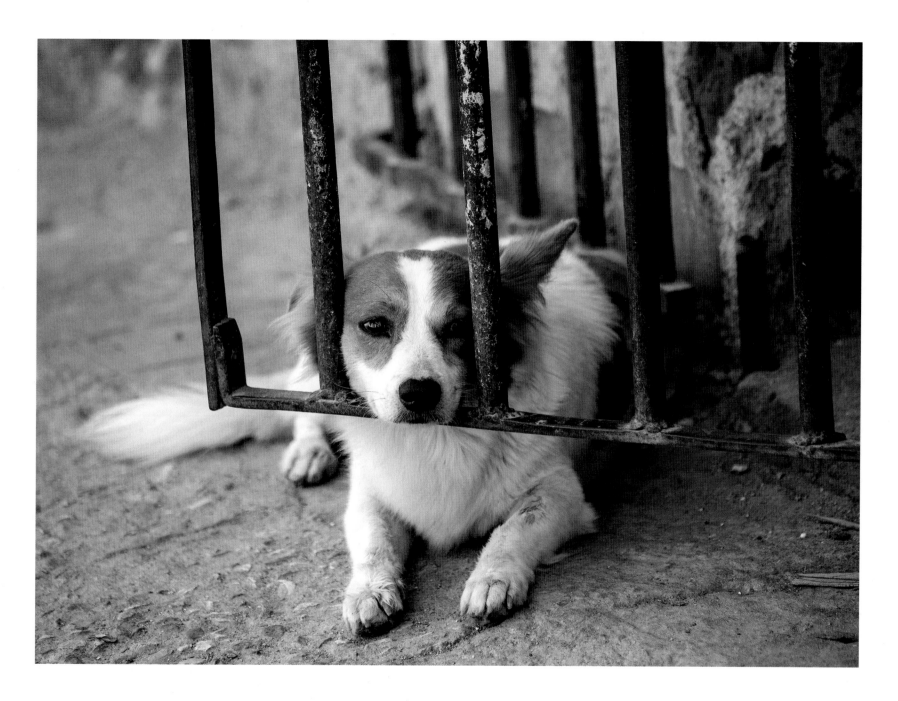

Resting on Iron Gate, Centro Habana, 2011 | 59

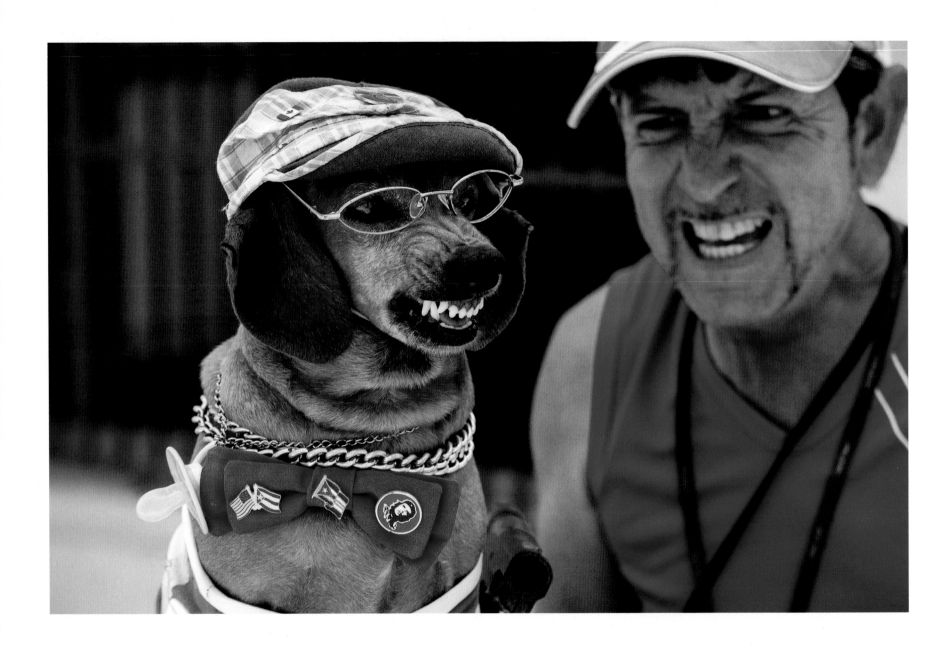

60 | Growl or Grin? Habana Vieja, 2013

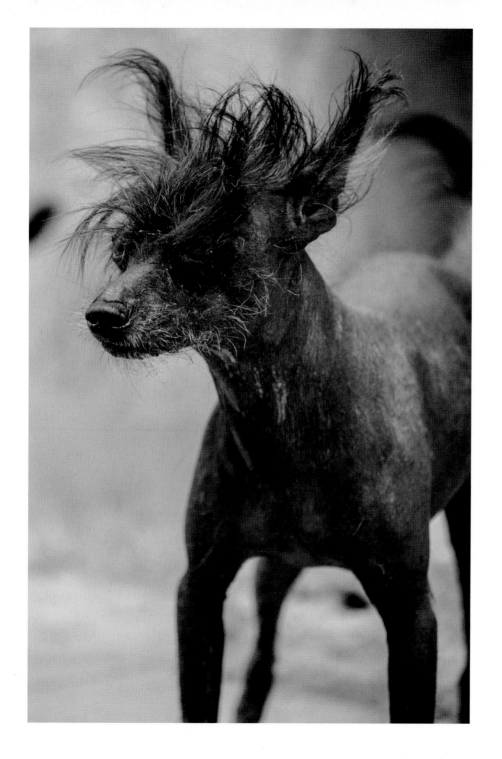

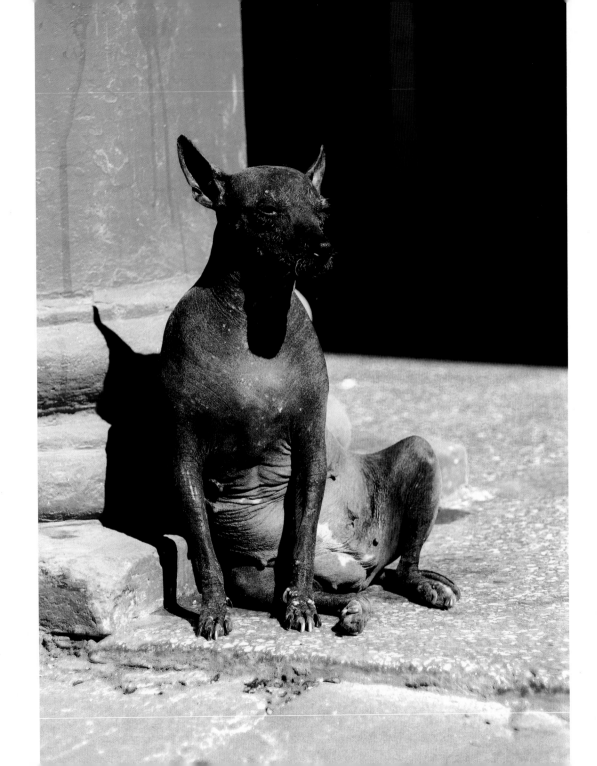

62 | Hairless Hound, Habana Vieja, 2008

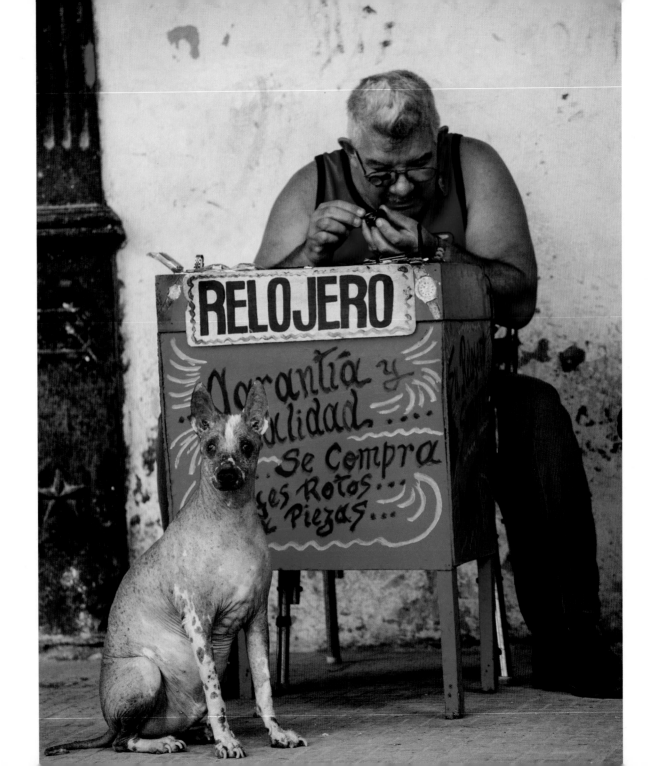

64 | Watch Dog, Habana Vieja, 2013

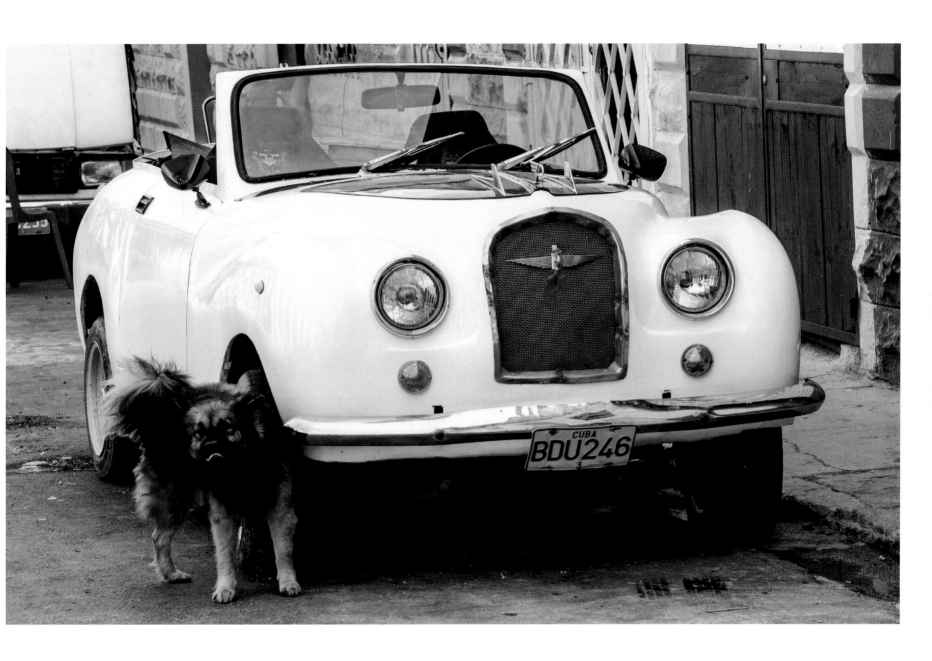

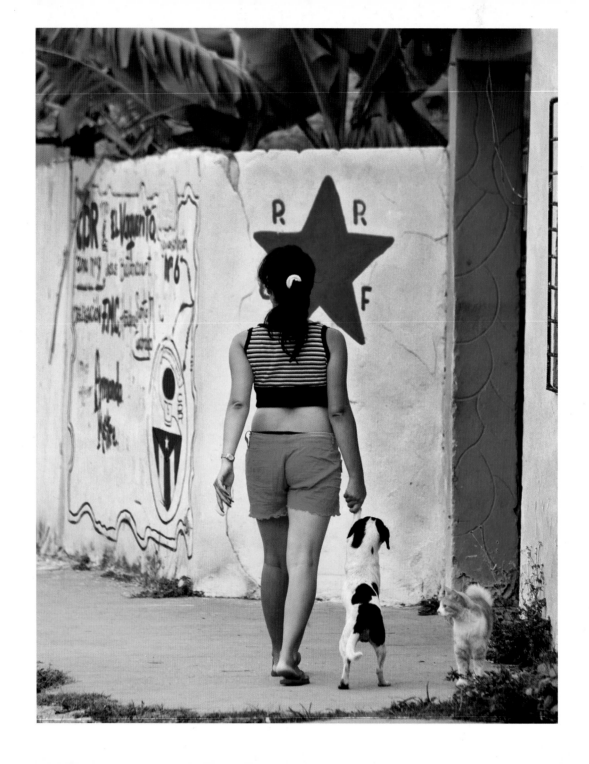

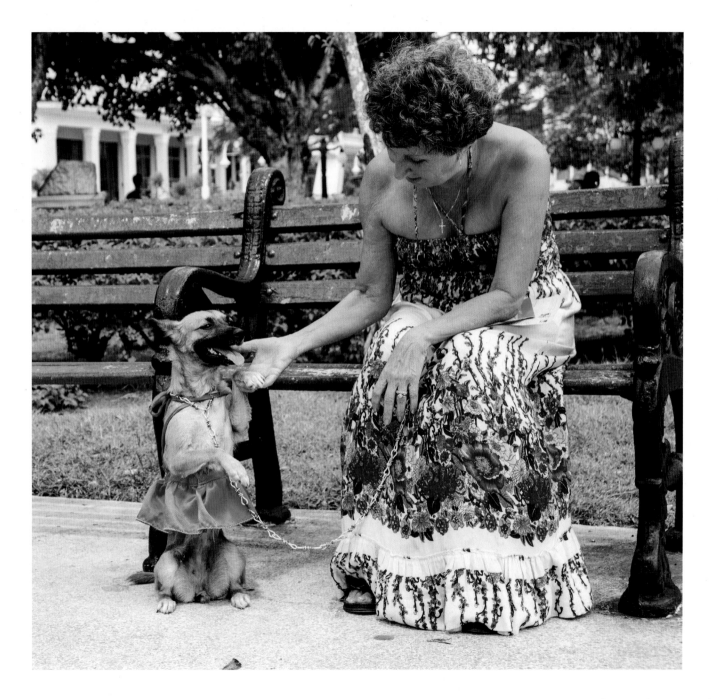

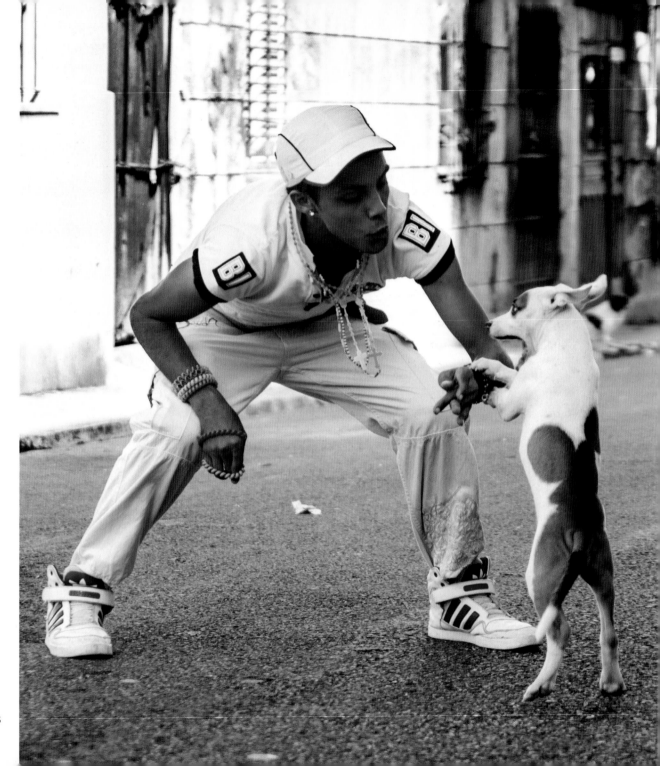

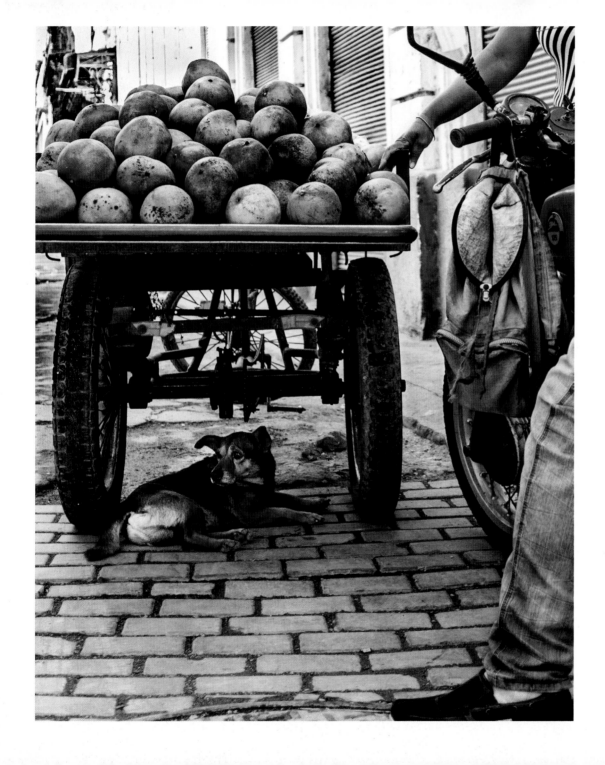

Dog under Mango Cart, Habana Vieja, 2013 | 69

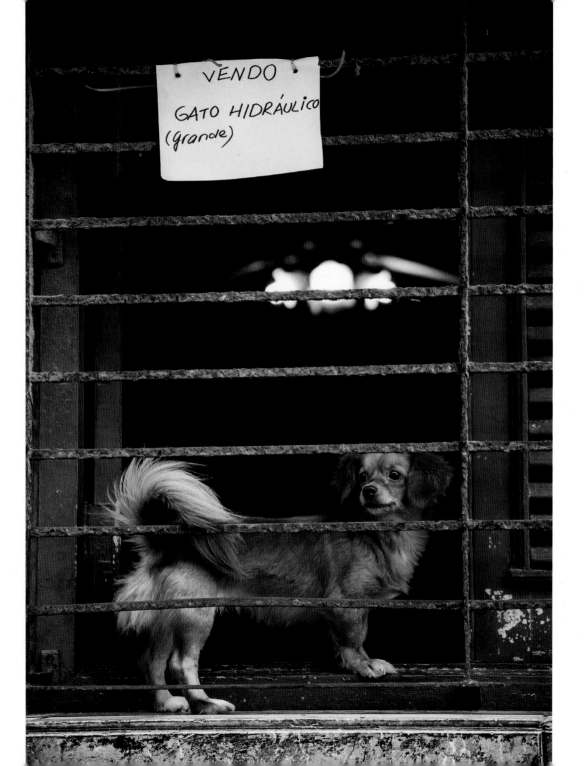

Dog Selling Cat, Centro Habana, 2013 | 71

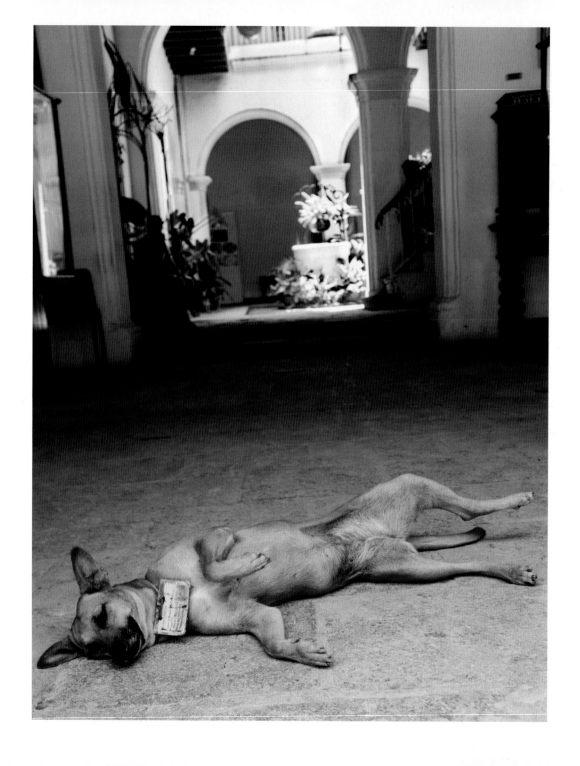

Canelita Catches a Snooze, Habana Vieja, 2013

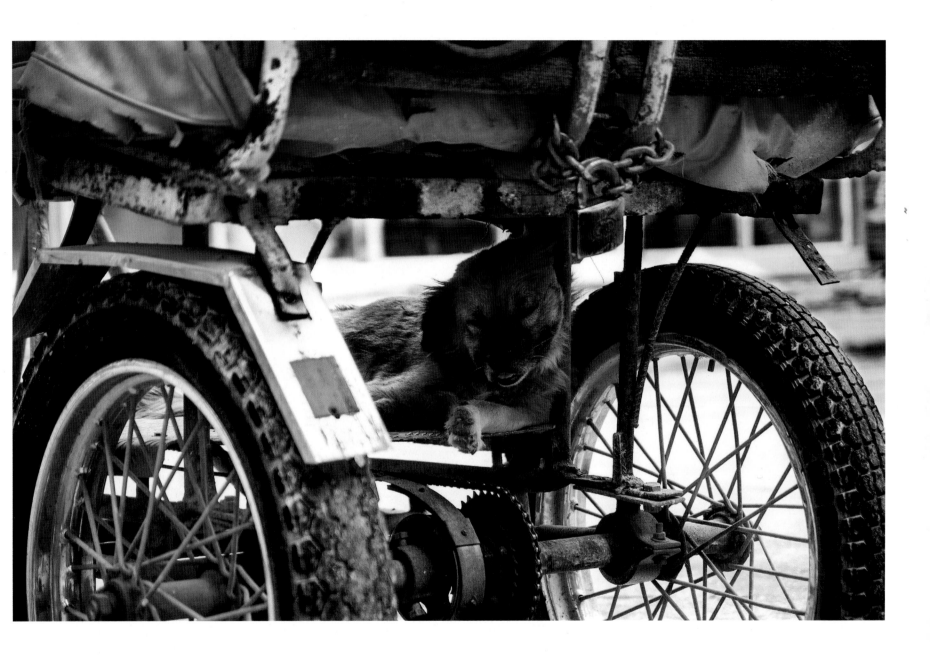

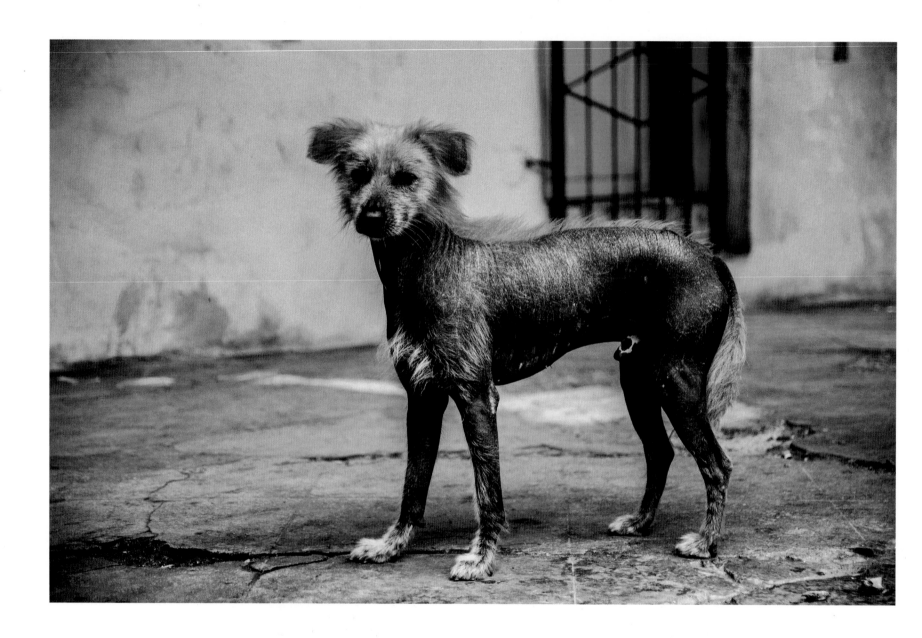

Perro Chino, Habana Vieja, 2012

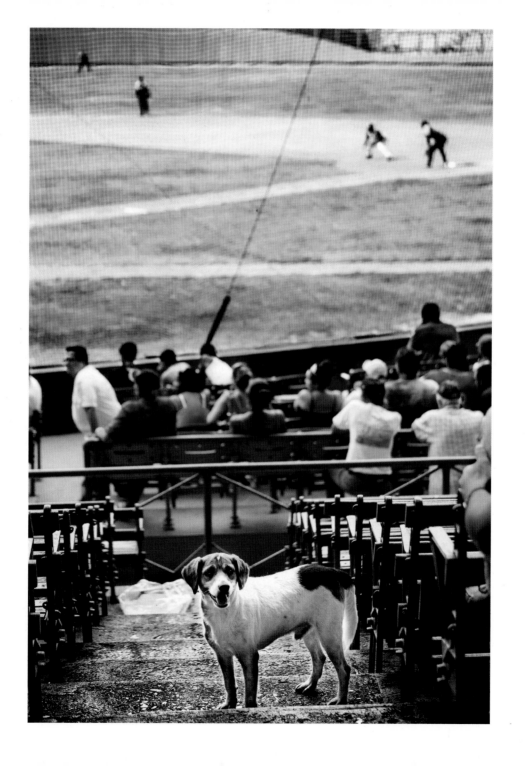

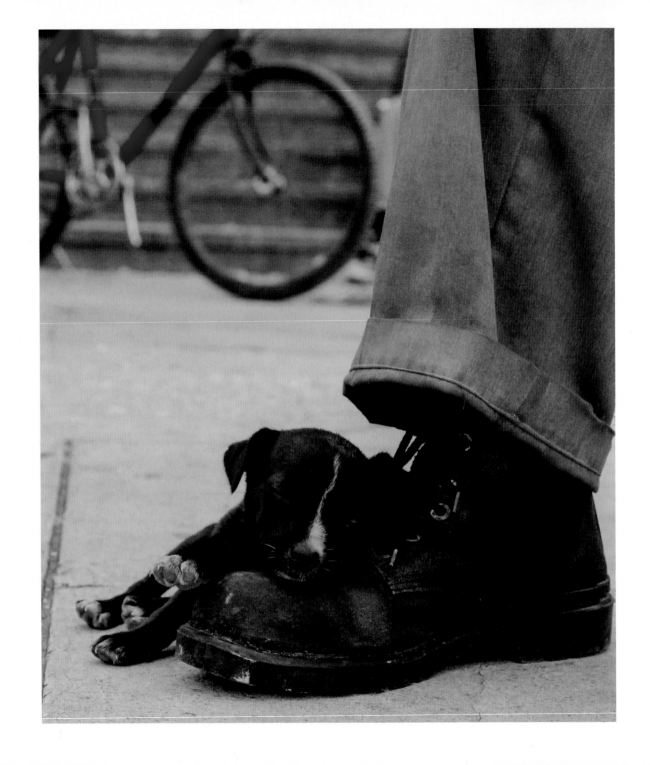

76 | Boot Sleeping Pooch, Vedado, 2009

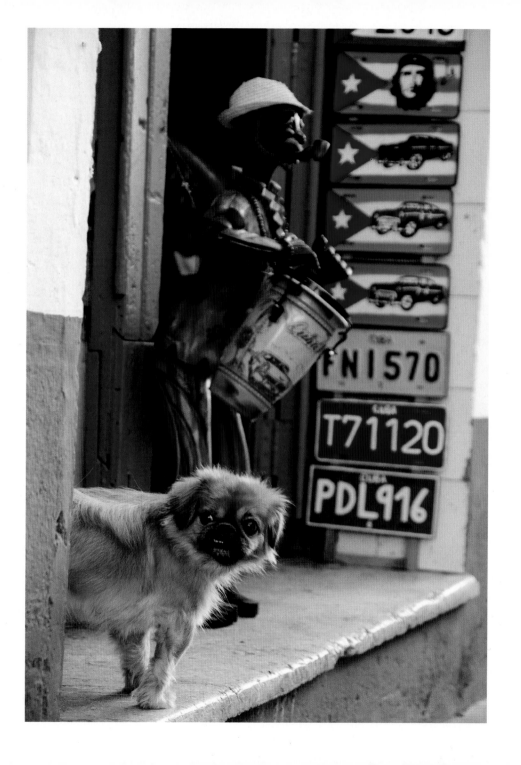

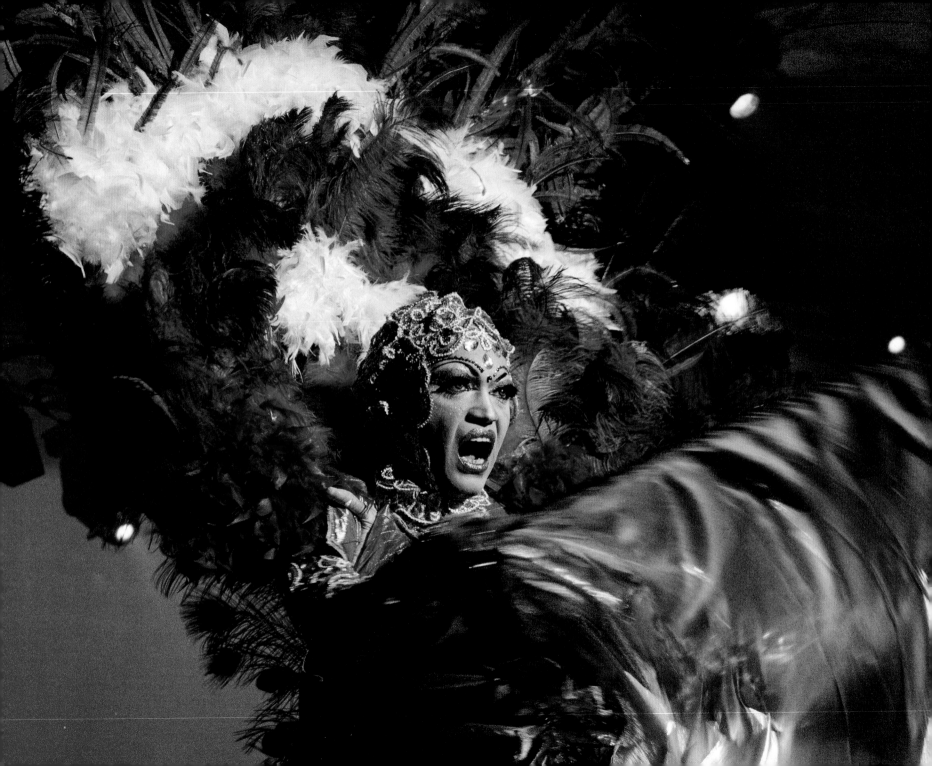

LA MÚSICA, ARTE Y BAILES

To know Havana was one of my dreams. Now that I know it, just imagine. Havana is very beautiful . . . it's the cradle of music and show.

NAT KING COLE

Cuban art brings you closer to the inner thoughts and meaning of the people of Cuba. It is art that excites and takes our minds to another level.

ALBERTO MAGNAN, CO-OWNER, MAGNAN METZ GALLERY

When we dance our spirit enables us to escape our hardships. We take the moment and live in the present. Our spirit soars and we hope our spirit generates energy and life in those who watch or dance with us.

LIDICE LÓPEZ, DANCER

Drag Performer, La Habana, 2011

Cuba *is* music. The island has always been a mainspring of sound, expressing Cubans' intense joy in life and sensuality. Cuba is beyond question the most influential source of music in Latin America. Its roots and rhythms—rumba and *son*—created the pan-Latin music of salsa, and in their older forms they continue to provide abundant riches.

For many American audiences, the golden age of Cuban music harkens back to 1950s images and recordings of Nat King Cole performing stylish *boleros* at the world famous Tropicana nightclub; Desi Arnaz swinging and singing lively renditions of "Babalu" with his big band on the iconic television show *I Love Lucy*; and the "Queen of Salsa" Celia Cruz belting out *canciones* with her sexy contralto and dynamic stage persona.

Fast-forward through the decades and one will find that modern Cuban music has evolved into a wide range of genres and styles. The diverse melodies include the traditional sounds of *son, changüi, bolero*, rumba and salsa to more contemporary dance-oriented styles of *timba*, Latin jazz, Latin pop, and *reggaetón* (a new genre popular with the younger generation of Cubans, blending the sounds of Jamaican reggae with salsa, Latin hip hop, and electronic).

Classical music continues to be a staple for musical instruction taught privately and in schools and universities. The form is studied, practiced, and performed by notable and world-class Cuban artists. The internationally acclaimed Orquesta Sinfónica Nacional de Cuba (National Symphony Orchestra of Cuba) has toured the world extensively, including a successful twenty-city tour in the United States in 2012.

The Revolution put tremendous strain on Cuba's musicians, who often found it difficult to make ends meet. Many, including Celia Cruz, Arturo Sandoval, and others, opted to leave their beloved country to make the most of their talents internationally. Thanks to the hugely popular *Buena Vista Social Club* album and film released in 1997, Cuban music once again found itself on the top of the global charts—danced to, sung to, and listened to by an international community and introduced to a new generation. Octogenarian Cuban musicians Ibrahim Ferrer, Rubén González, Omara Portuondo, and Compay Segundo became overnight global stars. Produced by veteran American musician and producer Ry Cooder, the project developed into a major international hit, prompting a worldwide tour for the group and sparking renewed interest in traditional Cuban music.

To understand the genesis of Cuba's music history, one needs to go back to the sixteenth century when the island became inhabited by Spanish immigrants and their African slaves. The Spanish imported African slaves to Cuba from 1522 until the late 1880s—long after the trade was illegal elsewhere. Little surprise, then, that Cuban music has deep and evident roots in African ritual and rhythm. Fusing these African rhythms and vocal chants with European folk dance music of *zapateo, fandango, zampado, retambico*, and *canción*, the island's music evolved into a richly harmonic and percussive style. Over time, other melodic influences and dances from Europe and the United States, including the waltz and minuet, would alter and enhance the sounds of Cuba's music. Notably, however, there remains almost no detectable influence from the island's pre-Hispanic tribes, save the use of *maracas* (shakers); Cuba's Indian culture was effectively obliterated by Spanish colonization.

The roots of most Cuban musical forms also lie in the *cabildos*, a form of social club among African slaves brought to the island. Cabildos preserved African cultural traditions, even after the Emancipation in 1886 forced the island's African population to unite with the Roman Catholic Church. During this time, a new religion emerged combining Roman Catholic beliefs with the Yoruba religion of Africans. Developing and spreading throughout Cuba and other Caribbean islands, this new religion became known as Santería. An integral component of Santería is the use of percussion. Complex drum patterns called *toques* represent specific *orishas* (deities or "saints"). Over time the percussion instruments of Santería, like the double-headed hourglass-shaped *batá* drum, greatly influenced the Cuban sound. By the twentieth century, elements of Santería music had appeared in popular and folk forms. Be it Latin swing, *merengue*, or the rumba, the complex Santería rhythms are the heartbeat of Cuban popular music, working away beneath the Latin layers.

Music is deeply woven into the fabric of Cuban daily life, almost like breathing. While strolling city and village streets, one can hear a plethora of musical styles wafting from residences, blaring out of car stereos, and spilling from eateries. Many restaurants and bars showcase their own resident musicians who entertain their clientele.

Like most elements of Cuban culture, music (and the arts in general) can be divided into two categories: pre- and post-Revolution. Pre-revolutionary music was more commercial in nature. Entertainment was business: a way for musicians, entertainers, record companies, and nightclub proprietors to make money, and lots of it. The "watering down" of Cuban music during this period made it more palatable to less musically savvy international listeners. The infectious groove of the *cha cha cha*, for example was all the rage. Havana's Mafia-run nightclubs the Tropicana, Capri, Salon Rojo, and El Parisien featured music that catered to tourists who flocked to the island in search of a raucous time. Furthermore, radio airwaves flowed freely into the country without interference, influencing Cuban musicians with popular music coming from America's shores.

During the early years of Fidel Castro's Revolution, a dramatic shift occurred in how Cuban musicians, primarily the singer-songwriters, approached their craft. *Las canciones* (songs) were written to support the messages and ideals of *La Revolución*. No longer were American influences accessible or welcomed. Ironically however—similar to socially conscious American artists like Dylan, Baez, Seeger, Ochs, and Guthrie—Cuban artists Noel Nicola, Pablo Milanés, Carlos Puebla, Silvio Rodrígues, and Sara Gonzáles emerged as forerunners who created Cuba's brand of folk music, *La Nueva Trova* (new song movement), inspiring a generation of musicians across the island.

During Cuba's infamous Special Period, when the island's citizens were basically closed off from the rest of the world (see next chapter), musicians used the harshness of their conditions to express themselves in new ways. José Luis Cortés was one of the artists who lead the way, making music that reflected the brutal realities of the times, lyrically and musically. In the midst of this troubled period, Cortés and his group N.G. La Banda (New Generation, The Band) became Cuba's leading musicians in the genre called *timba*, a mix of jazz and rumba seasoned with reggae and funk. Along with other artists, they were able to express through songs what people were saying in the streets and feeling in their lives, both good and bad.

The original Buena Vista Social Club group no longer exists, but its spirit lives on in dozens of state-owned salons known as Casas de la Trova. The casas range from grand old colonial buildings with courtyards and palm trees to small, impromptu performing spaces. The informal atmosphere of the casas is always lively with high quality musicianship. Here locals freely mix with tourists. As the night wears on and the liquor flows, the pulsating music becomes more spirited, and it is not uncommon to see folks dancing into the early morning hours.

Cuban music is infectious. And Cuban musicians play with a spirit of inclusiveness that is stimulating. On any given street corner, musicians gather with their acoustic instruments in groups or as soloists to show off their skills and entertain an audience of passersby. With tip jars or boxes at their side, the musicians pound out glorious sounds that reverberate up and down the streets, sometimes causing an impromptu fiesta on the spot. Other musicians may join in, creating a mini-concert. And those who simply want to catch their breath after exploring the city soon find themselves losing track of time and lingering because the *tres* guitar, vocal harmonies, and percussive rhythms are irresistible.

Located in the heart of Centro Habana (Central Havana) is Cuba's oldest record company and recording studio. The hallowed halls of the historic Estudio EGREM (Empresa de Grabación y Ediciones Musicales/Recording Studios and Music Publishing Enterprise) have been graced by a who's who of Cuban and international artists, including Nat King Cole, Josephine Baker, Silvio Rodríguez, Sonia Silvestre, Soledad Bravo, Vicente Garrido, Susana Baca, Roy Brown, Los Van Van, Orquesta Reve, members of Buena Vista Social Club, and the incomparable Cuban jazz pianist Chucho Valdés. Since the Buena Vista Social Club phenomenon, EGREM has become famous by association, similar to London's Abbey Road being identified with the Beatles and Detroit's Hitsville U.S.A. studio with its trademark Motown Sound.

Ever evolving, the music of Cuba reflects a deep connection with the Spanish and African cultures of her past. Not only has the unique integration of musical style and traditions and spiritual beliefs transformed life on the island, giving identity to its people; it also continues to influence twenty-first-century music and musicians the world over, including American pop music. One might even go so far as to say that among Cuba's greatest global exports, music is her purest and most enduring commodity.

ART

Cuban art reflects the ethnic diversity of the island culture. Blending styles, forms, mediums, and movements, divergent artists create insightful expressions of the "Cuban experience."

In the competitive and often lucrative art world, Cuba's marketplace for art has finally come of age. From New York to Paris, art galleries, museums, and music venues showcase the beautiful expressions of Cuban painters, sculptors, photographers, and mixed media artists.

Cuban art mirrors the social challenges that are unique unto the island itself, often dealing with history and creating works that have a distinct Cuban identity. Contemporary artists of all genres illustrate the country's complexity by presenting a variety of themes, often mixing Afro-Cuban

and Roman Catholic icons in a rich, exotic surrealism. These paintings vibrate with passion, color, and sensuality.

As with the proliferation of music, art is everywhere in Cuba. Contemporary painters and sculptors transform their homes into open studios and small street galleries. Graffiti artists paint startling Afro-Caribbean-themed murals on city walls, converting entire neighborhoods into vibrant canvases reflecting cultural, societal, and political expressions. By incorporating patriotic motifs, much of the art becomes state-sanctioned and is therefore considered a valid form of artistic expression. Conversely, radical artists who integrate nonconformist ideas or critique the government in their murals and graffiti can see their art mysteriously vanish almost as quickly as it is created, making the chance to view such artwork for some aficionados more exciting than "safer art." Be it short-lived, the power of this controversial artwork can leave a lasting impression.

While the government monitored artistic freedoms in the early days of the Revolution, the Castro administration also subsidized university arts programs that provided opportunities to those who would otherwise have had little chance to become artists, let alone the opportunity to receive a higher education. Actions like this and the Cuban Literacy Campaign mirrored the divergence among Revolution and reform and education for all. But this educational reform in 1960s Cuba was a watershed period that allowed many gifted artists to emerge.

Cuban art is a direct reflection of the rich diversity of her people and traditions. For many Cuban artists, art is not only a means or mode to express themselves and their views but also a way of documenting a moment in their history and way of life. No matter the medium or style, the work of Cuban artists explores a wide range of subjects, from the abstract and spontaneous to works that represent real life scenarios of people, places, and issues including religion, politics, race, and sex.

The high value the Cuban people place on the arts is evident in the way they treat their homegrown artists. Unlike most painters, sculptors, and multimedia artists in other countries, who juggle odd jobs in between creative projects and barely eke out a living, Cuban artists—even those whose success is modest—enjoy a level of celebrity and high income well exceeding that of most of their fellow citizens.

The influences of Cuban art over the last two centuries are clearly palpable. Cuban artwork created in the nineteenth century saw heavy inspiration from European classicism. Later, in the 1920s, Cuban artists began experimenting with more avant-garde styles. They joined restless artists in other parts of the world in what became known as the Vanguard movement, which rejected European-based academic conventions. Perhaps the best known of Cuba's Vanguard artists, Wifredo Lam, who worked in Paris with Picasso, Matisse, and Miro, made a point of infusing his work with a distinctly Cuban spirit.

Standing out among Cuba's current crop of internationally renowned artists are Manuel Mendive, José Fuster, and Salvador González Escalona. With a career spanning fifty years, Mendive is recognized for his groundbreaking work that captures the vast sociocultural significance of the African diaspora. His artistic approach is deeply inspired by his personal relationship with Afro-Cuban Santería. Often using naked actors and dancers as his canvas, his primitive-styled images rooted in the Yoruba religion and featuring West African visual motifs transform body painting into

living works of art. These "performance processions" usually occur to live music and are always presented in conjunction with his public exhibitions.

Often referred to as the "Picasso of the Caribbean" or the "Cuban Gaudí," Naïf artist José Fuster has transformed his home and neighborhood into an ornate gallery of murals and mosaic-tiled expressionism. In the small fishing village of Havana's Jaimanitas district, more than eighty of Fuster's neighbors have allowed the unconventional artist to create multi-themed mosaics over the structures of their community, his eccentric canvas. Gaudí-esque roofs, walls, doorways, benches, verandas, walkways, and street signs blaze with a kaleidoscopic show of ceramics; a magnet for visitors to Havana. Both Fuster and Mendive are prolific in a variety of artistic media; their paintings, engravings, sculptures, and sketches are frequently featured in galleries and museums around the world.

Mural artist Salvador González Escalona has created his own artistic haven in the Callejón de Hamel barrio in Central Havana. A public temple to Santería, the funky narrow alleyway twists and turns for two blocks in a potpourri of mosaic tiles and colorful hand-painted murals along walls and a four-story apartment building that looms over the street. A hodgepodge of sculptures created from scrap materials—pieces of bathtubs, hand pumps, old tires, automobile parts, pin wheels, and an array of other discarded items—add a dynamic, tactile element to this eclectic display of Afro-Cuban artistic expressionism. A bonus to this artistic experience is a weekly Sunday rumba that provides enough feverish music and dance to call forth the spirits—the *orishas*.

Like the artists who have made their mark armed with brushes, paints, ceramics, and textiles, other Cuban artists outfitted with cameras have made significant contributions to the world of photography. Photographers Alberto Korda, Liborio Noval, Osvaldo Salas, and Roberto Salas snapped some of the most extraordinary images in the days of Cuba's Revolution. Korda's iconic capture of a menacing-looking yet ruggedly handsome Che Guevara is one of the twentieth century's most recognized photographs. In work now assembled in books and occasional art installations, these photographers collectively amassed some of the most captivating images of one of the most spectacular political stories of the twentieth century.

The crown jewel of Cuba's artistic community is the citywide Bienal de La Habana (Havana Biennial art exhibition). Established in 1984 and generally held every two years, Havana's Biennial led the way and inspired the worldwide emergence of biennials through the following decades. Over the years the event has evolved into a true international gathering, attracting artists from around the world who canvas the Cuban capital with diverse forms of artistic media. Artwork populates galleries, museums, city squares, the Malecón, the Morro Castle, the Paseo del Prado, and various other prime points throughout Havana. The impressive month-long event, curated and organized by the Wifredo Lam Contemporary Art Center, aims to make art accessible for the masses to experience, participate in, and enjoy.

DANCE

Dance is intrinsic to Cuban life. There seems to be a constant rhythm in people's chromosomes that shows up in any and every thing, at any time and anywhere. It has been said

that Cubans, men and women, "walk as if they are dancing." For people from toddlers and teens to folks in their later years and everyone in between, the slightest hint of a beat can get their feet and bodies moving into an enviable, naturally sexy groove. Movement has been Cuba's main language even before words. Cubans have always expressed themselves through dance. People dance everywhere; on the streets, in their homes, at clubs, in restaurants and pavilions, in school, on television, and on the stage. In fact, the entire 780-mile-long island is a melodious melting pot of rhythm, music, and dance that few other places on the planet can come close to matching.

Like everything else on the island, popular dances in Cuba are marked by a history filled with mixtures of African, Spanish, and Chinese influences. Dance styles are derived from the shared musical names—each distinctive in its particular rhythm, beat, and movement. Salsa, bolero, cha cha cha, conga, mambo, and merengue are some of the more classic styles that are commonly known to most people. Many of the dances such as the conga, rumba, and mambo evolved directly from African religious dances, and from the marriage of Spanish guitar and earthy African rhythms came the classic Cuban *son*, which forms the roots of today's salsa.

The *habanera*, also known as the *danzón* and *son*, remains one of Cuba's most popular dances. Originating in the nineteenth century, the sexy body-to-body, slow-paced dance bears striking similarities to the Argentine tango with enlaced legs, precise kicks, hip grinding, and sensual movements.

The habanera had been Cuba's national dance until the Revolution, when the government designated the rumba as the country's official dance, honoring and recognizing the island's African heritage. The rhythm-driven rumba is performed to a chorus of drums, claves (sticks establishing rhythm), and maracas, often beginning with a soloist singing improvised syllables and sounds called *diana(s)*. The singer then prefaces the lyrics about to be sung with an ad-lib declaring the purpose of the particular rumba or, if inspired, launches instantly into the song. The rumba is so closely identified with the island that it has been said: "Rumba without Cuba is not rumba, and Cuba without rumba is not Cuba."

Performance venues for dance have always been a vital part of Cuban culture. Before the Revolution, the Tropicana nightclub was arguably the most popular nightclub in Havana, if not the world. Amid a lush garden of tropical plants, trees, and shrubs, today the spectacular open-air venue still maintains its standing and charm as one of the world's poshest and most historic supper clubs. Extravagantly costumed and spirited, choreographed performances feature a bevy of scantily clad showgirls and dancers in a two-hour-long spectacle covering most of the bases of popular Cuban show and dance music, from son to bolero to danzón to salsa, with a bit of Afro-Cuban religious music thrown into the mix.

A somewhat lesser-known treasure of dance in Havana is a spry, lively, and fit group of mostly septuagenarians known as the Santa Amalia Dancers. Some of Havana's coolest cats (and kittens) this side of Harlem, these aging hoofers jitterbug, swing, boogie woogie, and even tap to the liveliest jazz music with the fervor, spirit, and passion of people half their age.

The original group of about fifty avid jazz lovers was formed in the 1960s. Meeting monthly in secret at the

private home of founding member Gilberto Torres in the remote Havana barrio of Santa Amalia (hence the moniker), the group listened and danced to American jazz music that had been outlawed and was considered taboo by the Cuban government. Torres's modest living room, with every inch of wall and ceiling plastered with posters, photographs, and album covers of every imaginable jazz artist, and furniture shoved against the walls to make room on the linoleum for uninhibited dance, had been transformed into a vibrant speakeasy. The Saturday jams were highly spirited. Rum flowed, music pumped, and local policing by the neighborhood watch group turned a blind eye while the raucous "meetings" became an outlet for the pent-up passions of members. The gatherings were apolitical and always only about the music.

In pre-Revolution Cuba in the 1940s and '50s, many of the club's members had come of age dancing to the music of Duke Ellington, Dizzie Gillespie, and Cab Calloway. Reminiscing about the Havana of old, members often recall the days of their youth, having seen iconic artists such as Nat King Cole, Sarah Vaughn, and Oscar Peterson in decadent Havana hotspots like Hell, the Zombie Casino Club, and Sans Souci.

While the sounds of jazz and styles of dancing may be immortal, over the decades several of the group's members have passed on, including Torres, and one member literally died while dancing at a club party. Yet the remaining members continue their tradition and now meet on the second Thursday of every month to dance and party at the Unión Nacional de Escritores y Artístas de Cuba (UNEAC, the National Union of Writers and Artists), a former sugar baron's mansion in the posh neighborhood of Vedado, where the rum still flows and a live band and recorded music are loud and lively.

As of 2014 the number of Santa Amalia Dancers had fallen from fifty to about twenty, including a few newer middle-aged members. However, this faithful, hard-core group of jazz enthusiasts still shows up ready to cut a rug, many dressed to the nines and wearing spiffy *guayaberas* (Caribbean shirts), fedoras, and fancy footwear. Watching these older folks spin, dip, slide, tap, and dance their hearts out, with smiles as wide as a royal palm is tall, it is hard to believe that many are grandparents and great-grandparents. Deservedly, the new millennium brought the Santa Amalia Dancers some prominence when they were featured in the 2004 documentary film *Nosotros y el Jazz*, examining the throwback group and the storied era of dance and music in Havana.

For decades, Cuban ballet has plièd and pirouetted to the heights of international ballet, producing some of the world's best dancers. The renowned Ballet Nacional de Cuba (National Ballet of Cuba) is a formidable force globally in the world of ballet. Founded in 1948 by *Prima Ballerina Assoluta* Alicia Alonso, her husband Fernando, and his brother Alberto, it was initially named the Alicia Alonso Ballet Company, and its productions often featured its namesake in lead roles, making Alonso a household name in international ballet.

The Revolution's reform of previous discriminatory policies barring blacks and the underprivileged from participating in the arts made artistic discipline and creation accessible to everyone. Aspiring dancers and artists from remote

areas around the country flocked to Havana to pursue their artistic passions and dreams. The National Ballet of Cuba opened its doors and continues an expansive outreach to find and train the next generation of exceptional ballet dancers.

Today ballet dancers are among Cuba's most celebrated and esteemed artists. In a sense, the once highbrow world of classical ballet has now become the unofficial dance of the people.

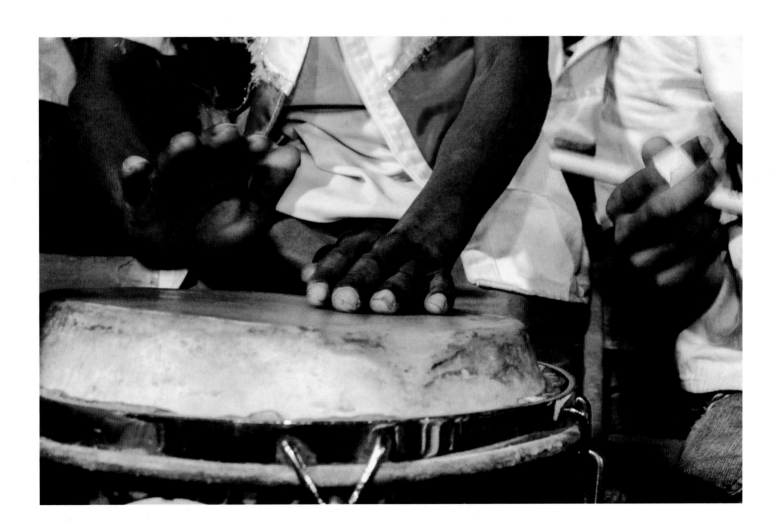

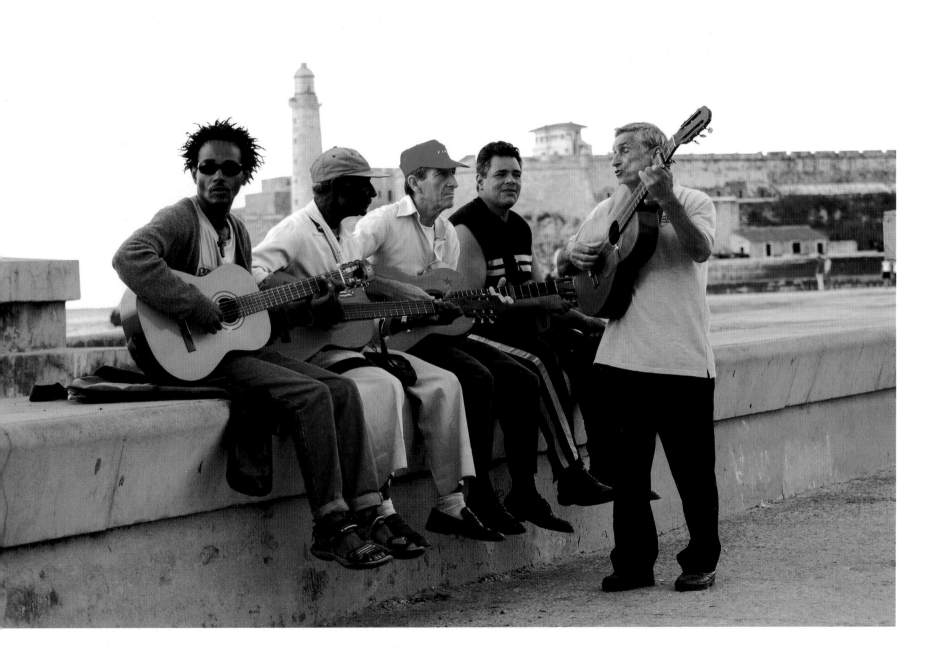

Musicians, El Malecón, 2008 | 89

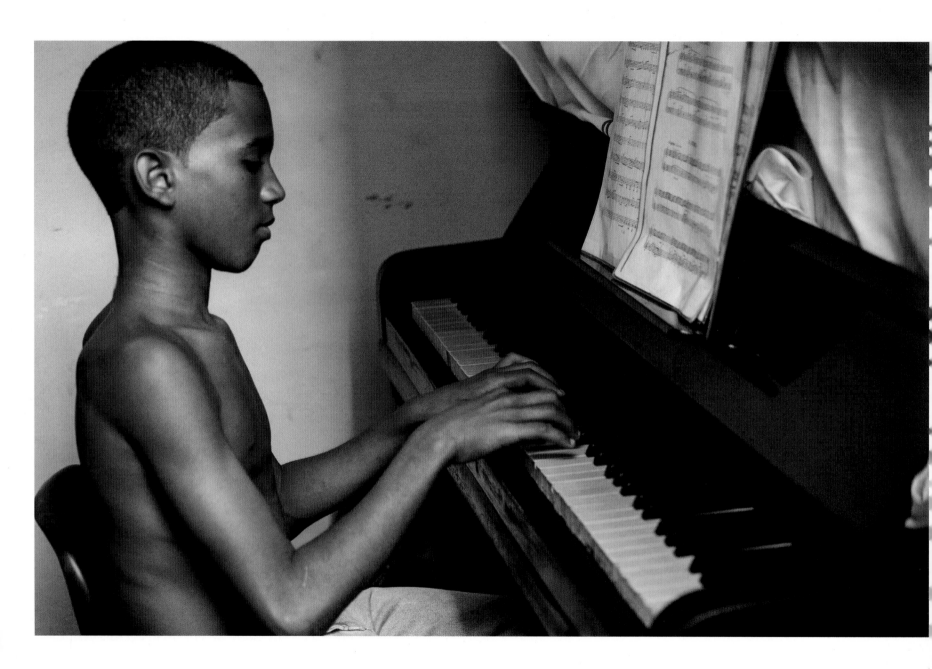

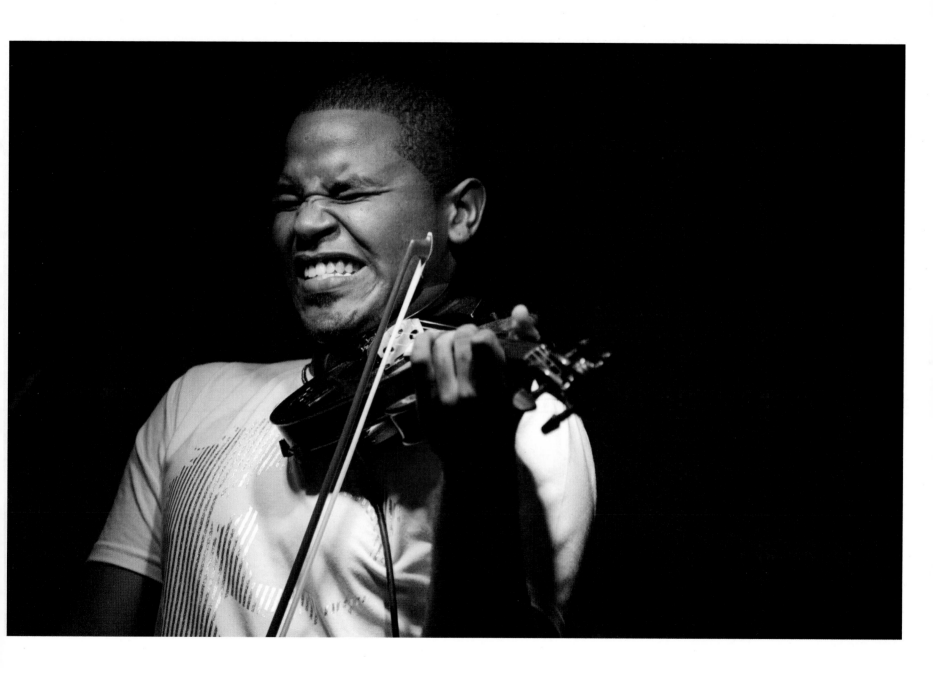

Julio Valdes Fuentes, Jazz Violinist, La Habana, 2008 | 91

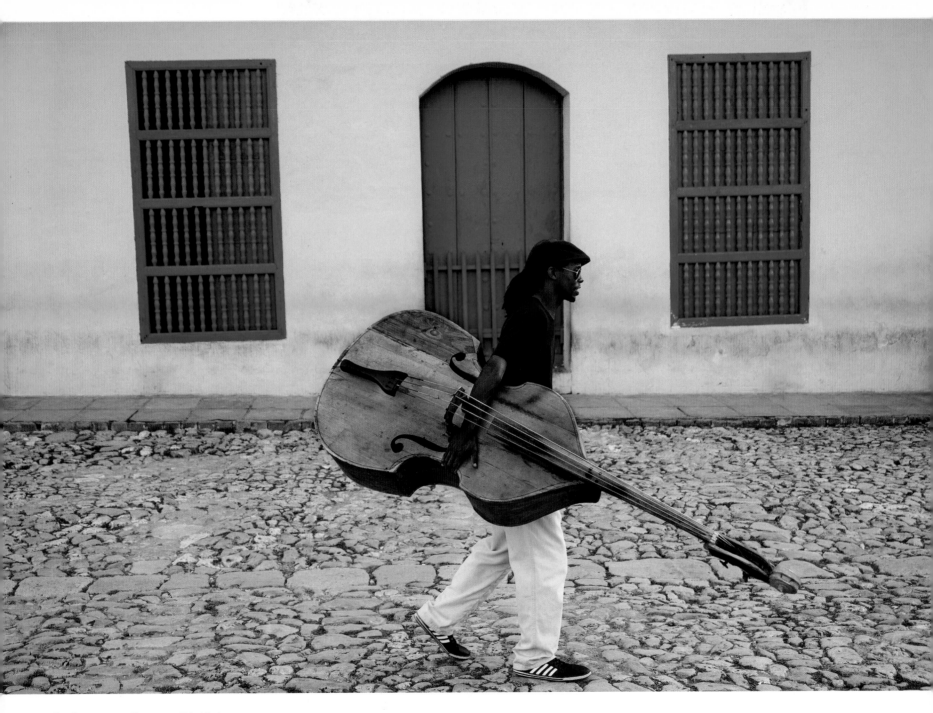

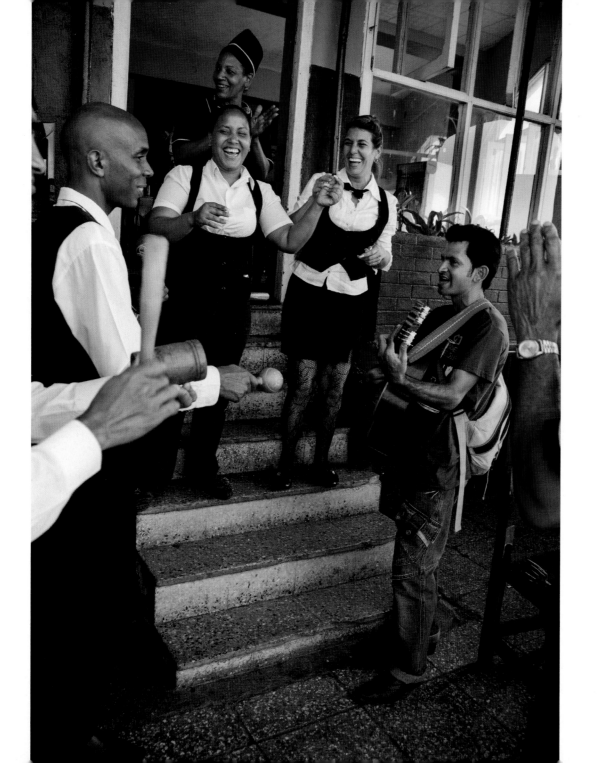

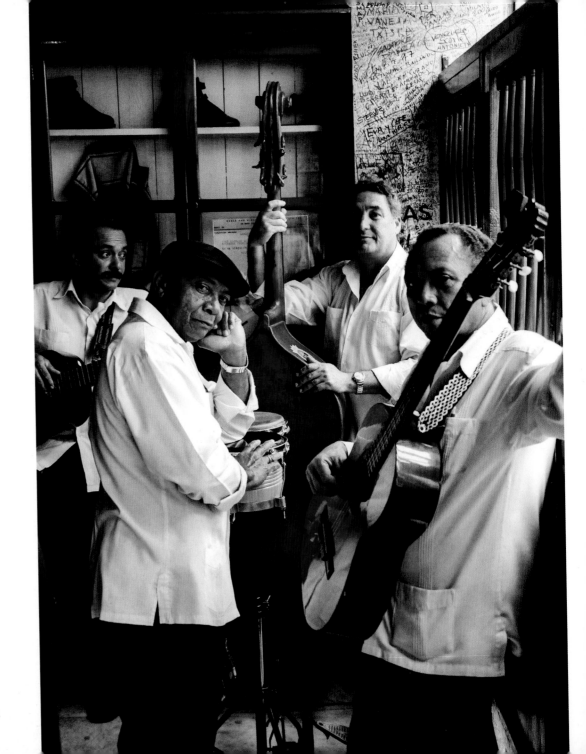

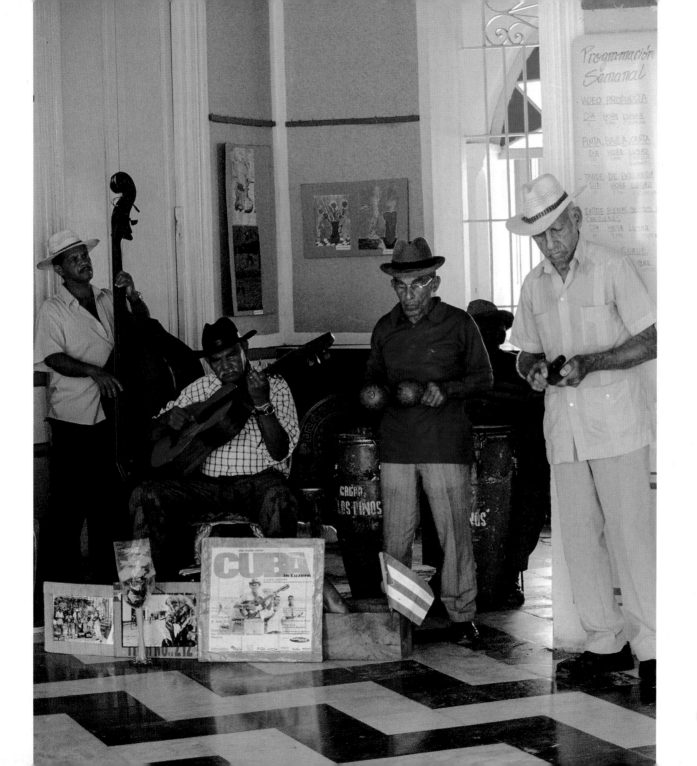

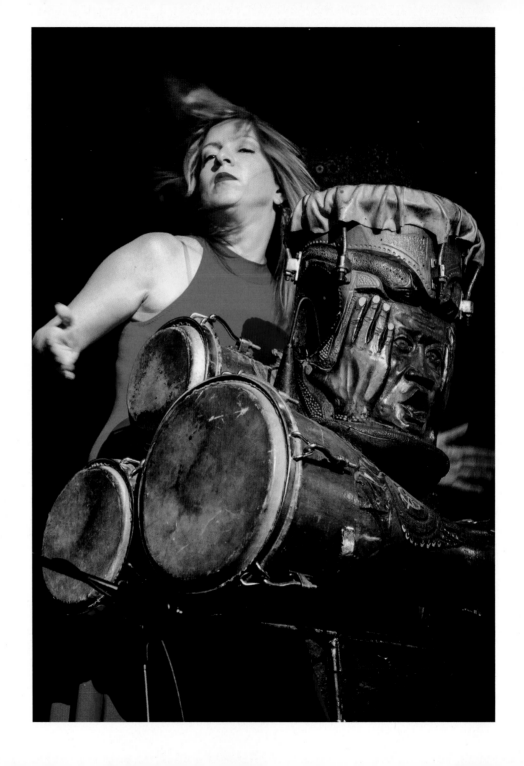

96 | Lady Drummer, La Habana, 2011

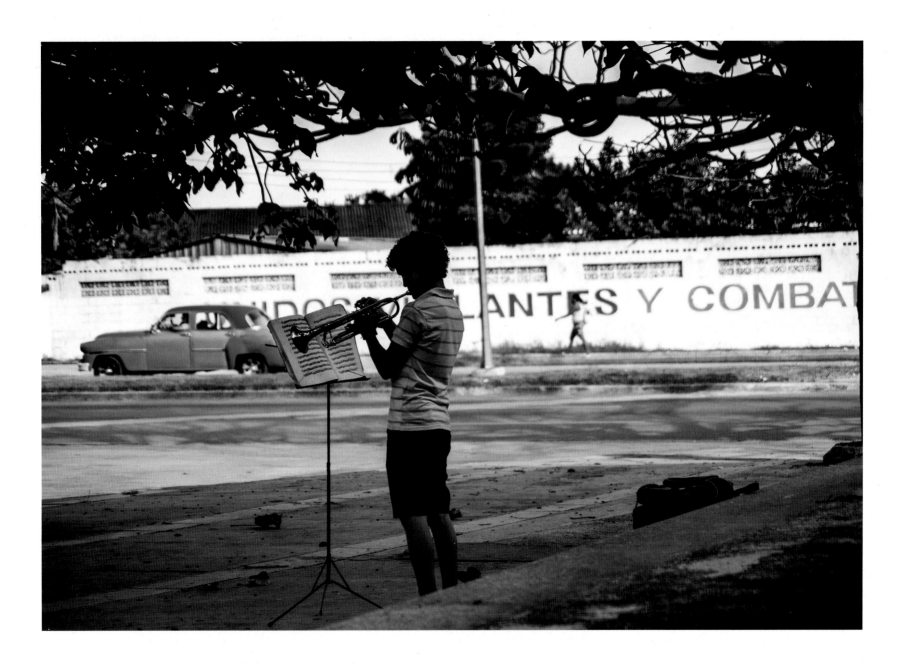

Schoolboy Trumpet Practice, La Habana, 2013 | 97

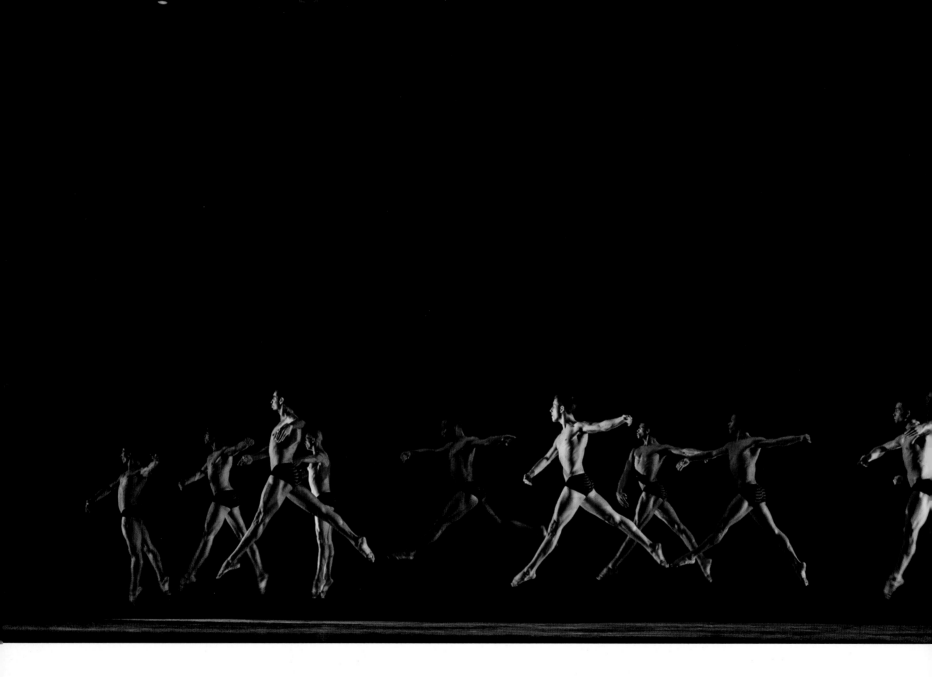

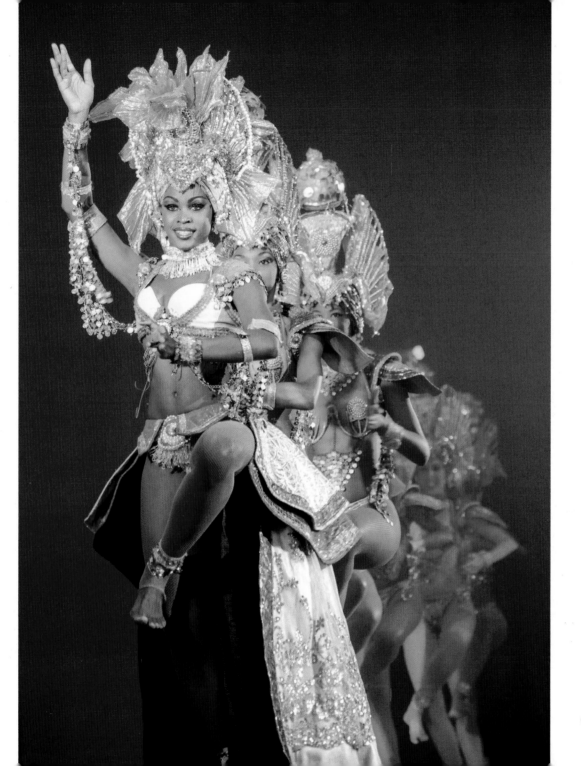

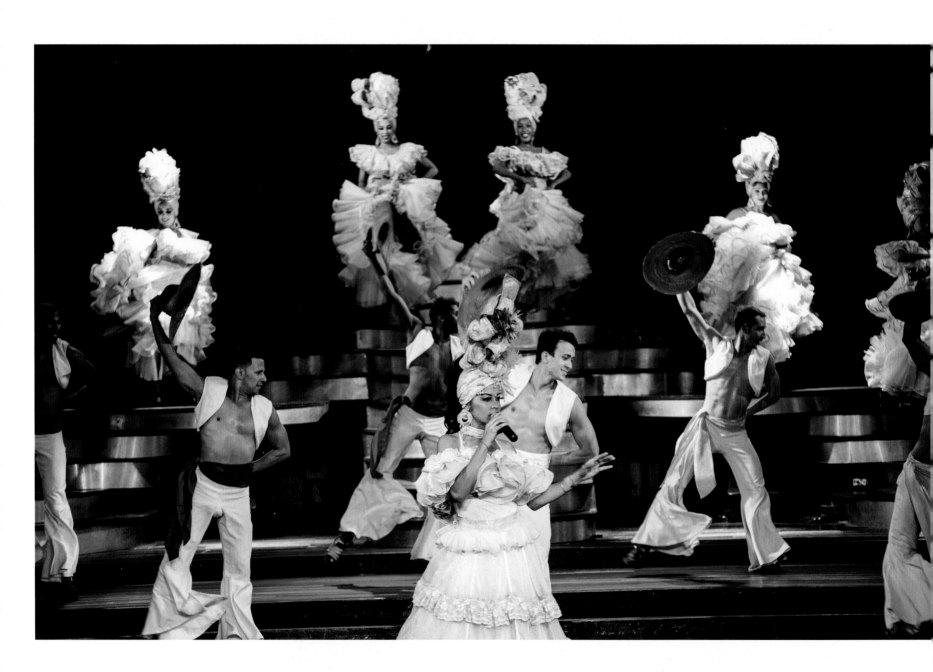

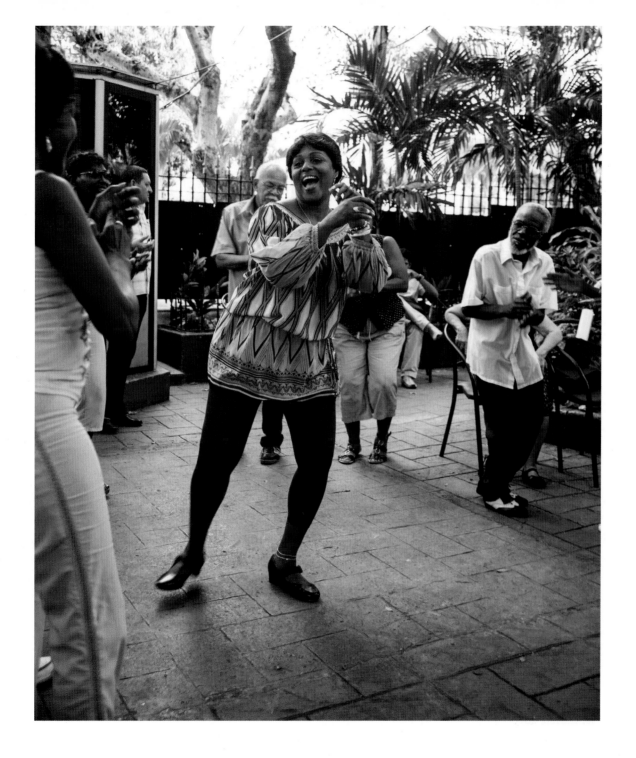

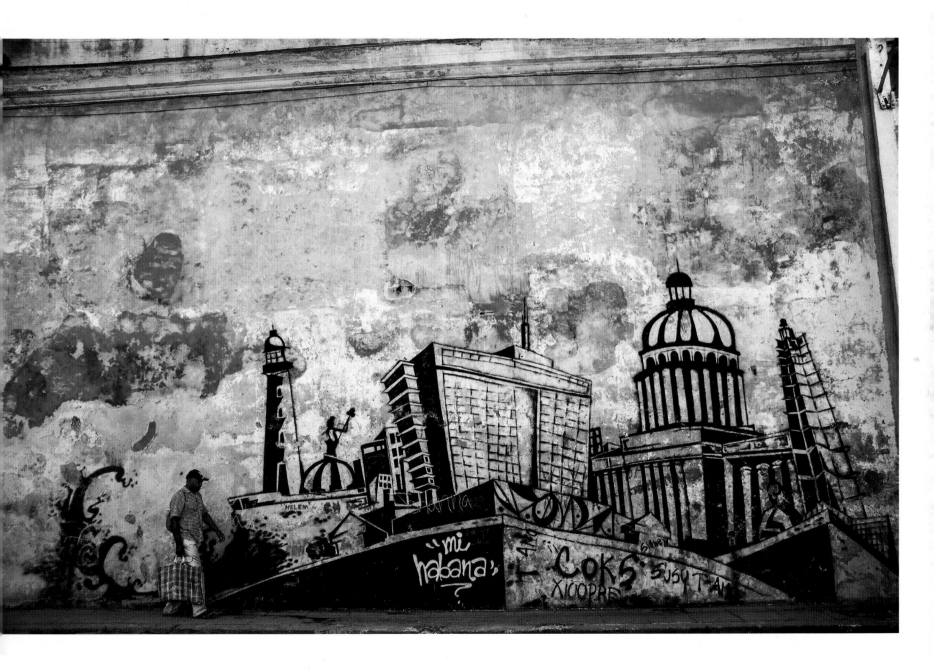

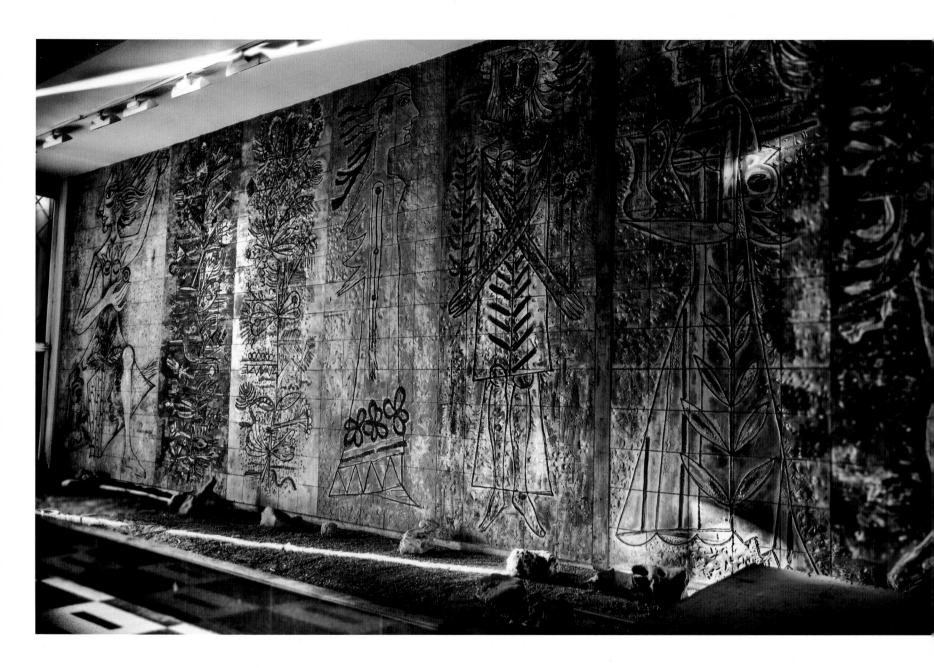

| Ceramic Tile Mural *Historia de las Antillas* by René Portocarrero, Havana Libre Hotel, Vedado, 2013

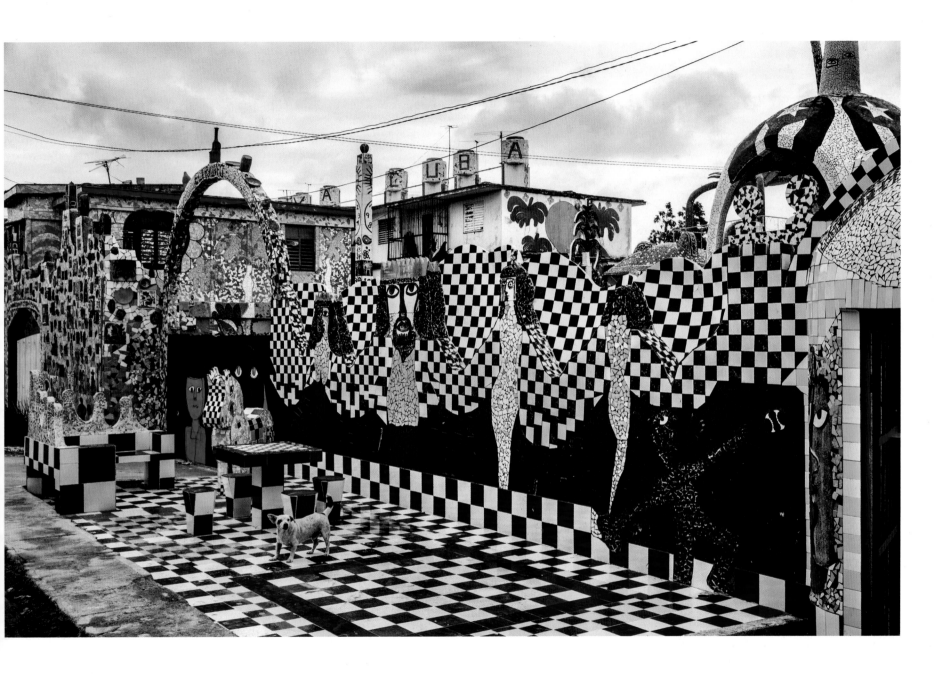

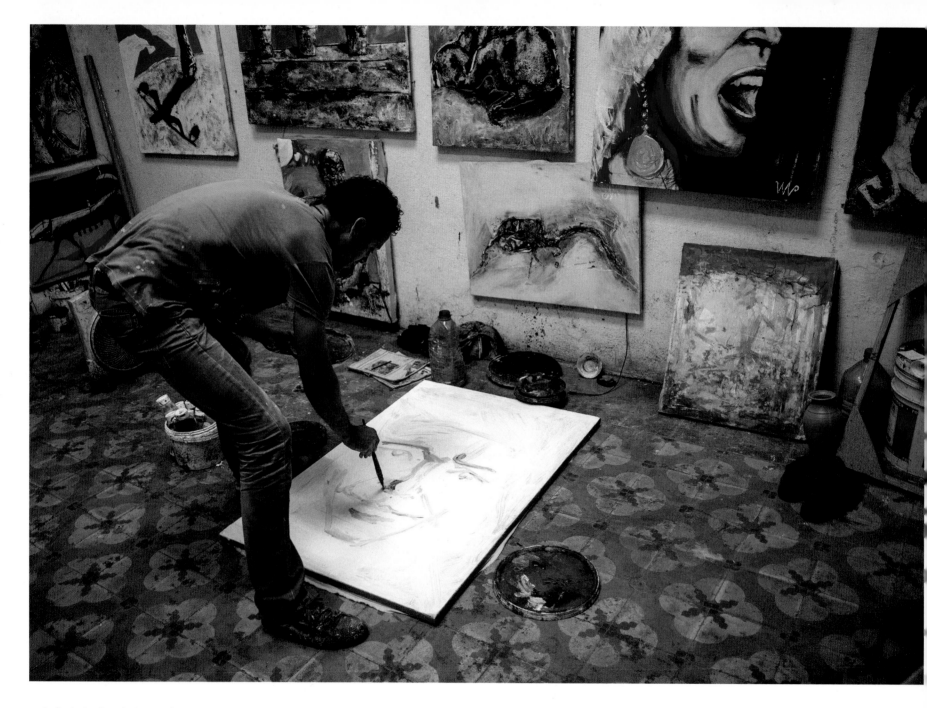

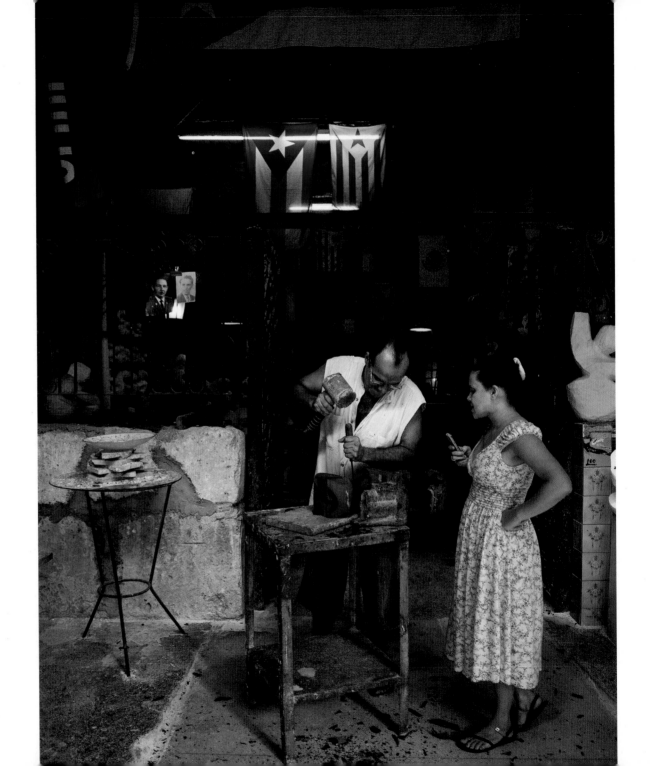

108 | Leo Creating, Centro Habana, 2013

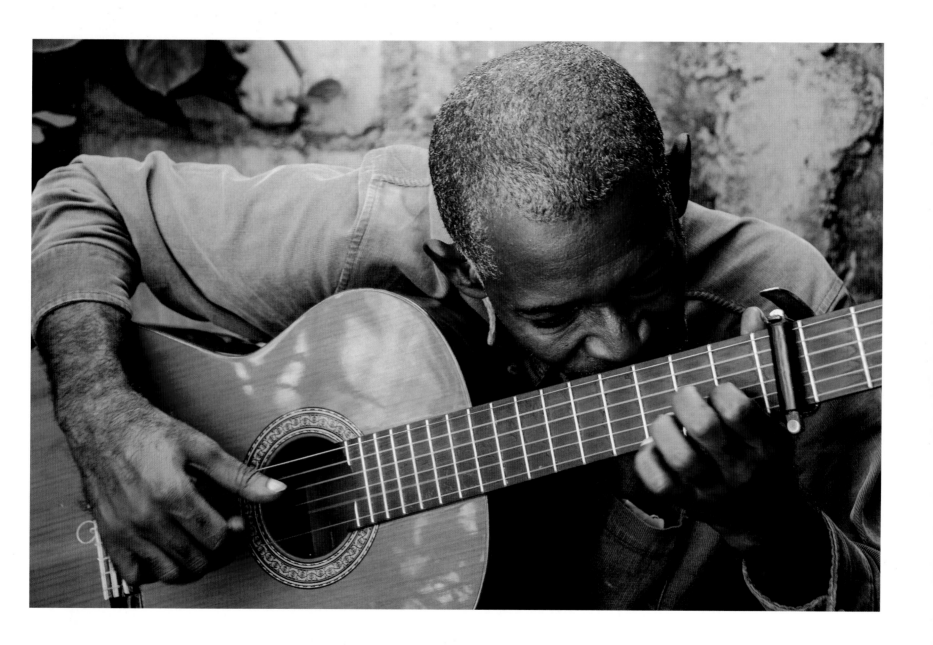

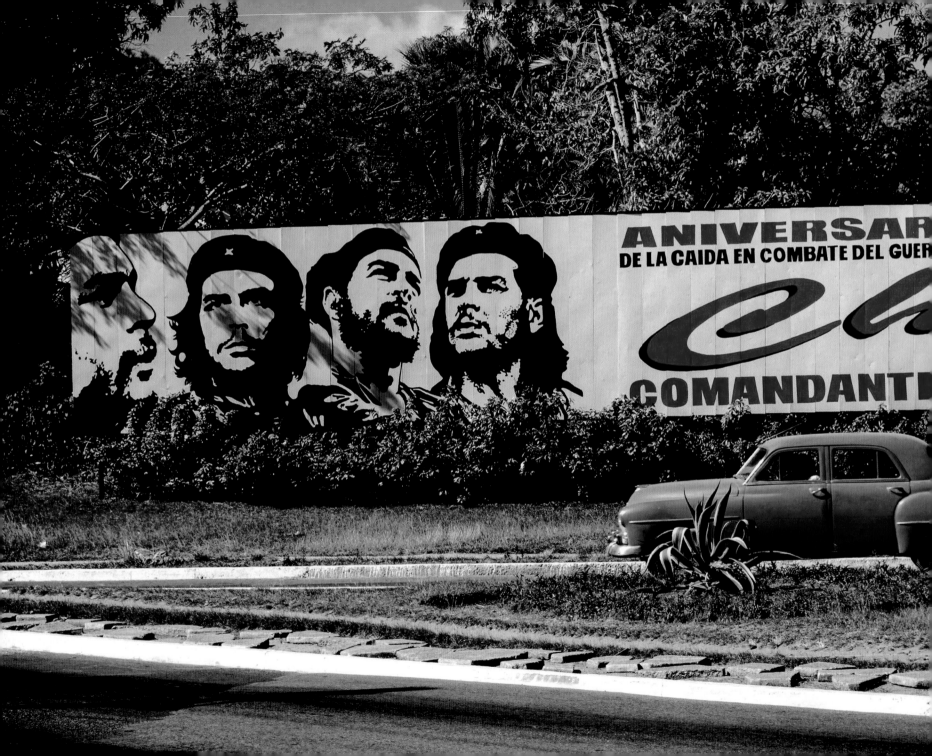

LA POLÍTICA

Like stones rolling down hills, fair ideas reach their objectives despite all obstacles and barriers. It may be possible to speed or hinder them, but impossible to stop them.

JOSÉ MARTÍ

Roadside Che, Pinar del Río, 2008

On new year's eve in 1958—while unsuspecting party-goers were having a ball in Havana's casinos, playing cards, placing bets, pulling slots, throwing dice, drinking, dancing, and toasting in the New Year—an armed revolt against the Cuban government was reaching its climax. Presidente Fulgencio Batista would flee the country by morning, giving way to a new administration and era in Cuba.

On his journey from the Sierra Maestra mountains where he and his militant fighters had holed up for two years, engineering their plan to topple Batista's regime, Fidel Castro paused to give speeches to throngs of cheering admirers who had gathered in Cuba's rural villages, towns, and cities. Finally, on January 9, 1959, Comandante Castro, accompanied by his band of guerrilla fighting brothers Che Guevara, Raúl Castro, Camilo Cienfuegos, and hundreds of other rebels, rode triumphantly into Havana and world history. And for decades to come, Fidel Castro would remain the most recognizable and intriguing of all political leaders of the contemporary world.

While Castro's revolutionary faction—known as the 26th of July Movement (named to honor a failed attempt at overthrowing Batista's government in 1953)—marked a shocking change for Cuba, revolution was nothing new in the island's history. The birth of the Cuban independence fighter can be traced back to the Mambises. A group of guerrilla fighters who fought during Cuba's Ten Years War (1868–78) and War of Independence (1895–98), the Mambises are the root of Cuban national identity and pride. Many were of African descent and had escaped from slave ships and fled into the Sierra Maestra mountains to avoid servitude. Others were slaves intentionally set free by slave owners to join the uprising in the fight against Spain for liberty. The Mambises' African heritage and fierce bravery, combined with their historic struggle and stance against apartheid-like injustices, made heroes of these warriors in the eyes of their fellow countrymen. Some might argue that their fight, resilience, and fervor for independence were a bellwether of changes to come.

A half-century later Fidel Castro, being a historian and strategist, not only symbolically used the Sierra Maestras as his base while staving off Batista's troops but also mobilized his knowledge of the Mambises to remind his followers that the desire for independence had always been in their blood, unifying Cubans across racial divides to join his own rebel forces.

Initially, after Castro's takeover, it was business as usual for Cuba's relationship with the world. That is, until Fidel unveiled his Communist leanings. Increasingly aligning his new government with the Soviet Union and embracing the ideals of Marxism, Castro would rapidly alienate himself and Cuba from having a sustainable relationship with the United States.

Castro took the initiative in proposing closer relations with the Russian government. Because Castro had for years been denounced by Cuba's Communist Party as "a dangerous adventurer," Soviet authorities were initially suspicious of his intentions. But when Castro began to attack anti-Communism as a threat to the Revolution, the Russians decided that he was someone with whom they could do business.

The Kremlin moved to take full advantage of Cuba's close proximity to the United States by installing both short- and long-range nuclear warheads in the northernmost part of the

island. The "October Crisis" of 1962, also known as the "Cuban Missile Crisis," dramatically deepened the rift between Castro's Cuba and the Western superpower and thrust the world to the brink of nuclear disaster. In the ensuing showdown, President John F. Kennedy countered with further sanctions against the island nation. But still Fidel Castro would not back down, and neither would Soviet Premier Nikita Khrushchev.

For thirteen tension-filled days the world held its collective breath as the Soviet Union and Cuba went head-to-head against the United States over the placement of nuclear warheads. The confrontation finally ended on October 28, 1962, when Khrushchev ordered his fleet to back down. Soon after, Khrushchev reached an agreement with Kennedy to dismantle Cuba's offensive weapons under the condition that the United States remove its arsenal in Turkey and Italy aimed at the USSR. The world breathed a sigh of relief, but the United States would thereafter maintain an aggressive show of power and vigilance against Cuba, imposing even tougher sanctions on the socialist state.

January 1, 2009, marked the fiftieth anniversary of the Cuban Revolution. Even through a world-threatening nuclear missile crisis, the collapse of her Soviet ally, and repeated efforts by Washington and other outside influences to squelch it, the Revolution survives. In the decades since Castro's Revolution, the world has seen ten U.S. presidents come and go. Eisenhower, Kennedy, Johnson, Nixon, Ford, Carter, Reagan, Bush 41, Clinton, Bush 43, have all served out their terms, resigned, been voted out of office, or passed on, while Fidel, like the Energizer Bunny, keeps going and going and going. Despite relinquishing his acting presidential powers to his younger sibling Raúl in 2006, Fidel, the elder statesman, remains a prominent and influential figure in the Cuban political arena. A prolific writer, he often contributes articles to the official Cuba Communist newspaper *Granma* and is rumored to have been composing his memoirs, while brother Raúl has methodically led the country through the Obama years.

In a secret deal brokered by Pope Francis and the Vatican, on December 17, 2014, President Barack Obama surprised the world when he announced the restoring of U.S. diplomatic relations with Cuba. Re-establishing these ties marks a dramatic turning point, ending a fifty-plus-year standoff born during the depths of the Cold War. Although the embargo technically continues, at least at the time of this writing, Obama swiftly put into action policies to ease restriction on remittances, travel, and banking relations. During simultaneous press conferences in Washington and Havana, Obama and Castro affirmed their desires to improve U.S.-Cuba relations. Obama stated, "Today, America chooses to cut loose the shackles of the past, so as to reach for a better future for the Cuban people, for the American people, for our entire hemisphere and for the world." A new day has dawned.

THE SPECIAL PERIOD

If Castro's Revolution is regarded as a time of new independence and sovereignty, then what he called the *"Período Especial en tiempo de paz"* (Special Period in time of peace) would be considered by its people and most historians as Cuba's darkest hour. Not unlike America's Great Depression of the 1930s, the Special Period was a time of severe economic hardship lasting for most of the 1990s and into the

new millennium. Blindsided by *glasnost*, the USSR's abrupt disintegration, and the resulting significant loss of import trading from its Communist ally, the socialist island found itself on the brink of economic collapse. With abandonment by the Russians, for the first time since the 1500s Cuba found itself on its own. Fearing the worst, hundreds of thousands of the island's residents fled the country to Miami, through the shark-infested waters of the Florida Straits, on boats, rafts, tire inner tubes, and other jerry-rigged floating contraptions. Many did not make it.

With severe shortages of food, gasoline, and other amenities at an all-time low, the Cuban people were forced to change their lifestyles significantly and find ways to survive increasingly nightmarish levels of poverty. Citizens had to tighten their belts and endure harsh conditions to maintain some semblance of "normalcy" during this desperate time. Frequent and long-lasting electrical blackouts thrust people back to a time of candlelight. The abrupt halt of petroleum imports eliminated regular motorized transportation, prompting widespread usage of bicycles, horses, and carriages. Others had to walk unimaginable distances to get to and from work and school. The collapse of agriculture and farming caused severe famine. Strict rationing became the norm. Lack of medicine imports and medical attention left people ill and turned otherwise treatable conditions fatal. With their backs to the wall, many turned to black market activities to supplement means for survival.

When the Soviet subsidization was terminated, Cuba's pattern of trading partners shifted from the USSR to Europe and Latin America. Then in the 2000s the island's geopolitical reality changed again and Venezuela became Cuba's principal trade partner. Venezuela's late president Hugo Chávez provided support for Cuba through low-cost oil exports, trade and investment credits, and generous foreign exchange payments for Cuban exports of medical services. Soon afterward China became an important source of credit and imports for Cuba.

An economic crisis of this magnitude might have brought crippling despair on less resilient and spirited nations, but the Cuban people rose to the challenge. They adapted and transformed themselves.

One example of the forced reinvention was the development of sustainable food production. During the Special Period the breakdown in the country's transportation and agricultural sectors limited access to fertilizer and pesticides, decimating the island's once reliable crop production. With assistance from permaculturists from various countries around the globe, Cuba's Ministry of Agriculture began to implement organic gardening, not only in rural areas but most notably in urban areas of Havana. Living up to the ministry's motto, "Production of the neighborhood, by the neighborhood, for the neighborhood," urban agriculture has become an integral part of Havana's cityscape. Multiple varieties of fruits, vegetables, wheat, and rice are cultivated in gardens, raised beds, and on roof tops, providing residents with a healthier eating alternative. Now the practice of *organopónicos* (organic gardening) is mandated by the Cuban government and has grown to be one of the world's most successful sustainable agricultural systems.

Another way Cuba began to turn around its struggling economy was by relying heavily on international tourism. By the late 1990s the tourism surge had officially trumped the centuries-long export of sugar as Cuba's leading source of revenue.

Decisively confronting the crisis head-on, Cuba has emerged from its devastating economic depression and continues to march to the beat of its own drum, evolving at its own rhythm, in its own time, and by its own rules.

BILLBOARDS

In lieu of advertisements for all things capitalistic, Cuba's billboards promote a plethora of political propaganda. Dotting the country's roadways, buildings, parks, and city squares, thousands of prominent images and words on huge surfaces keep the Revolution front and center in the eyes and minds of the Cuban people. While most of the world uses advertising to endorse commercial products in hopes of bolstering sales, Cuban billboards cover a wide range of ideology and theories. With no uniform format, most contain quotes from historical figures, portray the virtues of Cuban socialism, or both.

Some of the messages are radically political in their jargon, many are antagonistic against U.S. government, others are colorfully cartoonish and humorous, some contain blown-up photos of the country's heroes, and *all* are revolutionary.

Cuba's billboards are a unique cultural phenomenon. Flaunted are the hallmarks of the Revolution: free healthcare, education for its citizens, free housing, guaranteed levels of retirement, emancipation of women, and racial integration. The majority of these giant placards carry messages featuring iconic Cuban heroes like José Martí, Camilo Cienfuegos, Antonio Maceo, and the country's adopted revolutionary soldier-of-fortune, the dashing Argentinian, Che Guevara. Some billboards tell the stories of the attack on the Moncada Barracks, the Battle of Santa Clara, the Bay of Pigs Invasion, the Cuban Missile Crisis, the alleged terrorist downing of Cubana Air flight 455, and the favorite target of critique, "*El bloqueo*" (the U.S. trade embargo). Other billboards feature images of Fidel and Raúl Castro and quotes from their speeches. As a way to remind the population of the most influential revolutionary heroes, occasional billboards also feature well-known female political figures, including Celia Sánchez and Vilma Espín, the late wife of President Raúl Castro.

THE CUBAN FIVE AND LITTLE ELIÁN

Another saga in the ongoing political chess game between the United States and Cuba is the controversial case of the Cuban Five. While the saga of the five Cuban individuals is not widely followed by most Americans, in Cuba these five men are revered as national heroes, if not living martyrs. Their images are prominently featured on billboards, pamphlets, and flyers throughout the country. The Five are often written about in newspaper articles, political essays, and books, and their story is a hot button topic with Cuba's governmental officials and many concerned citizens as well.

The five men, Gerardo Hernández, Antonio Guerrero, Ramón Labañino, Fernando González, and René González, have stated that they were in the United States for the sole purpose of monitoring the activities of anti-Cuban groups in South Florida, including some alleged to have been involved in several terrorist bombings in Havana in the 1990s. In subsequent years the Cuban government has acknowledged the fact that these men were sent to the United States to infiltrate these groups.

In a pre-9/11 crackdown on spies in the United States, the Cuban Five were arrested by FBI agents in Miami in September 1998. Eventually they were brought to trial in a case that lasted more than six months. The Five were convicted in June 2001 on multiple counts, including twenty-six counts of espionage, conspiracy to commit murder, acting as agents of a foreign government, and other illegal activities against the United States. Their sentences added up to a total of four life sentences plus seventy-seven years, and they were imprisoned in five separate maximum-security prisons across the United States. The unprecedented judgment also stipulated that they have no communication with each other and limited familial visiting rights.

Outraged by the verdicts, the Cuban government immediately mounted a worldwide campaign to "Free the Cuban Five," claiming the men were framed and that no classified documents or substantial corroborating evidence has ever been uncovered or presented by the U.S. government to support its case.

In recent years the Cuban Five became the Cuban Three with the early releases of two prisoners René and Fernando González. In a major shift to restore ties with Cuba, on December 17, 2014, President Obama made a deal to release the remaining network of the Cuban Five in exchange for jailed American contractor Alan Gross and a U.S. intelligence agent who had been imprisoned in Cuba for nearly twenty years.

Media attention to the Cuban Five in the United States, such as it was, took a backseat to the heartrending saga of Elián González. On Thanksgiving Day of 1999 the five-year-old Cuban boy was found by fishermen floating alone on an inner tube in the ocean off the coast of Fort Lauder-dale, Florida. His mother and eleven others had drowned in the preceding days trying to reach the U.S. coast. U.S. authorities placed little Elián in the protective custody of his paternal family members in Miami. When Elián's father, still in Cuba, demanded that his son be returned to him, an international custody dispute erupted, and the drama played out daily in the media. Both the U.S. and Cuban governments became involved as Florida's Cuban exiles worked to keep Elián in the United States while Castro's government sought his immediate return home.

After months of legal wrangling, media coverage, and demonstrations in the streets of Miami, in April 2000 U.S. Attorney General Janet Reno (with the blessing of the White House) summoned Immigration and Naturalization Service officers to the home of Elián's Miami relatives. In a dramatic and controversial move, the armed officers stormed the home, seizing the terrified child and forcibly removing him from the house. The boy was reunited with his father in Washington, D.C., and both returned to Cuba. Video footage of the child's terrified face and screams during the shocking raid played around the world, sparking international concern and controversy and turned up the heat once again on the divisive relationship between the United States and Cuba.

GAY CUBA

Cuba has become more progressive when it comes to social issues than one might realize. Its newest revolution is one of social and political reform around issues of equal rights for the island's Lesbian, Gay, Bisexual, and Transgender (LGBT) community.

At the forefront of this fight on the behalf of the LGBT community is Mariela Castro-Espín, daughter of Cuba's president, Raúl Castro. The married mother of three, Castro-Espín is the director of the Cuban National Center for Sex Education (CENESEX) in Havana. Since 2005 CENESEX has been educating people and campaigning for LGBT rights, HIV/AIDS prevention, and gender equality in Cuba. In a first for Latin America, Cuba's medical service provides free sex-change operations for its transgender community.

With Castro-Espín at the helm, Cuba's LGBT community has made tremendous strides in the last half-decade in terms of visibility, awareness, and acceptance. The country now hosts an annual International Day Against Homophobia (IDAHO). The action-packed month-long event includes symposia, lectures, films, concerts, and art exhibits. While overall change is slow and methodical, with still much work to be done, Cuba is arguably one of the most progressive Latin American countries with respect to gay rights.

Pedro Monzón, Cuba's former ambassador to Australia, suggests that attitudes in Cuban society toward homosexuality actually began to shift after the release of the 1994 award-winning yet controversial motion picture *Strawberry and Chocolate*. Monzón told me: "That film was an important beginning. Many of us who had never thought about the plight of gay Cubans changed our way of thinking after that film." He went on to say: "The time for change is long overdue. Many people do not know that there were transsexuals who fought in the Revolution alongside other guerrilla fighters. So the advances being made with regards to LGBT issues in our society [are] timely and good."

The country has come a long way on the road to equality. Gone are the days when gays were fired from jobs, imprisoned, or sent to labor and "re-education" camps. In recent years Fidel Castro himself has gone on record declaring that homosexuality is a "natural aspect and tendency of human beings." As a matter of recourse, in a startling admission in 2010, Castro not only apologized for the government's previous actions against gays but also personally took blame, calling it "a great injustice."

Southwest of Havana in the city of Santa Clara stands Cuba's original government-authorized gay establishment, El Mejunje, which recently celebrated its twenty-five-year anniversary. The small open-air venue is an entertaining paradise for the LGBT community. Famous for its outlandishly flamboyant drag shows and party atmosphere, El Mejunje remains the place where gays, lesbians, and their friends can be themselves without fear or judgment.

Presently Cuba continues its journey to bring equality for all citizens, with progressive results. Mariela Castro-Espín and many others dedicated to the cause know this newer revolution will take more time but are happy to continue the necessary work of breaking down barriers. Castro-Espín sums up her work by saying, "Homophobia is a cultural problem. The world is never ready for change, so it must be provoked. My hope is that the gay community and the non-gay community learn how to respect each other. To overcome their prejudices and learn how to understand even the things they don't yet understand. For now, that would be good. Later, we'll get more."

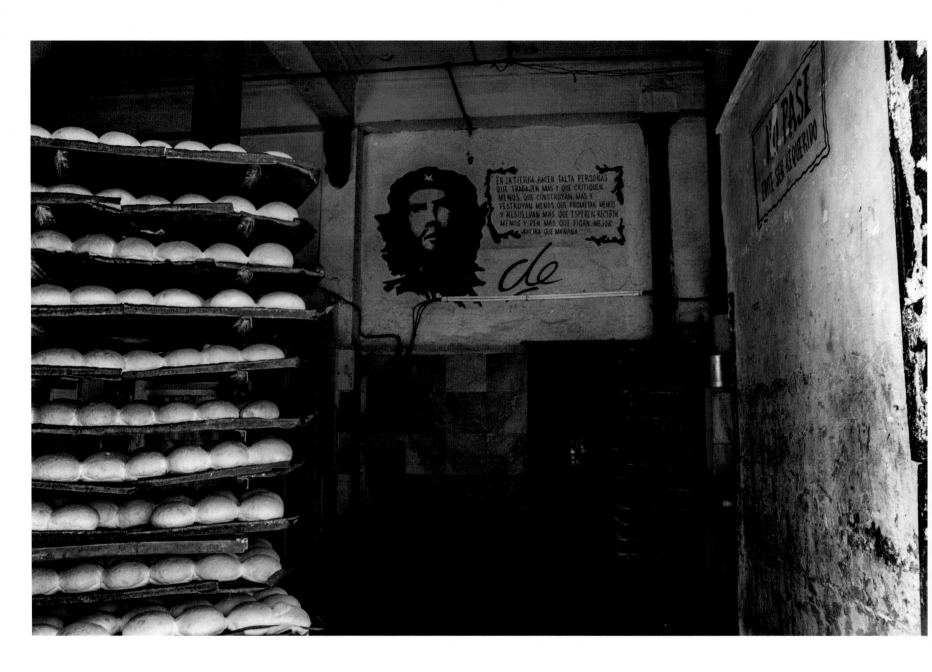

118 | Bread and Che, Centro Habana, 2013

Che Bicycle, Habana Vieja, 2013 | 119

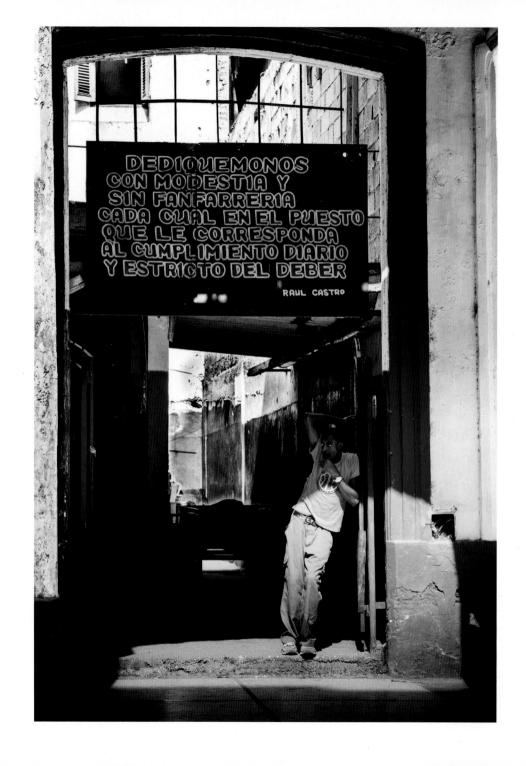

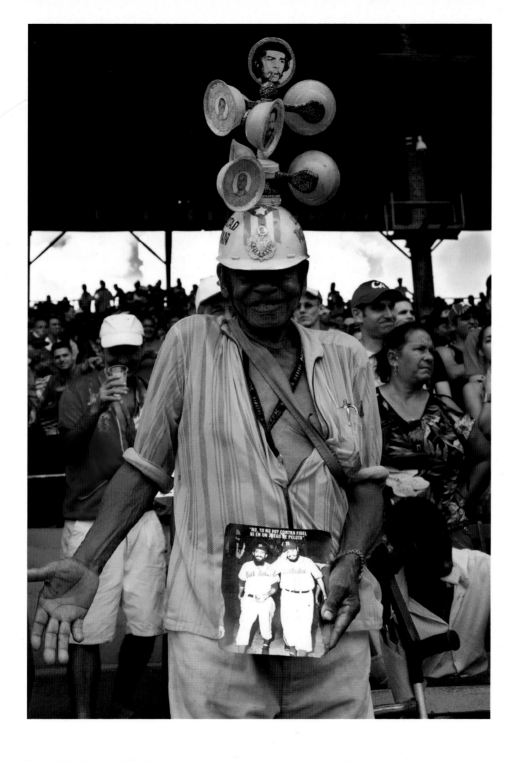

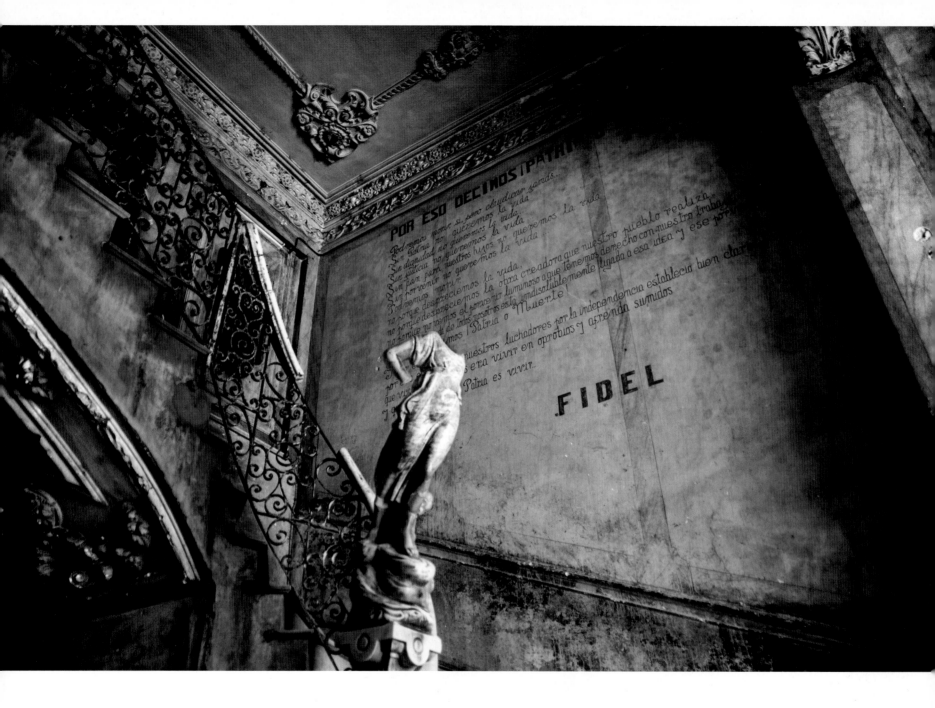

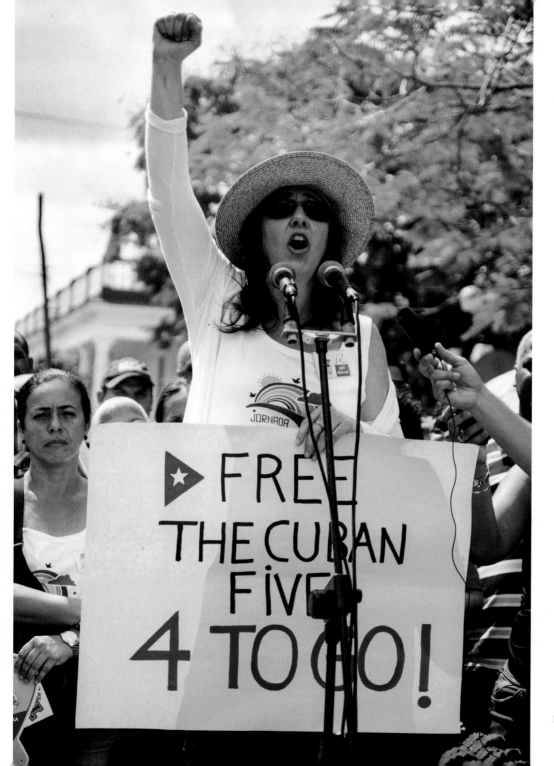

Mariela Castro-Espín Rallies the Crowd, Ciego de Avila, 2013 | 123

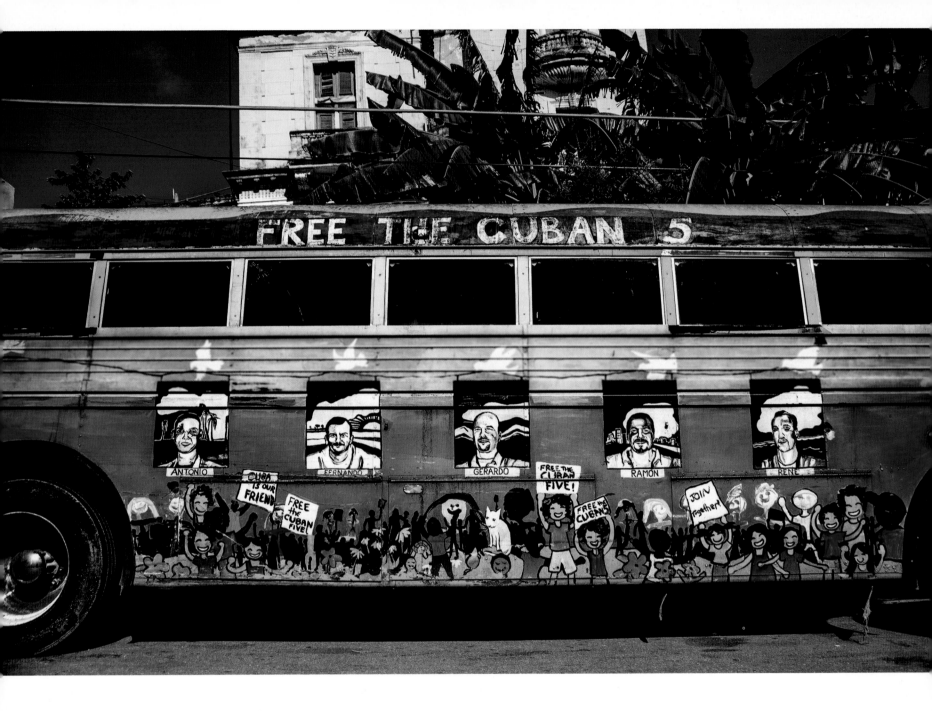

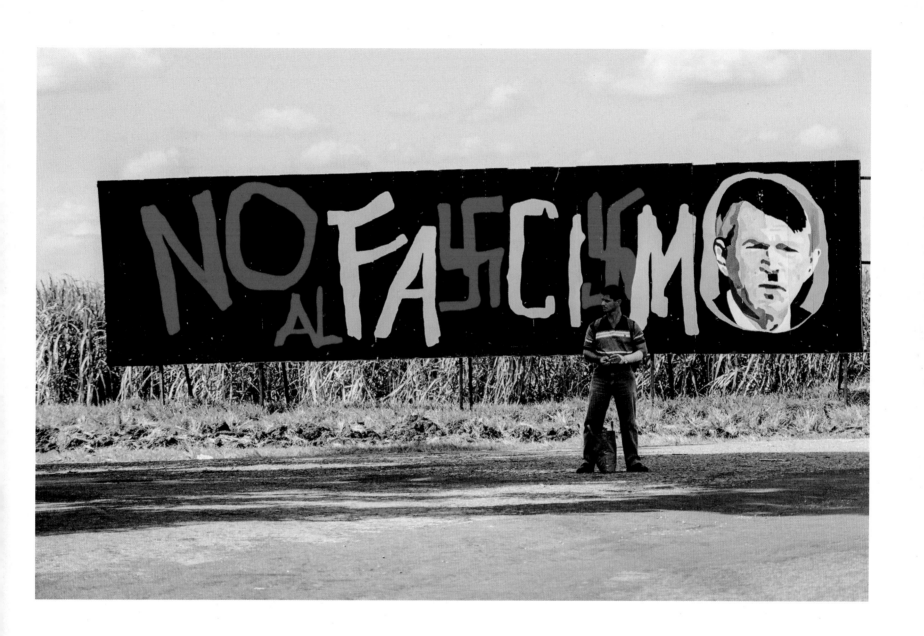

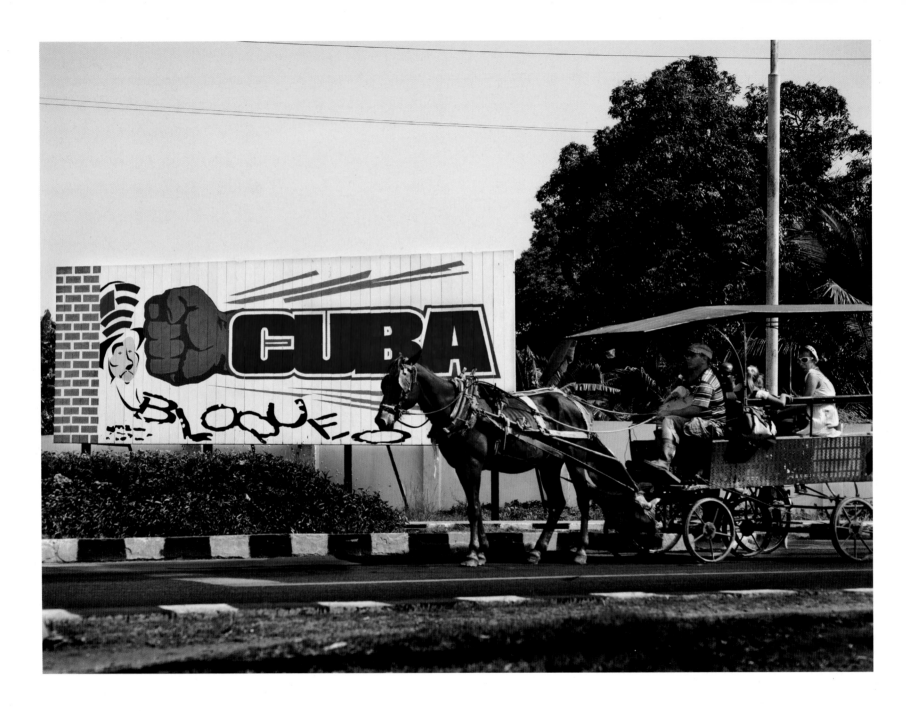

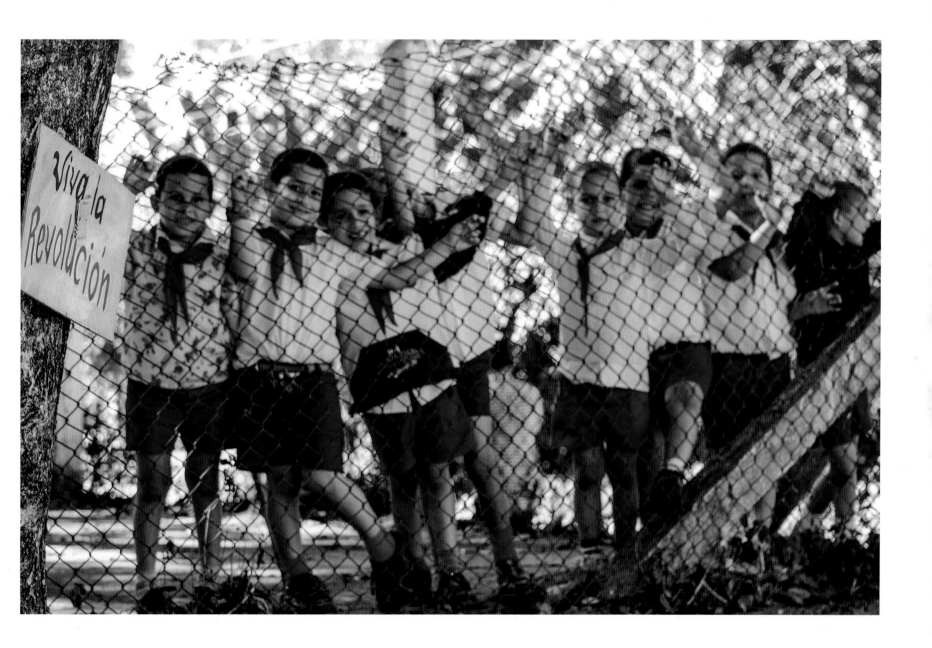

Revolutionary School Children, Viñales, 2008 | 127

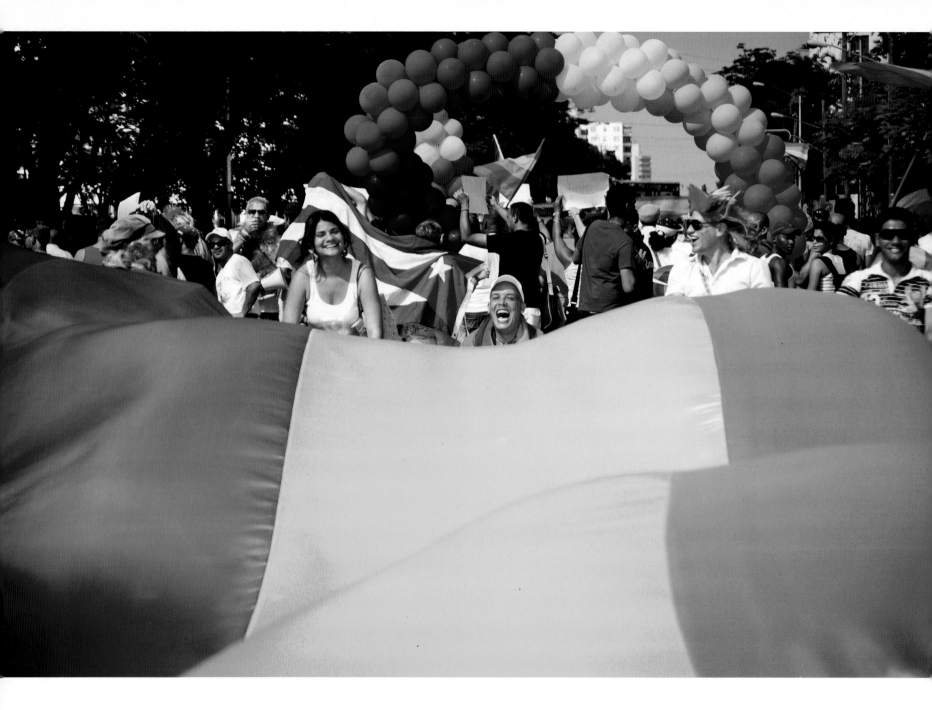

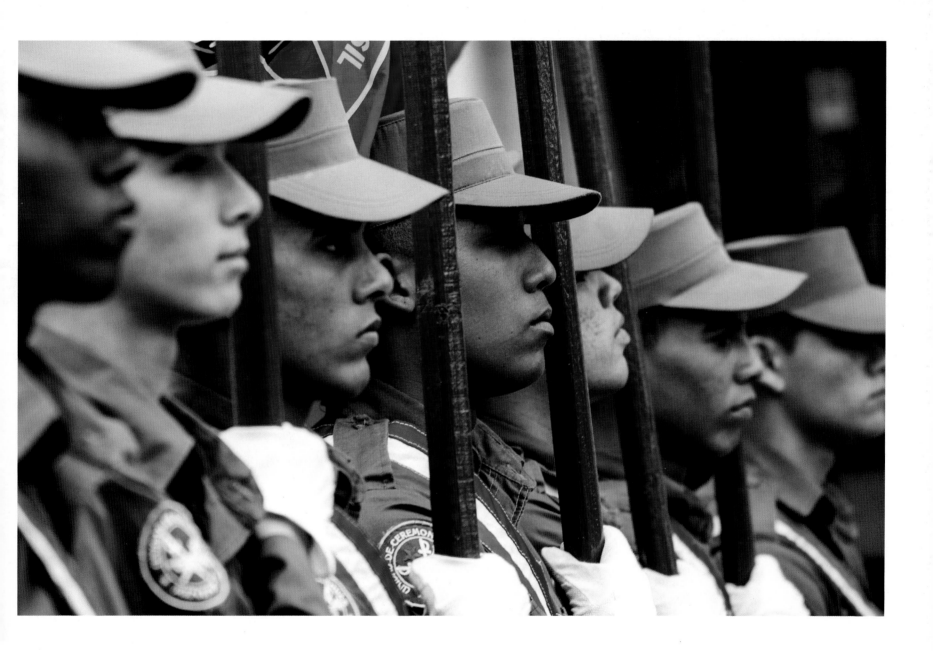

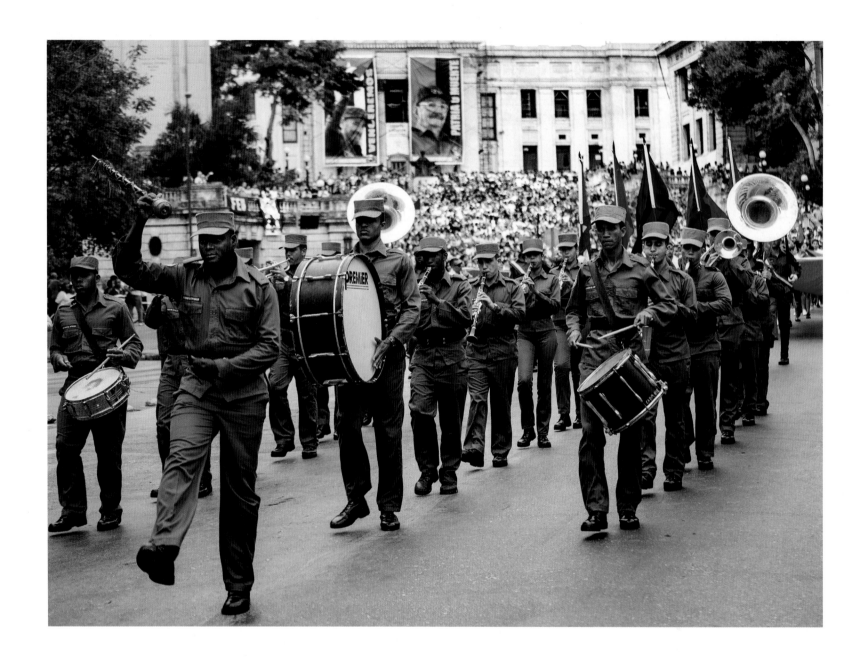

130 | Military Band, Vedado, 2012

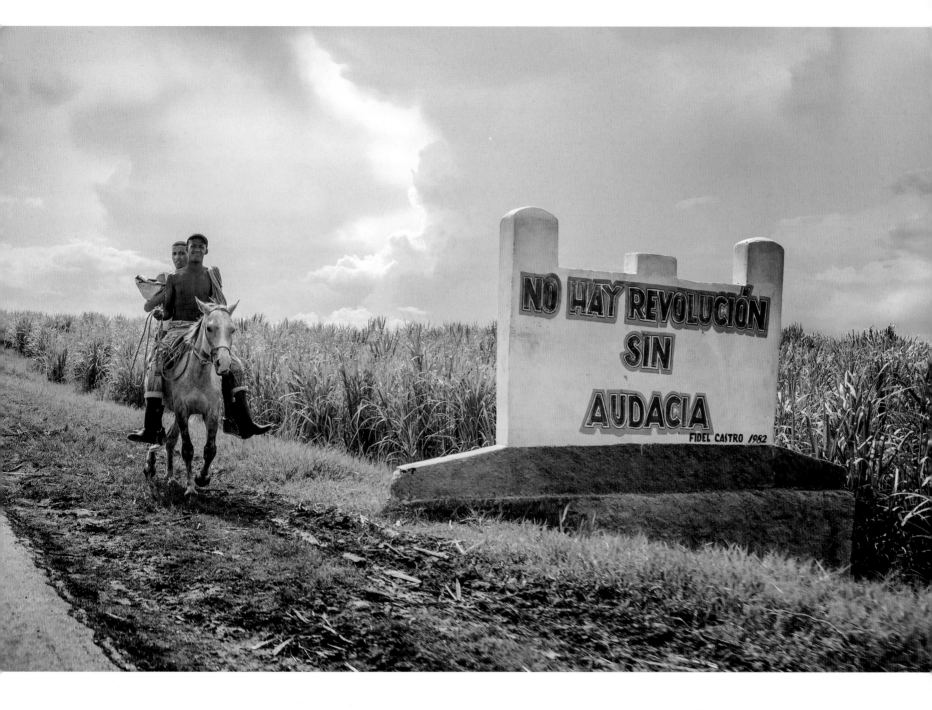

The sign reads: NO HAY REVOLUCIÓN SIN AUDACIA. FIDEL CASTRO 1982

Workers on Horseback, Road to Guantánamo, 2014 | 131

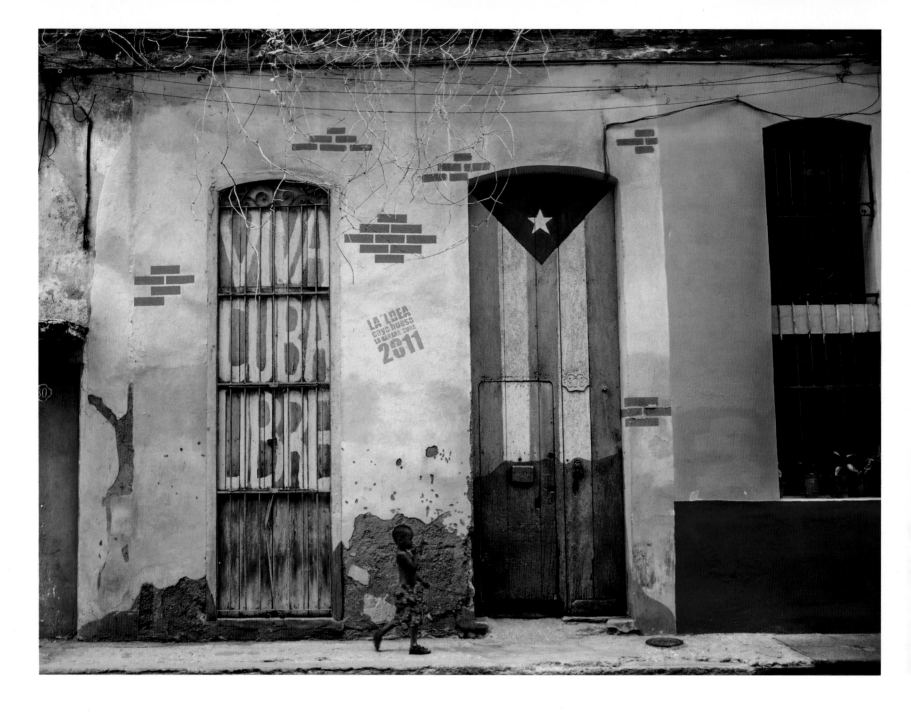

132 | Viva Cuba Libre, Centro Habana, 2013

¡Viva Cuba! Karl Marx Theatre, Miramar, 2013 | 133

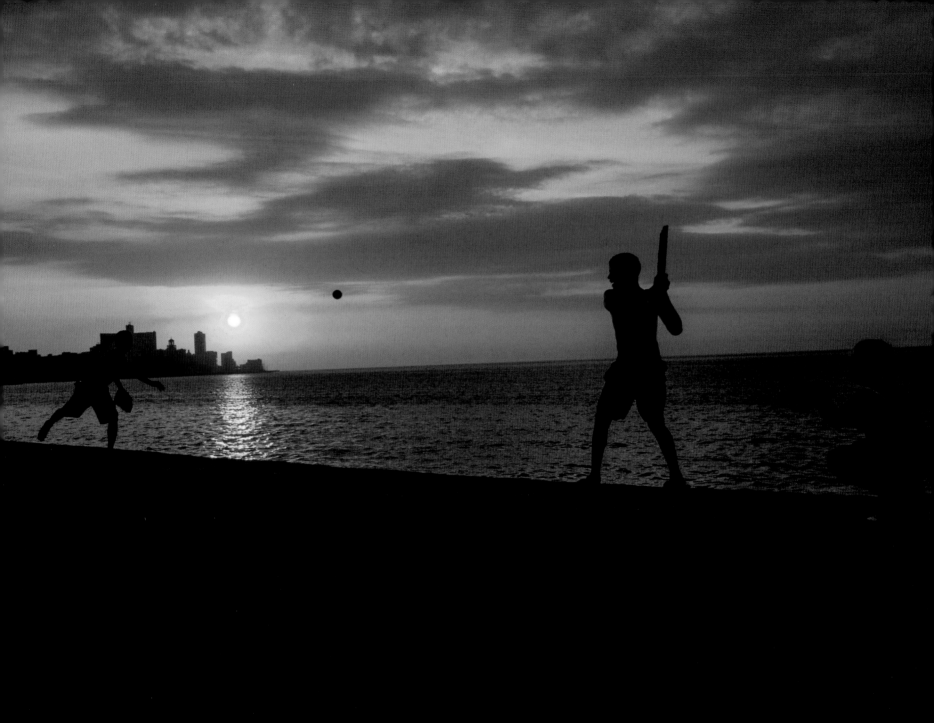

LOS DEPORTES

I had heard that Cubans are deeply religious people. In two days here (in Cuba) I have learned that baseball is their religion.

SAM LACY, *BALTIMORE AFRO-AMERICAN*

Boxing is well suited to the Cuban character. We are brave, resolute and selfless. We have strong convictions and clear definition. We are pugnacious and we like to fight.

ALCIDES SAGARRA, CUBAN BOXING COACH

Baseball on El Malecón, 2008

REGARDLESS OF POLITICAL BELIEFS, differences in governance, or the chasm between cultures, through the decades there has been one common love that Americans share with our Cuban neighbors.

BASEBALL

Baseball is Cuba's unchallenged national pastime and most beloved sport. The phenomenon of baseball on the island is a world unto itself.

When the boys of summer have ended their season stateside in October, Cuba's baseball season is just heating up. Cubans love their *béisbol* and, thanks to the island's balmy weather, play year-round. Fans take the game seriously and are dedicated to its players and teams. For Cubans, baseball signifies love, life, and passion—so much so that Castro's Revolution universalized participation in the sport, hoping to stoke feelings of nationalism. It succeeded.

Indeed, in Cuba baseball *is* king. Reporting from Havana during a June 2007 television broadcast, *Today Show* anchorman Matt Lauer stated, "The most passionate pastimes of the Cuban people are baseball, boxing and ballet. *And in that order!*"

The Cubans' adoration of baseball borders on fanaticism. To get a taste of the fervor, one only has to venture to the heart of Havana's Parque Central, located diagonally opposite El Capitolio (the Capitol building). In a section of the park appropriately known as the "*esquina caliente*" (hot corner), hundreds of Cubans ranging in age from teenagers to men in their nineties gather daily to discuss, argue, and debate the best and worst of Cuban as well as American baseball. To an outsider this hive of excitement and exertion may seem overly passionate, verging on the brink of physical violence. However, this long-standing Cuban custom is a social forum for free individual expression. For both Cubans and inquisitive foreigners alike, it is as informative as it is entertaining. Almost as a stylized ritual, if a gentleman has had enough or is being out-argued, he throws up his hands and walks off in disgust, all the while muttering his anger to himself and anyone else who might empathize with his position. Others yell at the top of their lungs over the merits of a certain player. Some gesture wildly with their hands or wave the game stats in a recent edition of the *Granma* newspaper. Onlookers converge around these animated exchanges, some piping in, others laughing. You might even see a few wearing Major League team caps, t-shirts, or belt buckles. The energy and passion are palpable and infectious. No serious hurt feelings ensue, however; there's always the next day's round of debates.

Even those of Cuba's approximately 12 million residents who don't follow the sport on a daily basis still embrace the prideful nationalism the game evokes. From the hustle-bustle streets of Havana to more rural settings in towns like Pinar del Río and Las Tunas, Cubans support the sport of baseball even more than the universal sport of soccer. Here baseball is a true cultural phenomenon. Kids of all ages play the game everywhere from street corners, apartment buildings, and parks to alleyways and every nook and cranny that can provide the faintest semblance of a baseball diamond.

Because of the perpetual lack of material goods, children and young adults creatively make do with anything on hand to play the sport they so love. Bottle caps become baseballs. Broom sticks become bats. Cardboard boxes become

gloves. Tin pans become bases. Nothing can stop them from playing.

As simplistic as street baseball can be, the professional Cuban National Baseball League is top notch and possesses some of the players rated the finest in the world. As a matter of fact, one could argue that the success of Cuban teams in recent World Baseball Classics, and other international competitions, has placed Cuba at the top of the international baseball scene.

Attending a professional baseball game in Cuba is like going to an impromptu rock concert. The packed stadiums, although not nearly as stately or as modern as America's, are adequately maintained and durable. Fans chant, dance, sing, and play a variety of percussive and brass instruments from well before the first pitch until the end of the game. Unlike at U.S. sporting events, *no one* leaves until the last out has been made. Meanwhile the teams on the field play hard-fought competitions with zest and incredible athleticism.

Teams show up to the stadium roughly ninety minutes before game time, already dressed in their uniforms, carrying their own equipment and ready to go. No luxurious locker rooms with multiple attendants await them; no state-of-the-art workout equipment, no hot tubs or Jacuzzis to soak away aches and pains will be found in these stadiums. After stopping to sign a few autographs on the way in to the clubhouse, it's a quick sandwich, chips, and soda for nourishment, a brief stretch and warmup, a lot of joshing around with each other (and the opposing team), and then hats-off, listening to a scratchy recorded version of the Cuban national anthem before the seriousness of the ballgame is underway. Some rituals are unfamiliar to North American fans: the catcher and hitter shaking hands before the first pitch of the game; the pitcher and hitter shaking hands after the batter is hit by a pitch; the umpires being served coffee and water by attractive young women in short dresses and fishnet stockings in mid-game; a female umpire manning the base pads; players conversing with fans and family in the stands *during* the game. Unlike the uber-commercialization of professional sports in the United States, which ultimately hits fans hard in the pocketbook, with Cuban baseball expect no scorecards, no programs, no advertising, and no souvenirs. Here it is truly about the game.

The ticket price is ten cents for Cubans and five dollars for foreigners. There is rarely designated seating; just one expansive concrete bowl steeply terraced with swarms of devoted *fanaticos*. Depending on the stadium, the concession area sells pork sandwiches, chicken and rice, popcorn and sodas. There is no beer or any other alcoholic beverage for sale; here it's BYOB.

Just as riveting as the sights of Cuban baseball are the cacophony of sounds. Blaring horns and hand-pumped noise-makers can be deafening and never cease from the moment fans enter the stadium. Add a churning sea of emotional hollering and the explosive cheers from rabid fans after a big hit or run scored by the home team, and the stadium erupts with a collective roar heard blocks away.

Between innings, salsa music from live bands in the bleachers or recorded *reggaetón* songs pumped through the stadium's sound system fill the air as fans chitchat, entertain each other, and sometimes taunt players of the visiting team.

Many players are Major League–caliber athletes who might never experience the big leagues of American baseball nor the big money that comes with playing in the majors. Most Cuban athletes choose to stay in their own country.

However, numerous players have defected to the United States seeking fame and fortune. Currently there are nearly thirty Cuban-born players on Major League rosters, and certainly more will be coming. With the historic moves by the Obama administration to normalize U.S.-Cuba relations, only time will tell how this scenario will continue to play out. In 2013 half of the twelve players up for Rookie of Year were of Cuban descent, with Miami Marlins pitcher José Fernández, born in Cuba but raised in Miami, winning the National League honors. The following season, in a rare unanimous vote by the Baseball Writers' Association of America, Chicago White Sox slugger José Abreu snagged the American League award. Previous Cuban-born Rookie of the Year winners include Tony Oliva (1964) and José Canseco (1986).

Currently the Cuban béisbol leagues consist of sixteen national teams divided into three divisions: the Orientales, the Centrales, and the Occidentales. Their playing season spans from the winter months well into the spring. Cuban baseball bans the trading and sale of a player: each player plays with his province's team.

In Havana the local Industriales Leones (the Lions) are gods. Dubbed the "Pride of Havana," the Industriales Leones are in essence the New York Yankees of Cuban baseball. Whether they are being celebrated or reviled, one cannot argue the fact that "the Blue Ones" or "the Blue Lions," as they are often called, are the island's most successful franchise. In the post-revolutionary Castro era of baseball, the Industriales have reigned supreme, holding a near-monopoly as winners of just about every Serie Nacional de Beisbol (Cuban World Series). In truth, their dominance has become so

anticipated by fans that a loss to a rival team often evokes as much discontent as do housing shortages and low wages.

The Industriales possess a powerhouse lineup of big league–caliber talent, headlined by the "great Mayeta," Alexander Mayeta. The first base slugger is a perennial superstar who possesses a swing as powerful as that of David "Big Papi" Ortiz, but with a baby face smile as captivating and heartwarming as that of Denzel Washington. His affable, approachable personality makes him seem less like a formidable warrior on the field and more like a friend you would hang out with, throwing back mojitos and puffing on Cohibas together at La Floridita. In his storied career Mayeta has put up Hall of Fame–type statistics that rival those of the best Major League players in the United States.

All around Havana, graffitied walls flaunt the Industriales team logo—a roaring lion over home plate with a capital "I" in blue calligraphy—and messages of devotion, reminders of the passion and love for the ball club. An apartment building peeks over the left-field wall of Havana's storied Estadio Latinoamericano (the Yankee stadium of Cuba), its entire exterior painted in the Industriales' bright azure, with a white gothic "I" running the height of its dozen stories.

Cuba has a rich baseball past. The game was introduced to the island in the 1860s and professional baseball began in 1878, less than a decade after its start in the United States. Eighty-seven Cubans, including Adolfo Luque, Minnie Miñoso, Tony Perez, and Bert Campaneris, played in North America's Major Leagues before the Cuban Revolution. Until his death in April 2014 at the age of 102, Conrado Marrero was considered the elder statesman and patriarch of Cuban baseball. A top amateur pitcher in Cuba, Marrero

turned professional at age thirty-five. In the early 1950s he spent five seasons in the majors pitching for the Washington Senators. And while he won only thirty-nine games in his Major League career, Marrero's larger-than-life personality earned him a feature story in *Life* Magazine in 1951. He was also the only former Cuban big leaguer to return to the island and make it his residence. Living his sunset years in a modest apartment with his grandson and great-grandchildren in the Cerro district of Havana, Marrero retained his feisty and engaging spirit until the end. Although blinded by cataracts and slowed by age, he had sharp mental recall when asked to recount his glory days on the field. Without hesitation he could spout forth vivid details of his showdowns with DiMaggio, Yogi Berra, and Satchel Paige, including the emotions and statistics of every play as if it happened yesterday. Marrero is lionized in Cuba and his likeness adorns a Cuban commemorative stamp.

The motto of Cuban sports is *"Deportes: el derecho de los gentes"* (Sport: the right of the people). This mantra is exemplified by the fact that games are often played on fields in remote provinces and small towns. At one point more than one hundred parks were used by Cuba's national teams; more recently the number of parks dropped by half due to a stricter safety policy based on concerns about injuries sustained on substandard playing surfaces. The use of multiple venues provides greater opportunity for all Cubans to attend more games, enabling them to cheer on their island heroes.

Cuban baseball is truly a unique entity unto itself. And it has survived many crises: the Revolution, the Special Period of severe economic depression in the 1990s, the pilfering of its players by the majors, and substandard playing condi-tions. May the sport live long into the future and continue to unite citizens and provide opportunities for sensational athletes to share their talents, not only with the island's inhabitants but also with the world. *Viva Cuba Béisbol!*

BOXING

Boxing, Cuba's second most popular sport, has its own storied history. The sport that first arrived on the island as a tourist attraction has become a nationally beloved pastime.

Professional boxing debuted in Cuba in 1909. However, it was quickly banned due the violence it created between blacks and whites. Continuing as an underground endeavor, the sport grew despite the ban, gaining in popularity across the island.

Once the ban on Cuba's boxers was eventually lifted in 1921, the business of boxing boomed for decades. Earning a reputation as a dominant powerhouse for cultivating talent, some of them world champions, Cuba's boxing establish-ment attracted elite boxers from the United States, including Jack Johnson, Joe Louis, and Sugar Ray Robinson.

On April 5, 1915, on a scorching Caribbean day, Havana hosted a title fight between legendary American heavy-weights Jack Johnson and Jess Willard. Before a massive crowd at the Oriental Park Racetrack, the underdog Willard (one of many "White Hopes" through whom boxing pro-moters sought to unseat Johnson from his reign) knocked out the champ in the twenty-sixth round of a match sched-uled for forty-five rounds. Still embittered years later by this first loss, Johnson would claim that he had "taken a dive" in the fight. However, historians and fans who have studied the

grainy black and white film footage of the bout regard Willard as having clearly won the fight.

Eligio Sardiñas Montalvo, better known as "Kid Chocolate," remains arguably Cuba's most successful and acclaimed boxer. Standing at a compact five feet six inches tall, he debuted professionally in 1927 and eventually became Cuba's first world boxing champion in 1931, ultimately winning feather and junior lightweight crowns. With a decade-long career lasting from 1928 to 1938, Kid Chocolate racked up an unprecedented fifty-five consecutive wins before succumbing to his first ever loss to English boxer Jack "Kid" Berg, on a decision many claim Chocolate should have won.

With his undisputed place in Cuban boxing history solidified, boasting 136 wins (51 by knockout) and only 10 defeats, Kid Chocolate is remembered for his unrivaled greatness in the ring. In homage to his legacy, the Sala Polivalente Kid Chocolate (a building named in his honor, located directly opposite the Capitol) hosts boxing matches and serves as a training facility for up and coming fighters. A large mural of a smiling Kid Chocolate on the building's exterior greets passersby. Further solidifying his impact on the world of boxing, he is the inspiration for the character Chocolate Drop in the Clifford Odets play *Golden Boy*, also made into a film and musical of the same name.

Nicknamed "Kid Gavilán," Gerardo González is regarded as one of Cuba's finest welterweight division boxers of all time. World champion from 1951 to 1954, he fought some of the best boxers of the era, including Sugar Ray Robinson, Billy Graham, Carmen Basilio, Bobo Olson, Johnny Bratton, and Gaspar Ortega. A flamboyant showman, the quick-footed, hard-punching Gavilán never suffered a knockout during his prolific fifteen-year career. His trademark "bolo punch"—a hook-swinging, windmill-swirling stinging blow—thrilled spectators and intimidated opponents for years and was later emulated by the likes of Muhammad Ali and Sugar Ray Leonard.

The industry of professional boxing suffered severely in 1962 when, in the name of Communism, Commandante Castro enacted Cuban National Decree 83a, which nationalized all sports on the island. As a consequence of the order, athletes who wanted to pursue their professional dreams had to make the agonizing decision to stay in their homeland or defect.

The dissolution of professional boxing gave rise to amateur boxing, which now thrives in Cuba. But don't let the word "amateur" fool you. Since 1972 Cuba has won thirty-two Olympic gold medals in boxing, more than any other country in that time frame. Those numbers would no doubt be even higher had Cuba not boycotted the 1984 and 1988 games.

Nestled deep inside one of Habana Vieja's crumbling neighborhoods, one place considered hallowed ground in Cuban boxing still thrives: El Gimnasio de Boxeo Rafael Trejo al Aire Libre (Rafael Trejo Boxing Gymnasium), named in honor of a slain revolutionary hero. It has been said that every great Cuban boxer since Kid Chocolate has trained here. To an outsider it may be hard to believe that this small, antiquated, dusty gym has produced more Olympic medalists than most entire countries. The open-air facility contains a single boxing ring in the middle of a rustic courtyard, enclosed by two towering, nondescript apartment buildings.

Despite archaic equipment and peeled-paint surroundings, a dedicated team of coaches, many former Olympians

themselves, transforms the spirit of el Gimnasio, inspiring its gifted, hope-filled athletes with the virtues of conditioning, discipline, and integrity in the ring.

True to the country's survivalist spirit, Cuba's boxing program has risen above its limited conditions and found its place in the competitive world of international amateur boxing, becoming a respected and dominant force.

CUBAN OLYMPICS AND BEYOND

Post-revolutionary Cuba prides itself on its success in sports, not only as a pastime but also to promote national pride. The slogan "Sports for All" denotes the country's promise to make fitness, sports education, and training accessible to all islanders and its commitment to the development of world-class athletes.

Fidel Castro has defined sporting activities as a person's right. As such, giving those who had previously been denied it the opportunity to participate in the upper echelons of sports society has been a key objective of his agenda. Before coming to power, the leader had been particularly concerned with the exploitation of the island's black and lower-socio-economic-status athletes, whom he felt had been used as "merchandise" by those who profited from their talents.

Fidel's declaration, *"El deporte cultiva los músculos, educa el carácter, desarolla la inteligencia"* (Sport develops muscles, builds character, and develops intelligence) has inspired Cuban athletes to excel at every level. The Instituto Nacional de Deportes, Educación Fisica y Recreación (INDER, National Institute of Sports, Physical Education and Recreation) is the governing body that oversees all sport entities in Cuba. Implemented soon after the onset of the Revolution,

INDER is the NFL, MLB, NBA, MLS, and NHL all wrapped up in one.

INDER's paramount and clearly defined mission is to promote sports excellence as well as the development of individual and social growth. At its core is the fundamental belief that physical education and sports develop an individual's character, which in turn contributes to society and state.

Under the INDER umbrella, the National Institute for Sports Medicine, the National Coaches program, and the National Physical Education Institute operate as subsidiary divisions to meet the needs of physicians, coaches, and trainers who help keep the machine of competitive sports well tuned and running.

INDER and Raúl Castro's administration now allow athletes to leave the island to play sports in other countries, provided they get governmental approval and return to Cuba during their sport's declared playing season to compete for the homeland. This policy opens the door for every athlete to venture to other Caribbean islands, Mexico, Australia, Asia, and Europe to compete in their chosen sport. The United States remains the exception.

Fútbol (soccer), like baseball, by design requires only space and a ball, and in Cuba space can be transformed into a soccer venue anywhere and everywhere: streets, hallways, doorways, and open fields. Unquestionably Cuba's second favorite team sport, *fútbol* continues to gain momentum and popularity around the island.

Cuba's national soccer team has yet to qualify for a World Cup, and their highest ranking to date in the Caribbean Football Union (CONCACAF) Gold Cup run has been the quarterfinals in 2003 and 2013.

The Summer Olympics continue to be the main showcase for Cuban athletes on the world stage; Cuba has never competed in the Winter games. Created in 1926, the Comité Olímpico Cubano (Cuban Olympic Committee) oversees the country's Olympic program. Since 1978 Cuba's Olympians have competed in twenty sports, including basketball, diving, cycling, fencing, gymnastics and modern gymnastics, judo, pistol shooting, roller derby, roller hockey, swimming and synchronized swimming, volleyball, water polo, wrestling, and of course, baseball.

As of 2012 Cuba's men and women athletes have won a combined total of 208 medals, including 72 gold, 67 silver, and 69 bronze.

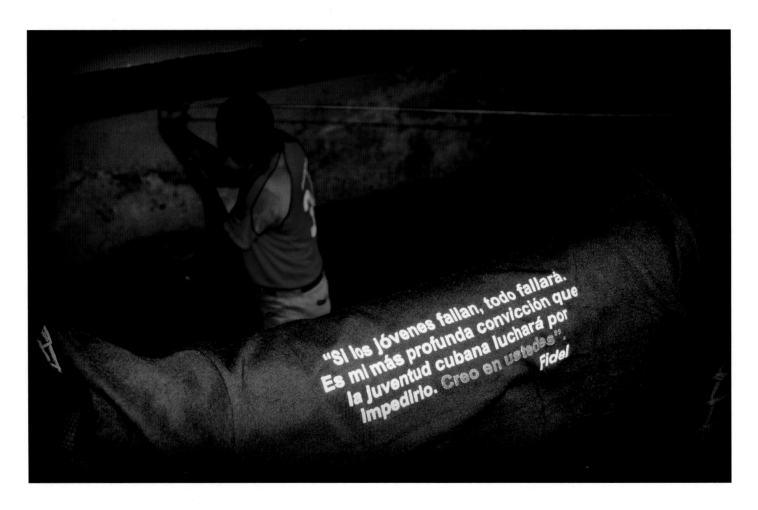

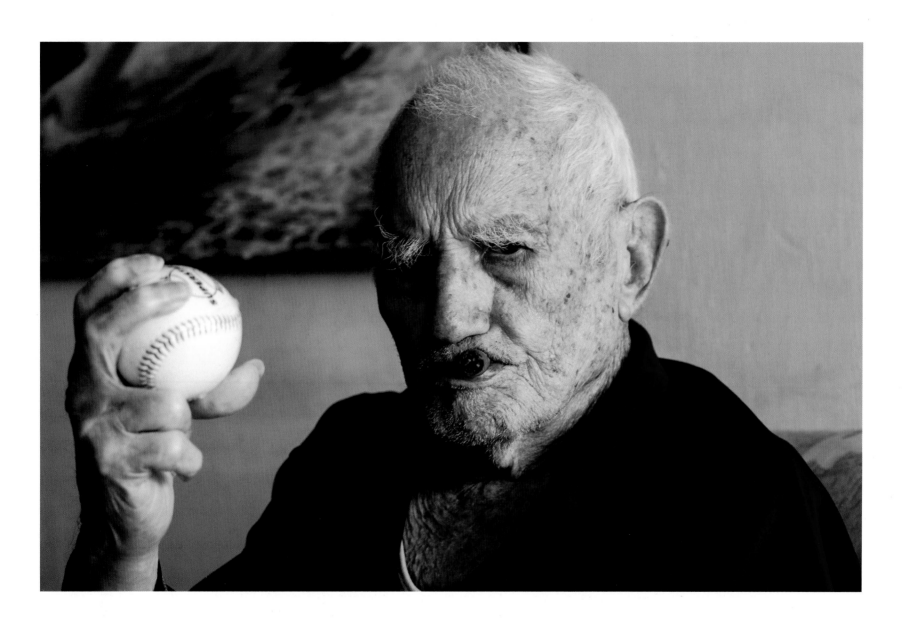

Conrado Marrero, Cerro, 2008 | 143

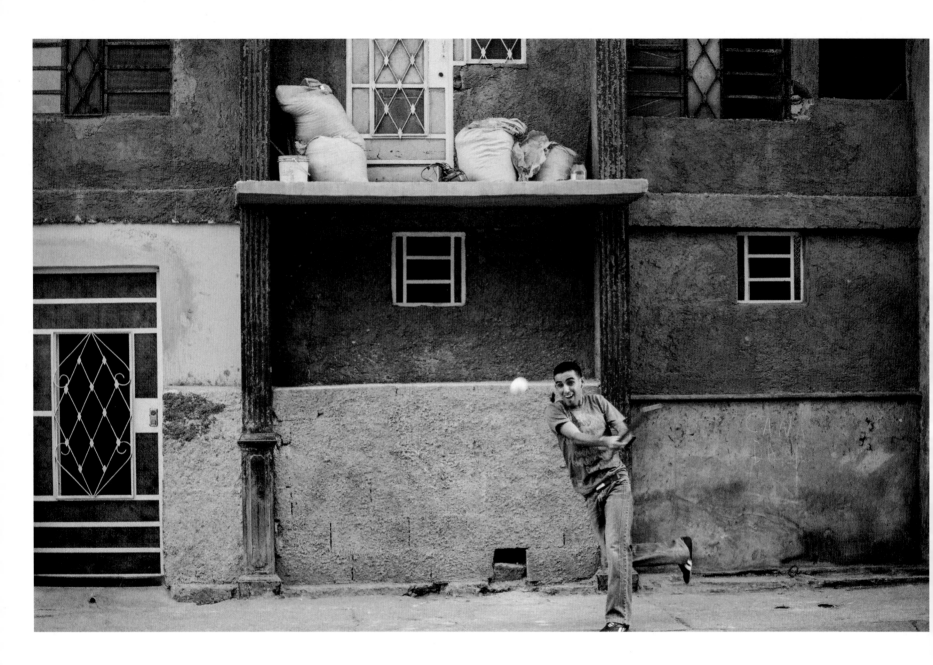

144 | Swinging Away, La Habana, 2006

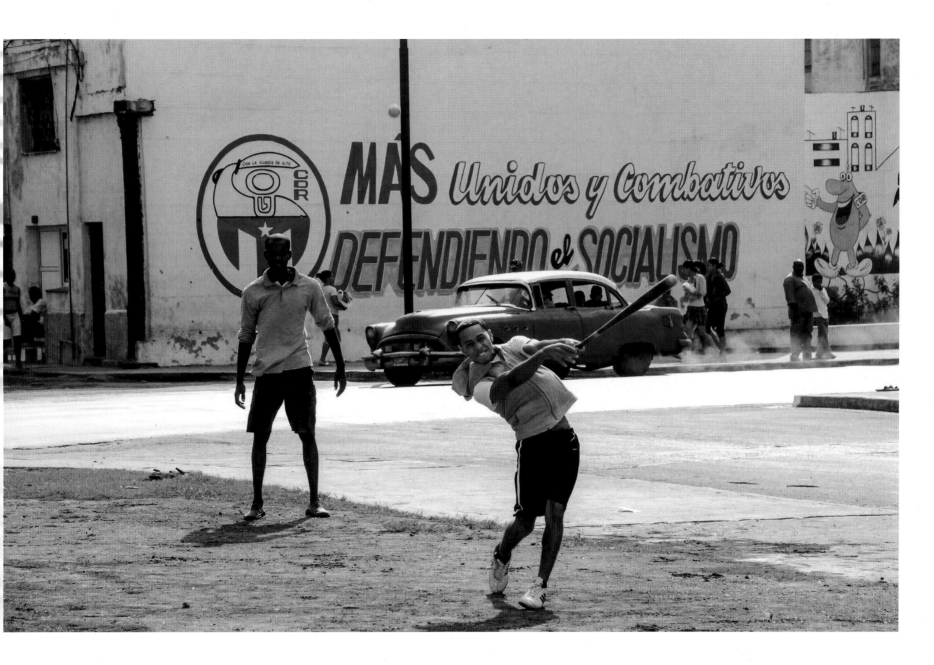

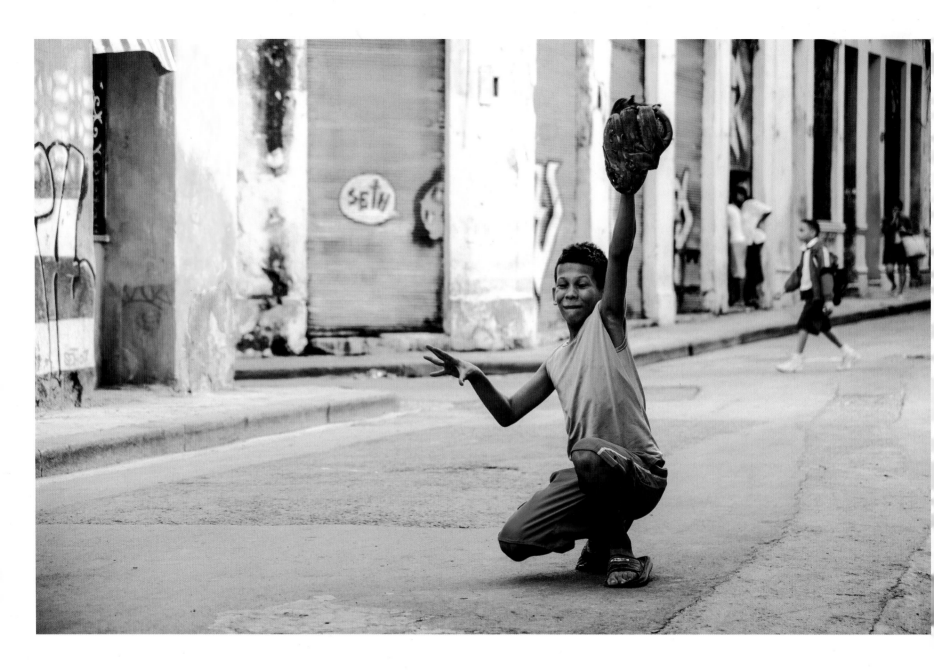

146 | Got It! Habana Vieja, 2008

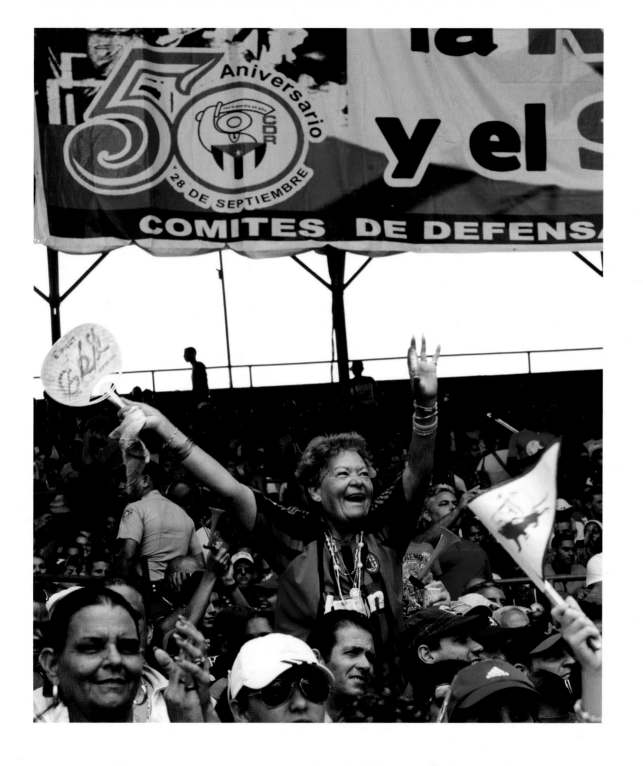

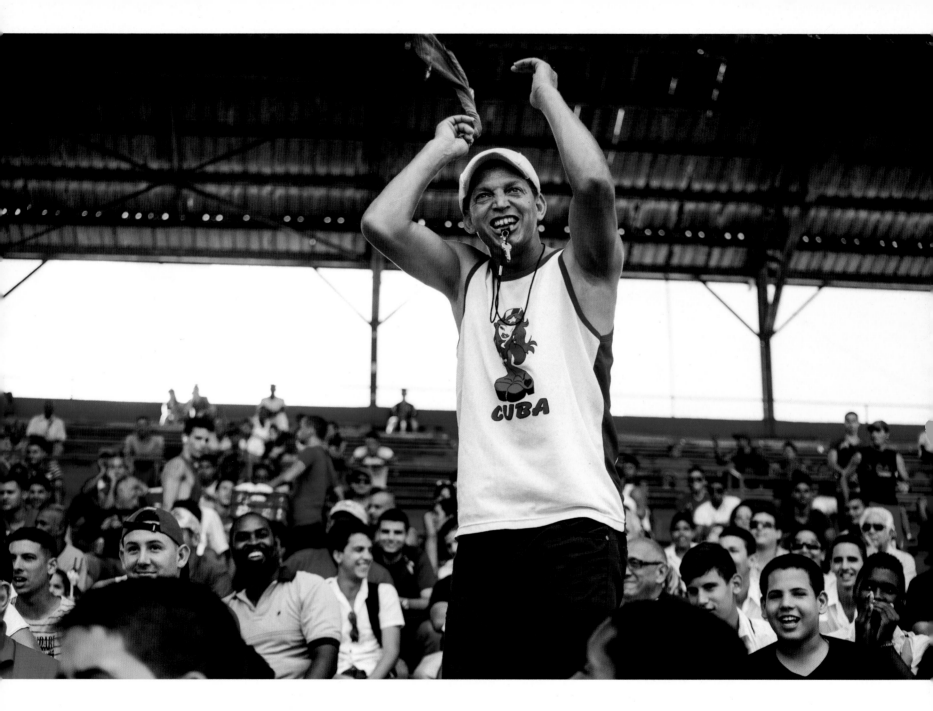

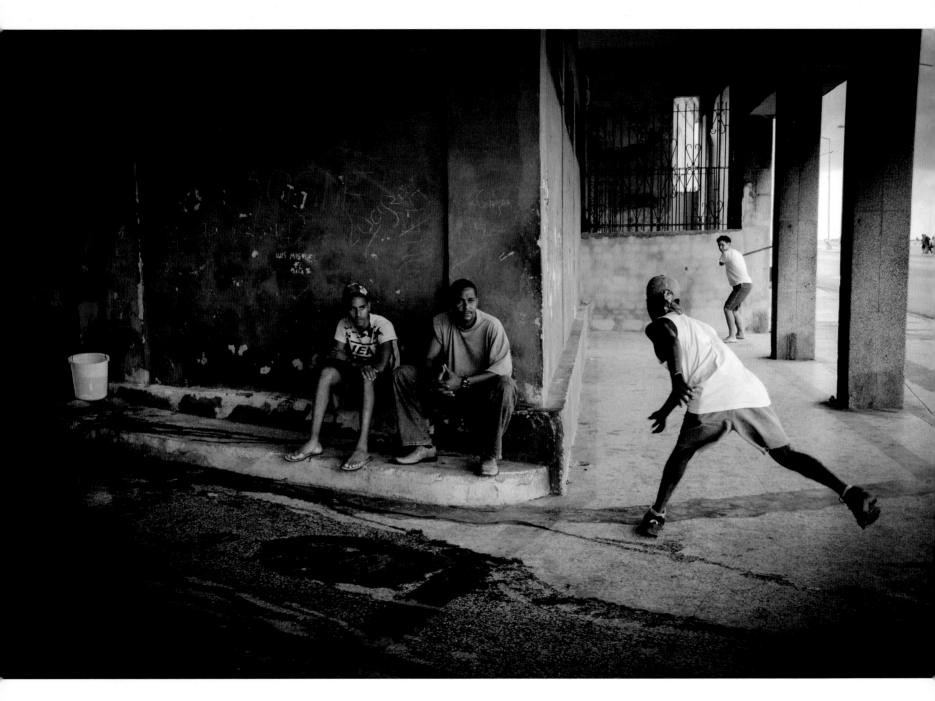

150 | Street Ball, El Malecón, 2008

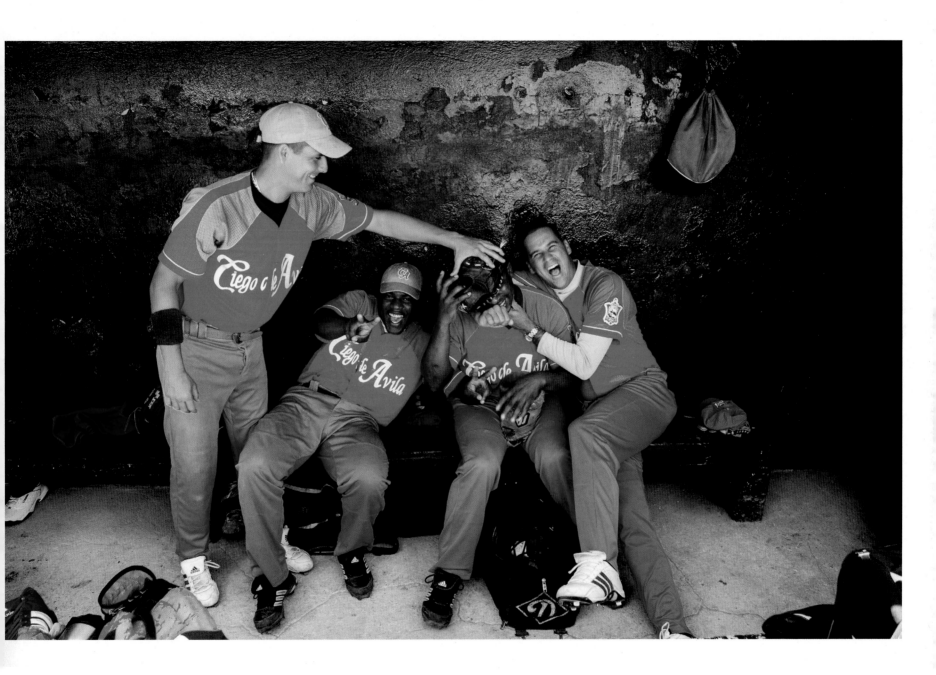

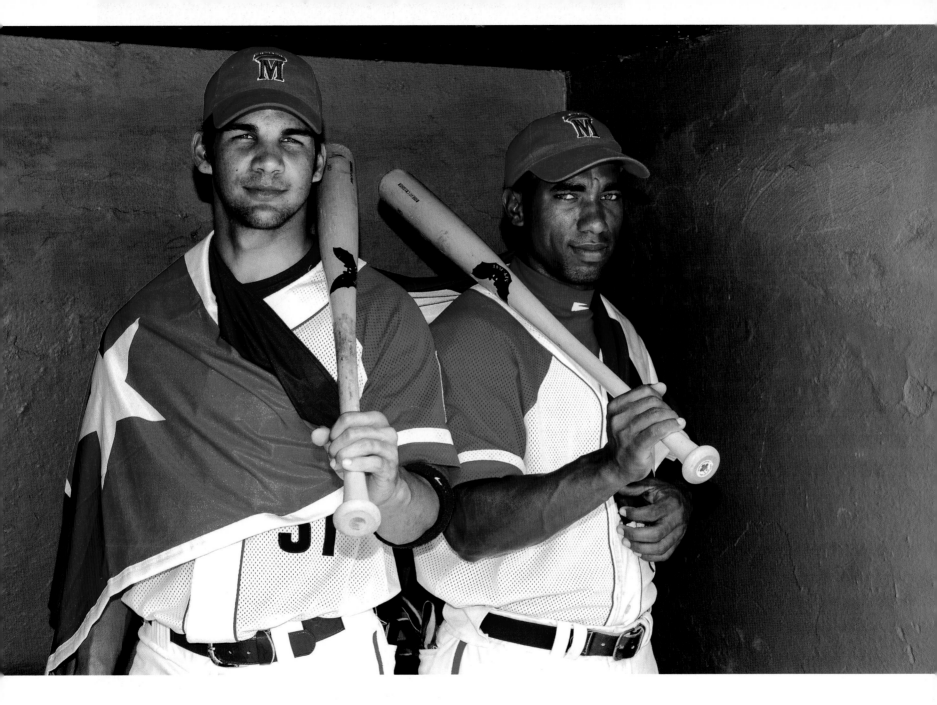

Trujillo and Ramirez Draped in Pride, Cerro, 2009 | 153

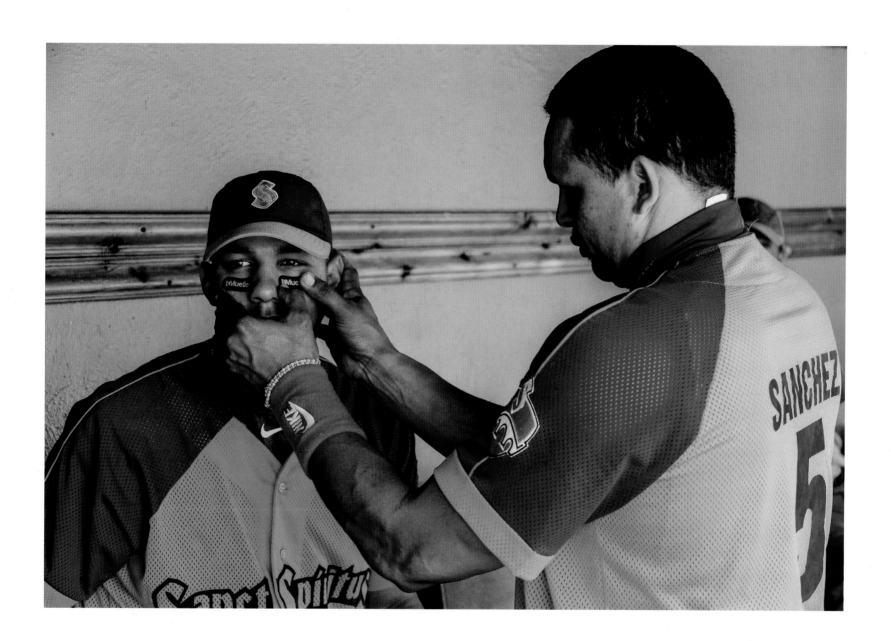

Let Me Help You with That, Cerro, 2009 | 155

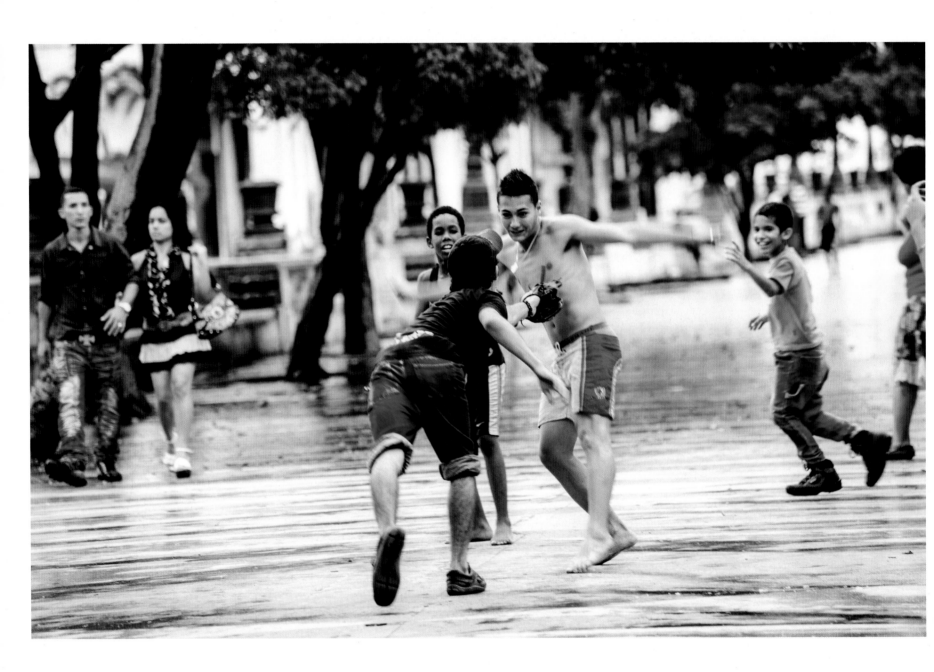

Disc Thrower, Sports City, La Habana, 2008 | 157

158 | Hero Worship, Habana Vieja, 2008

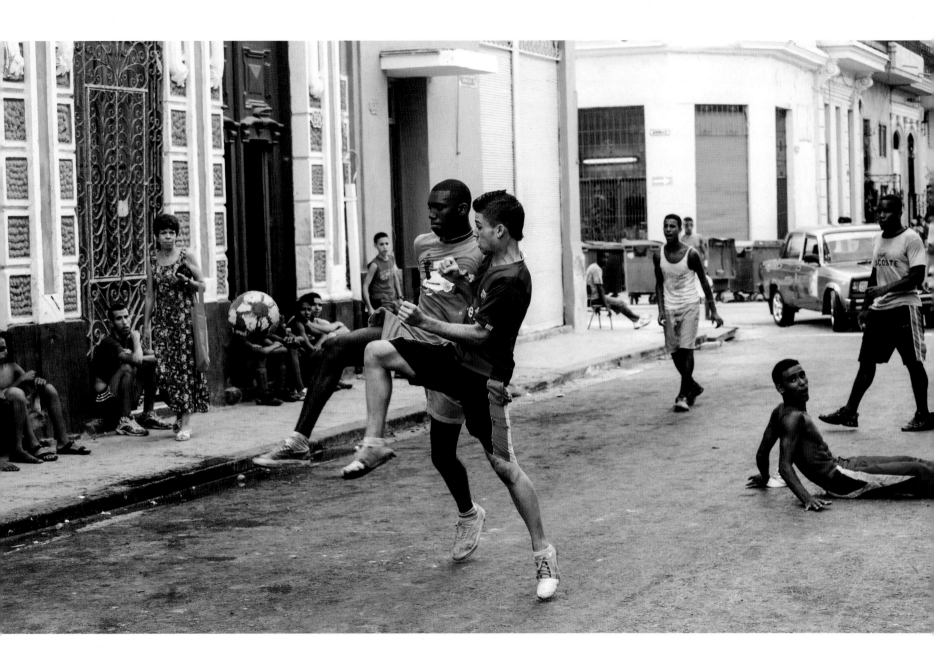

Street Fútbol, Centro Habana, 2010 | 159

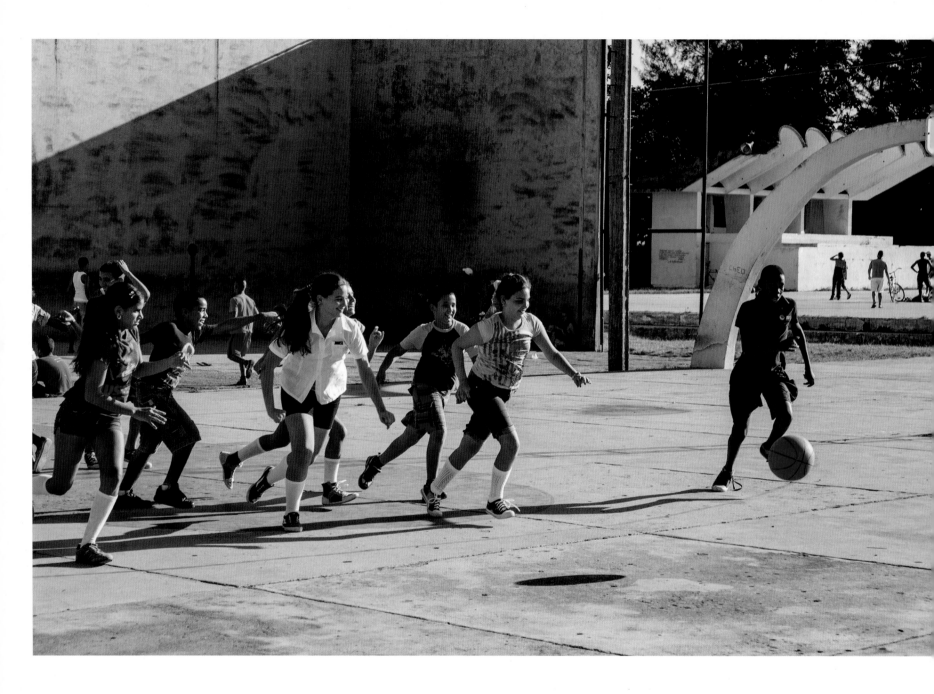

160 | Chasing the Ball, San José, 2013

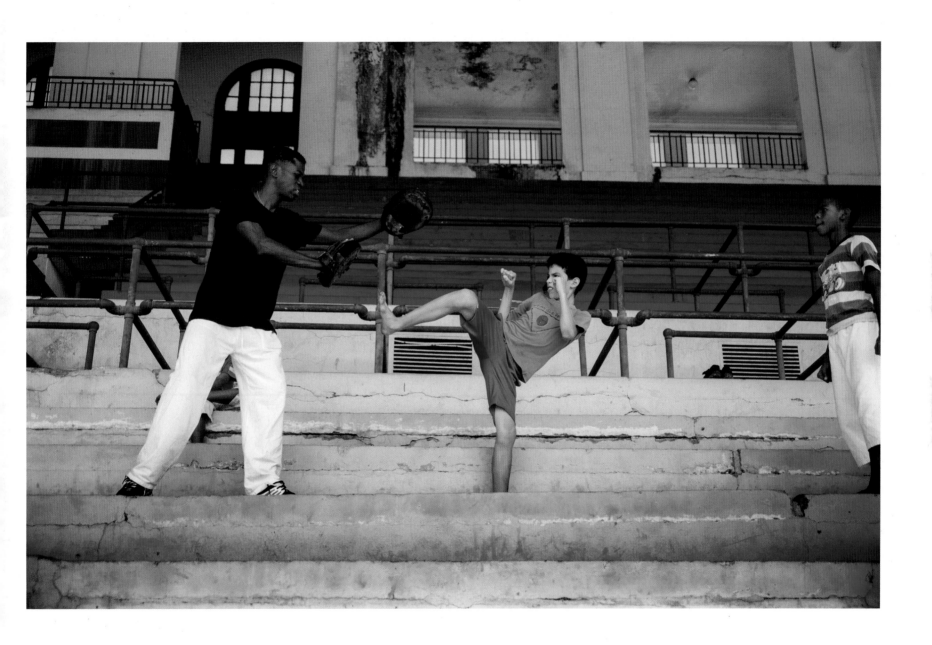

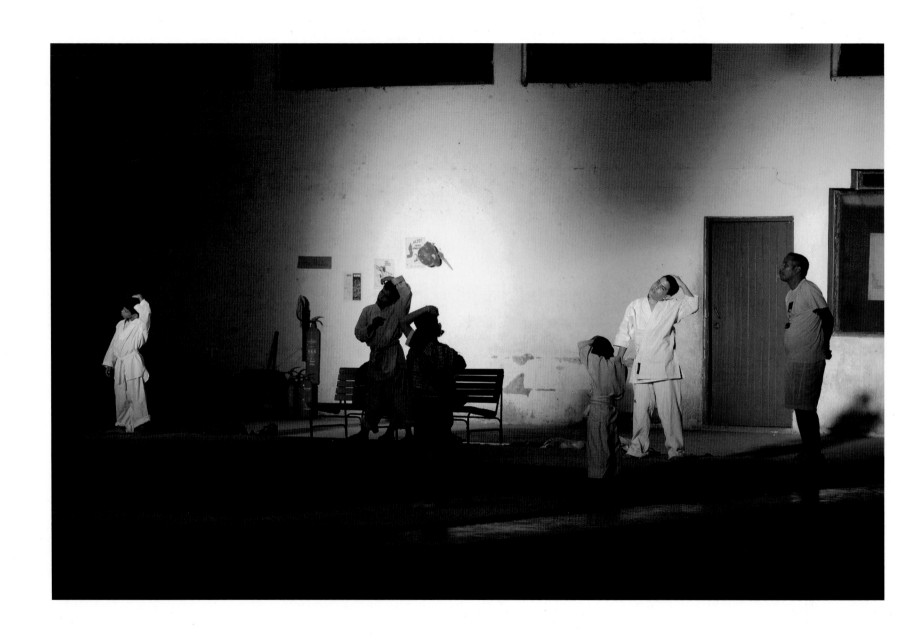

162 | Judo Warmup, Habana Vieja, 2008

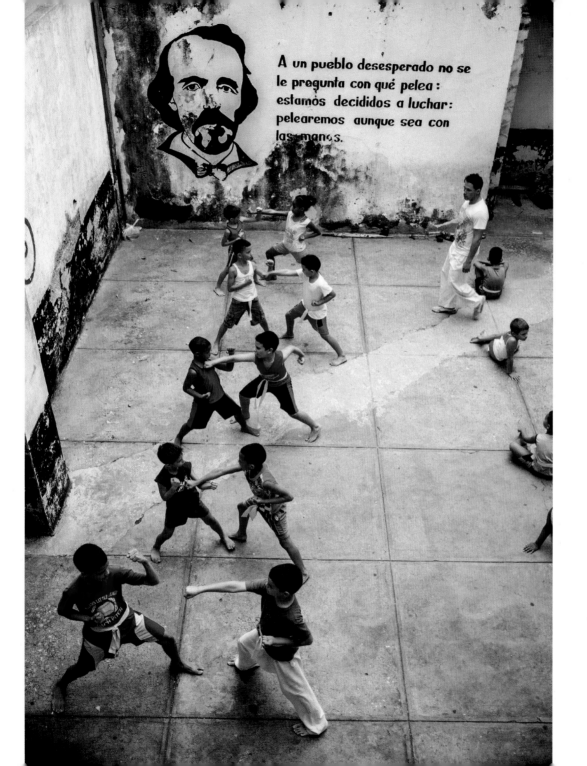

A un pueblo desesperado no se le pregunta con qué pelea: estamos decididos a luchar: pelearemos aunque sea con las manos.

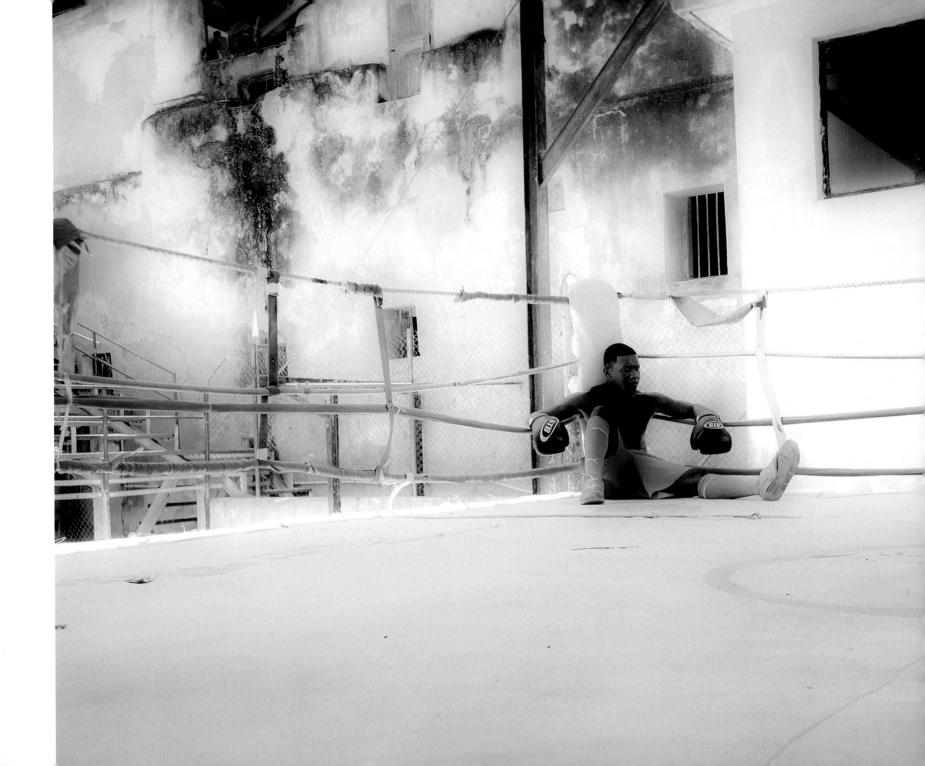

Left: Training Break, Habana Vieja, 2014. Boxing Gloves, Habana Vieja, 2008. | 165

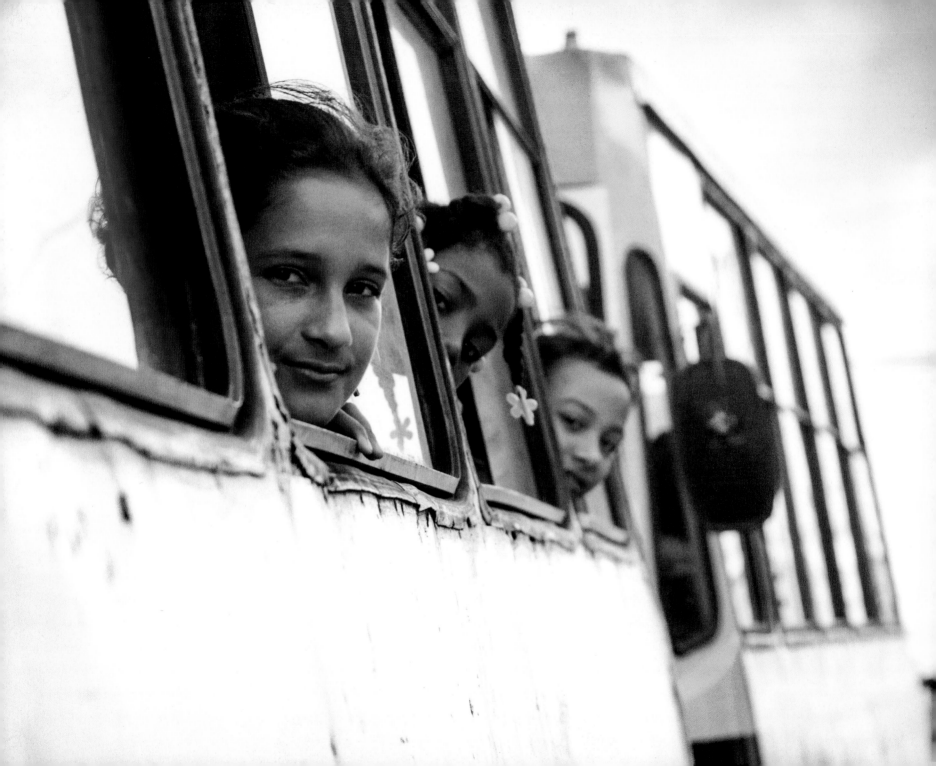

LA GENTE

Apart from the stunning architecture and natural beauty, it's the Cuban people who make the most profound impression; the Santería priests and priestesses, the Coco taxi drivers, the cabaret dancers, the old women puffing cigars, the mambo drummers, the men and women who have fine-tuned seduction into an art form. A rhythm flows through Cuba, from the tapping of the clave in salsa music to the drumbeat of the rumba, from vibrant carnivals to political rallies, from the seas crashing over the Malecón to the wind blowing through the Royal Palms.

MARIA FINN, *CUBA IN MIND*

School Bus Girls, Ciego de Avila, 2013

THE CUBAN PEOPLE ARE the country's most prized treasure and endearing asset. With their quick smiles, generous nature, and easy-going manner, they are the true heart and soul of the island.

Peeling back the layers on this eccentric yet complex culture reveals a gracious people, dynamic and captivating, innovatively resourceful, richly inspired, and in many cases creatively gifted.

Cubans are a warm, resilient, curious, talented, open, engaging, expressive, hospitable, and soulful people with an insatiable zest for life, love, and good times. They share a profound fondness for cultural activities, including art and music but especially dance.

Like dancing, laughter is a frequent physical and emotional outlet for expression. Most Cubans do not take life too seriously and easily joke about anything and everything, even life's adversities. *Chistas* or jokes, usually aimed at making fun of the joke tellers themselves, are as common as balmy tropical days. This is not to say that Cubans are shallow or cavalier; quite the opposite—they have learned to maintain a positive outlook and make the best out of challenging situations.

By and large, Cubans are a loyal people who value their national dignity and social achievements with immense pride. Intensely family oriented, they also have deep attachments to the communities in which they live. Everyone knows everyone, and they all look out for one another. Passions may be fiery, but people can and do spend hours heatedly debating politics, the economy, and sports without holding grudges.

While certain formalities exist with regard to religious practices, the education of the country's youth, and a strict adherence to government laws, when it comes to the cultural issue of "keeping time," a laissez-faire attitude pervades. With this casual attitude about time, punctuality and schedules are afterthoughts in Cuban society. It is not unusual for friends to promise to meet at a certain time and then show up an hour or two late. The tardiness does not engender resentment; it is just a normal occurrence and, frankly, expected.

Cubans are a highly social and physically expressive people. The men tend to greet one another with sturdy handshakes and an informal, *"Asere, qué volá!?"* (Hey buddy, what's up?). Women usually include a hug and kiss on the cheek when greeting friends and family. Particularly common among younger Cubans is the cheek kiss and a hug when greeting friends of the opposite and same sex. Cubans are also known for their inclusiveness. A stranger standing in their midst is not ignored but is included as if already a friend.

For the most part, Cubans like to be on a casual first-name basis, even using a professional title in conjunction with the individual's given name instead of the surname. Eye contact is essential when conversing with Cubans. Much like the Italians, Cubans use animated hand gestures when stressing an important idea or point, and their rapid use of the language is notoriously passionate.

As a whole, Cubans take great pride in their personal appearance. Even with modest means to support themselves, they are always impeccably dressed and do not leave the house until the hair is just right, clothes are wrinkle-free, nails are polished and perfect, makeup is flawless, and shoes

are scuff-free. Inspired by the latest music video from American and Latin-American artists, young Cubans in particular deck themselves out with knock-off versions of the trendiest designer-esque fashions that their budgets will allow.

Cleanliness is a way of life for Cubans, evident from the ever present display of colorful laundry hanging to dry on clothes lines in open windows, verandas, doorways, staircases, and yards, block after block after block. Women mop the floors of their homes on a daily basis, keeping them as spotless as possible.

Cubans treasure their tight-knit communities of neighbors and extended family. In many instances, when elderly people become incapacitated and can no longer take care of themselves, members of the entire neighborhood or apartment complex in which they live pitch in, rotating the duties of cooking, cleaning, and bathing, so that older people in need can stay in the comfort of their own homes without having to go to a care facility. Selfless acts like these are testaments to the compassionate and accommodating spirit of the Cuban people.

Boasting the lowest crime rate in the Western Hemisphere, the streets of Cuba are virtually free of the unlawful elements that tend to plague other countries in the Caribbean. The significant police presence in most tourist areas is a huge deterrent against crime. What's more, the penalties for most criminal acts involve swift and severe punishment. In fact, stealing from or harming a tourist often results in a lengthy jail sentence.

Prior to 1959 the streets of Havana were not so peaceful. Gun-toting criminals monopolized entire sections of the city, while dubious mafioso characters controlled the casinos.

To thwart the problem after the Revolution, Cuba formed its own grass-roots intelligence service. This sprang into nationwide action, monitoring the activities of crime figures and those who aimed to undermine the new government.

Today the Committees for the Defense of the Revolution (CDR) continue to keep a watchful eye over Cuba's neighborhoods. There is a CDR committee on every block in every city, town, borough, and village; each assigned to oversee its particular zone. In a sense, the CDRs have become a living version of the automated security cameras that monitor most large Western and European cities—the eyes that are always watching but that no one ever sees.

Courteous and helpful, Cubans are always eager to assist with directions when someone is lost or to advise solutions when a problem needs solving. There is never a shortage of help, although the dozens of opinions offered may leave you questioning which viewpoint is most accurate. But this is all part of the dynamic person-to-person interaction in Cuba.

As with any culture, Cubans have transformed their language with folksy *dichos* (sayings) that are unique to the island. Common remarks include: "*Que me quiten lo bailao*" (Nobody can take away the fun); "*Se acabó lo que se daba*" (It's over, it's done); "*No hay mal que por bien no venga*" (Things happen for a reason); "*Al mal tiempo, buena cara*" (When times are bad, put on a good face). While these mantras are part of the daily affirmative vernacular, the word *resolver* is perhaps the island's most frequently used verb. Literally meaning "to resolve," in Cuba it is synonymous with survival and overcoming all obstacles with inventiveness, spontaneity, and most important, humor. The expression is often used to describe the simplest personal victory,

such as resuscitating a twenty-year-old Russian Lada for a ride to the beach or tracking down a single out-of-season sweet potato for a dessert offering to Yemayá, goddess of the seas.

By American standards Cuba is a complicated country—politically speaking—but its people are not. Cubans are no different from every other person on the globe trying to carve out the best life possible for themselves and their families. However, there is one very distinct difference: Cubans sure know how to have a good time with a little bit of nothing and whole lot of heart and spirit. Whatever they may lack in material possessions, they make up for with a vitality and love of life that transcends the bounds of money, geography, and politics.

The island is blessed with an abundance of majestic jungle-shrouded mountains, sweeping emerald valleys, colorfully fragrant flora, diamond-dusted beaches, warm azure seas, and magnificent architectural structures. But ultimately these amazing riches and imagery are meaningless without the spirit of the people who are the real life force and who create the truest essence of what makes Cuba . . . well, Cuba.

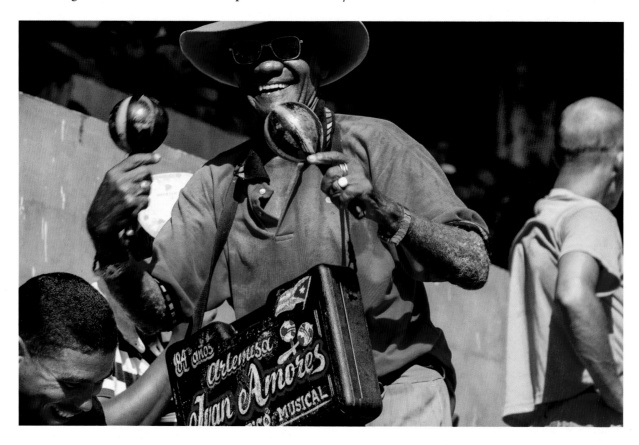

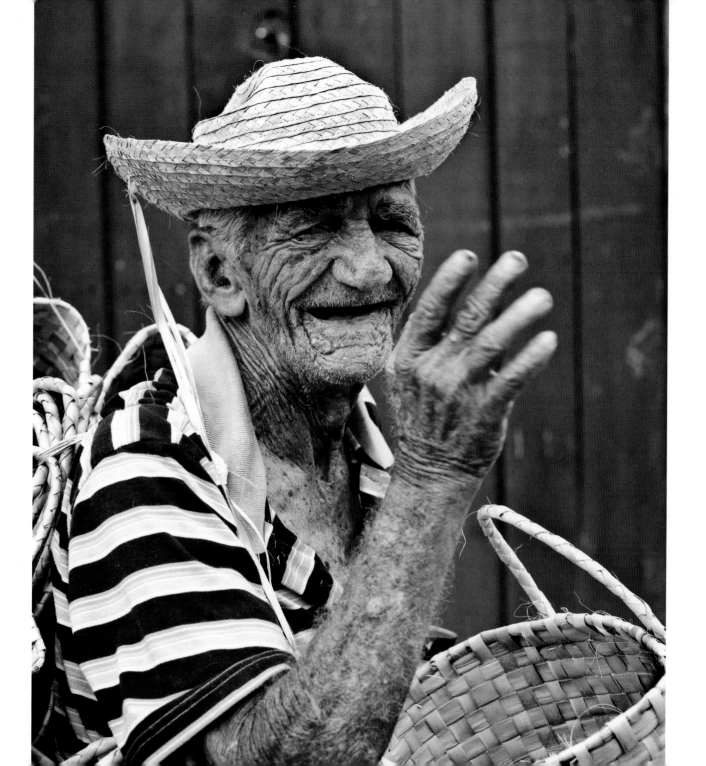

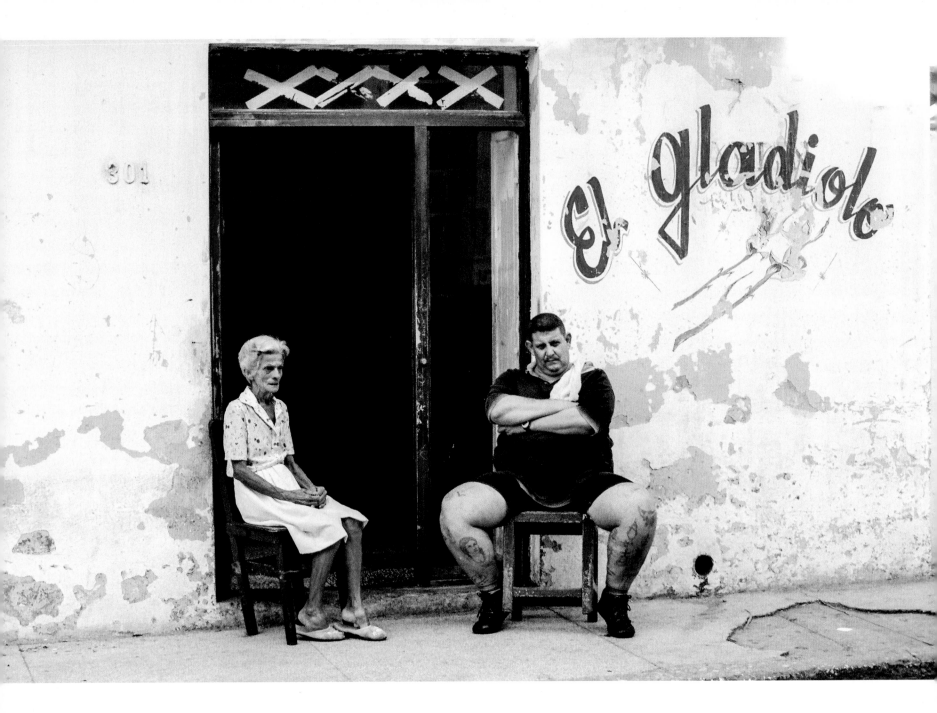

172 | El Gladiolo, Regla, 2006

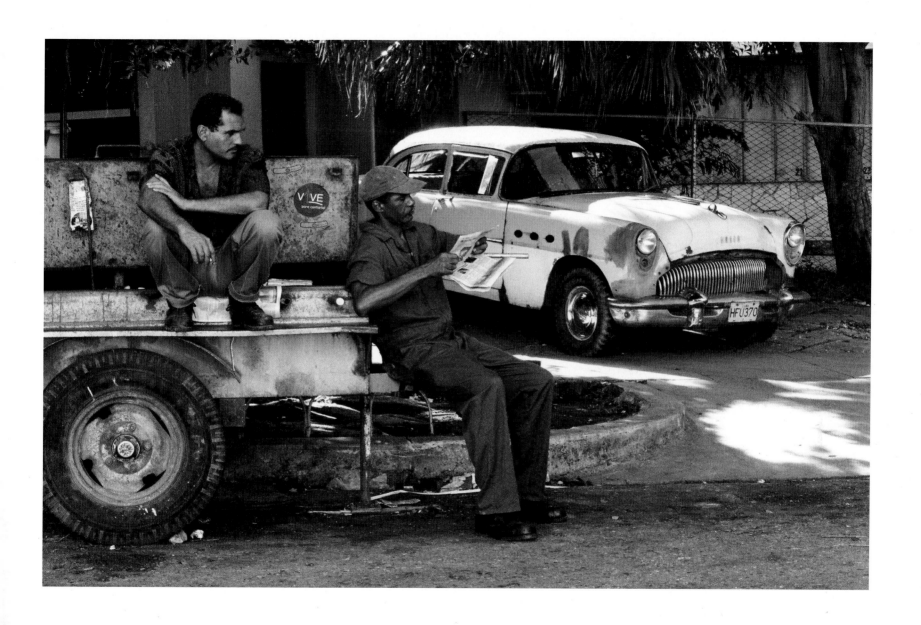

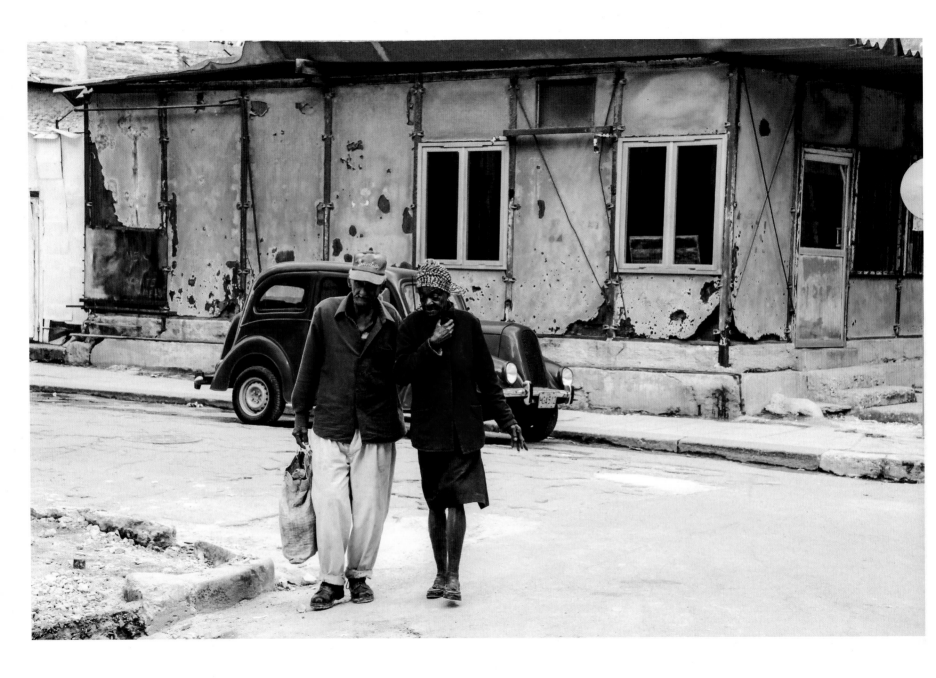

Blue, Centro Habana, 2008

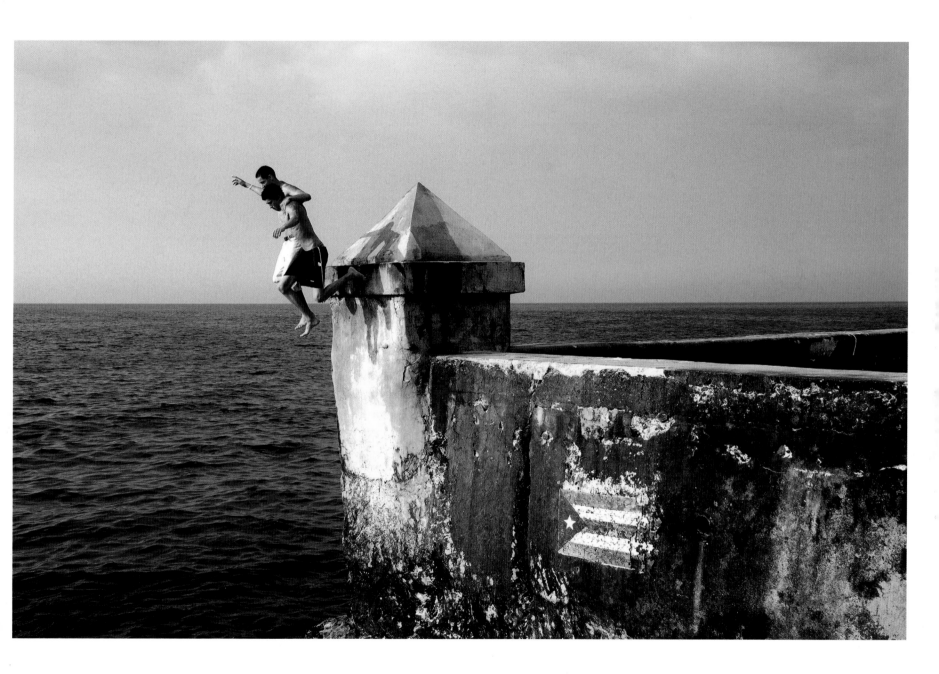

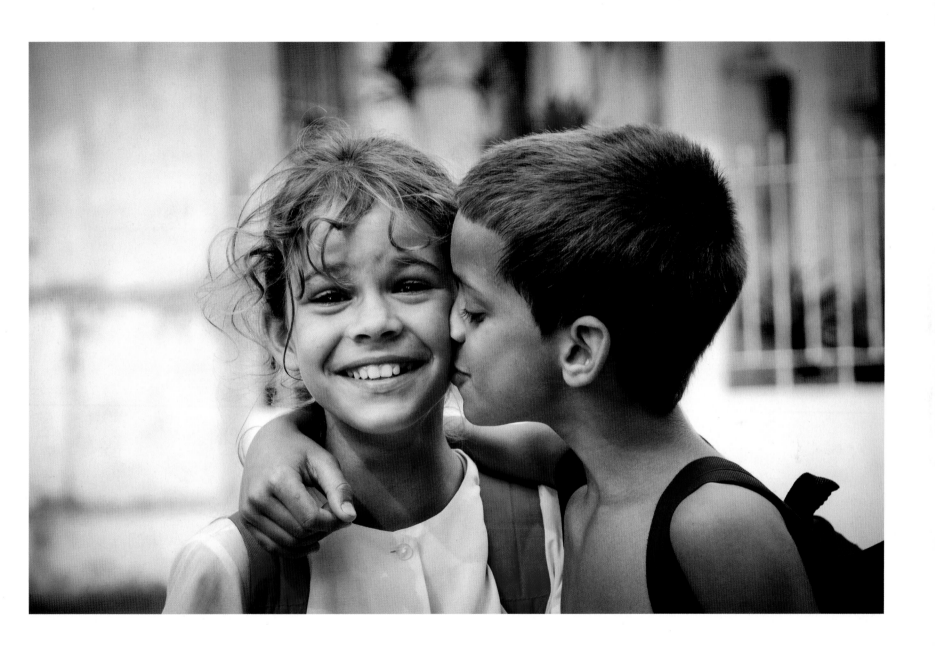

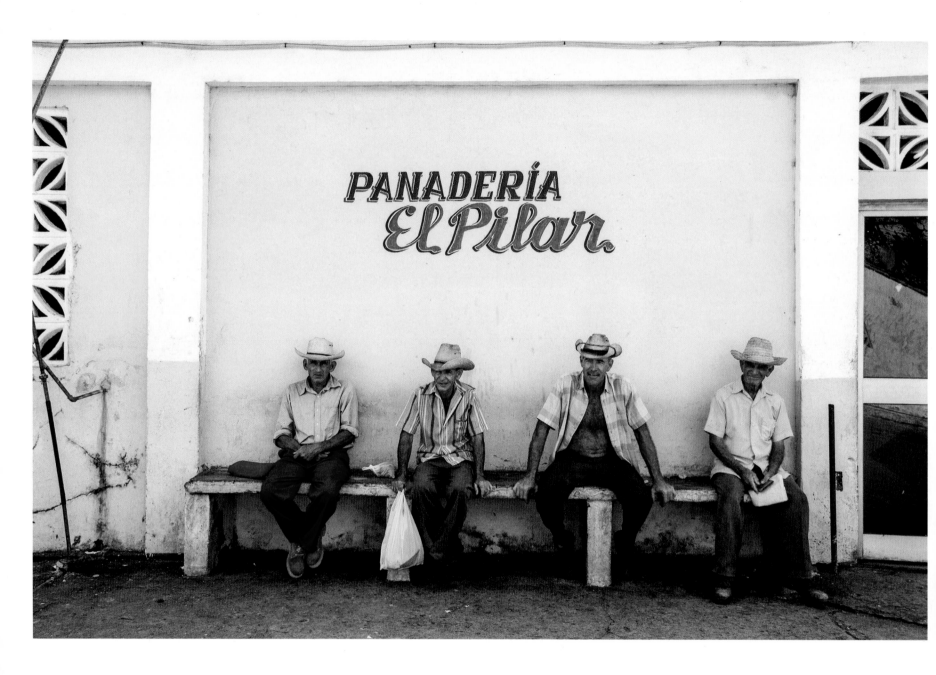

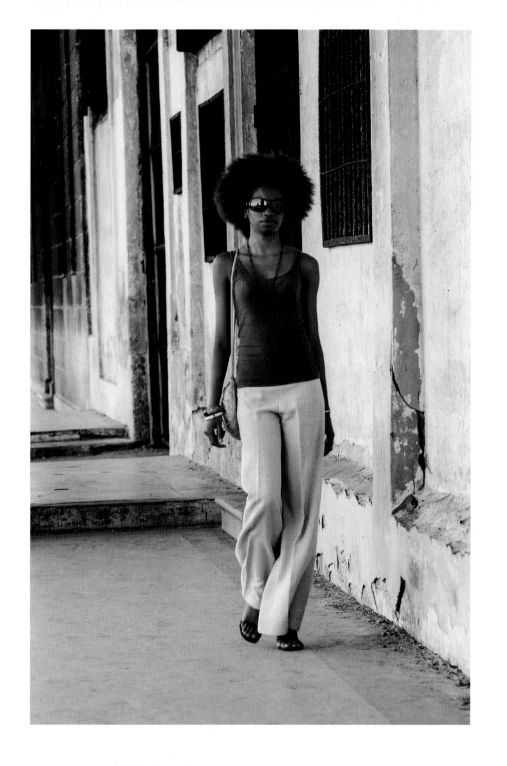

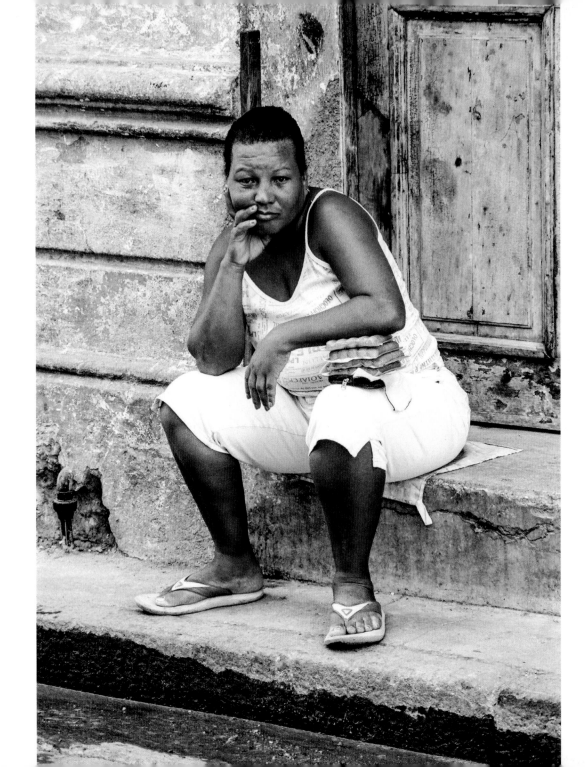

180 | Hot Dog Lady, Habana Vieja, 2006

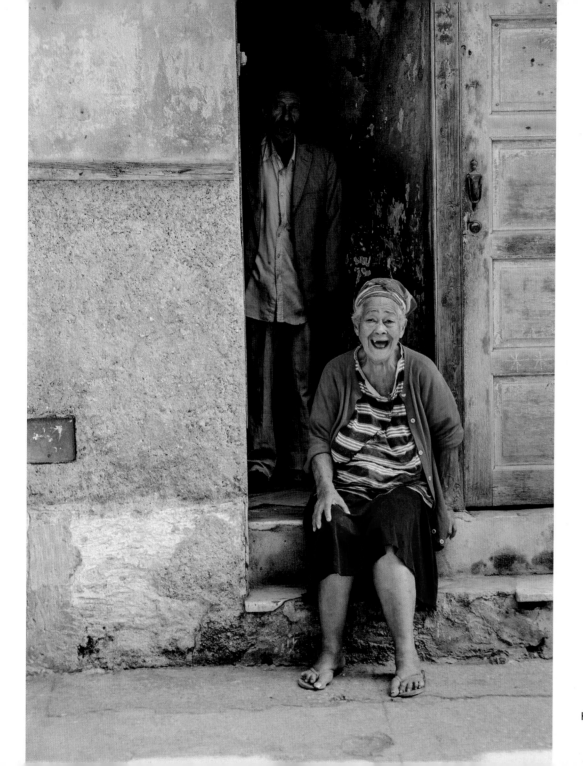

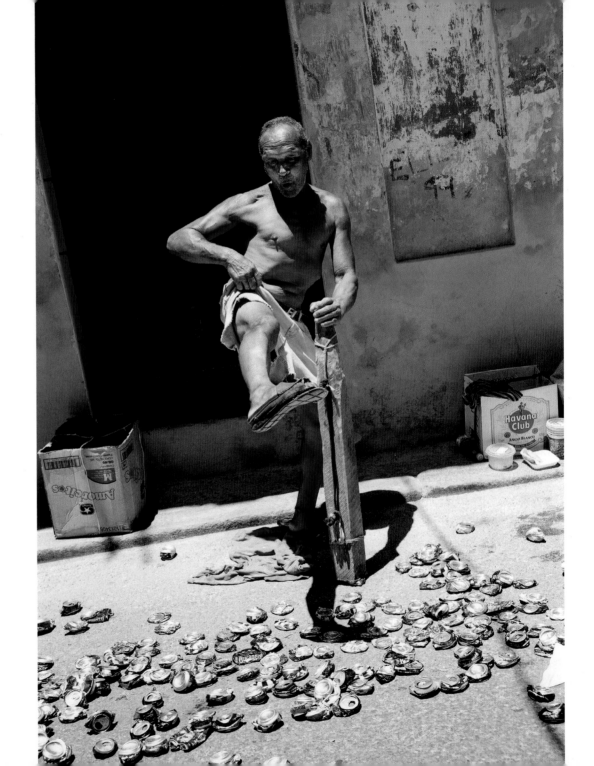

182 | Can Crusher, Centro Habana, 2011

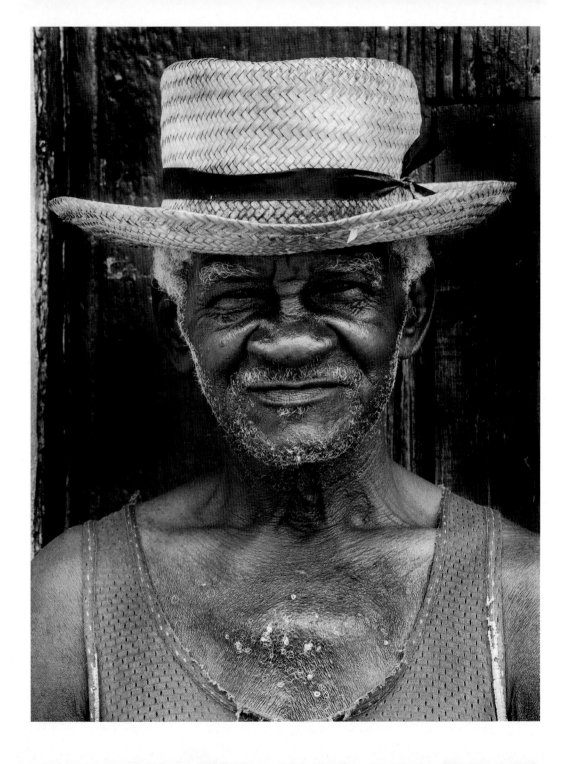

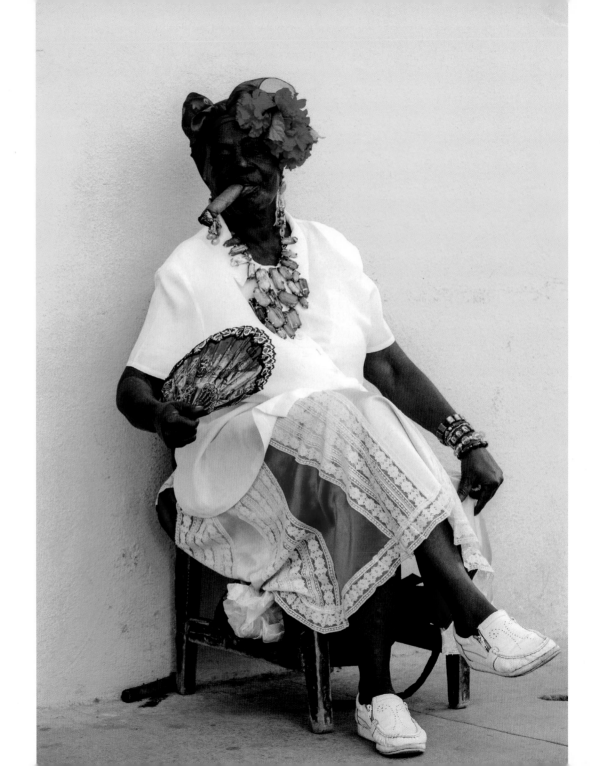

184 | Cigar Woman, Habana Vieja, 2008

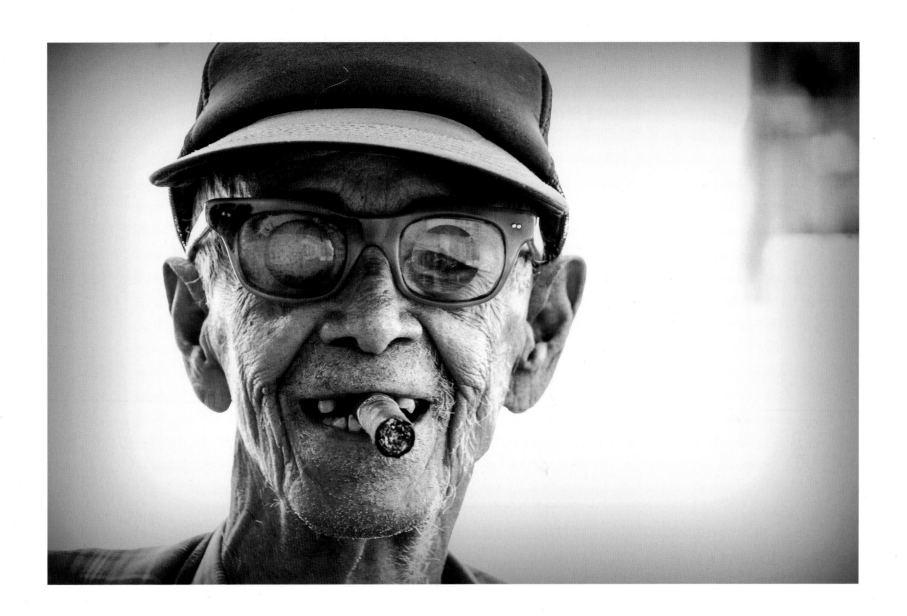

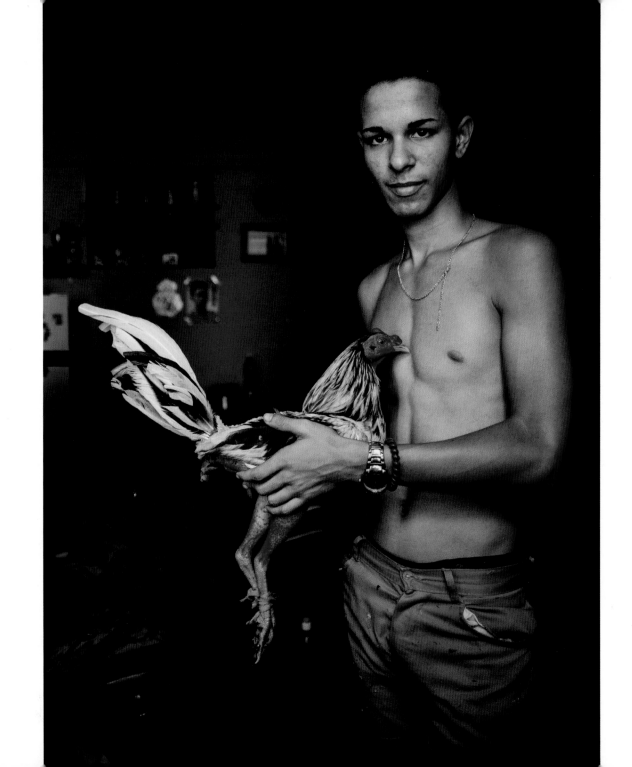

186 | Chico y Gallo, La Habana, 2014

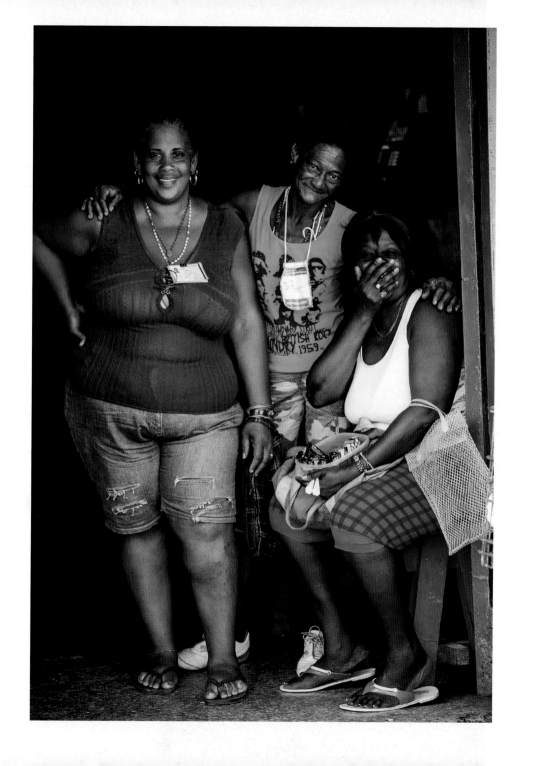

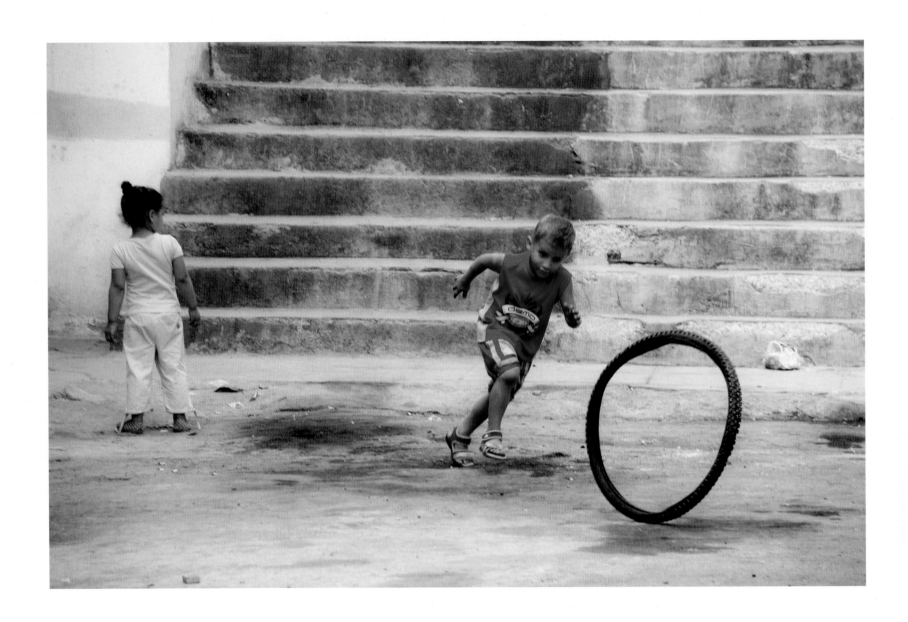

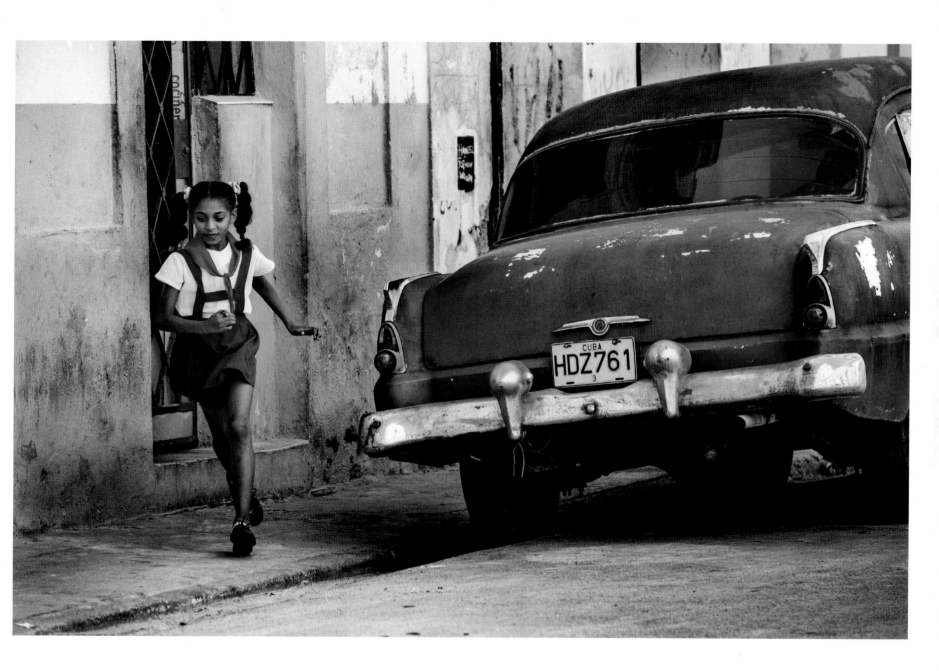

Schoolgirl Running, Centro Habana, 2013 | 189

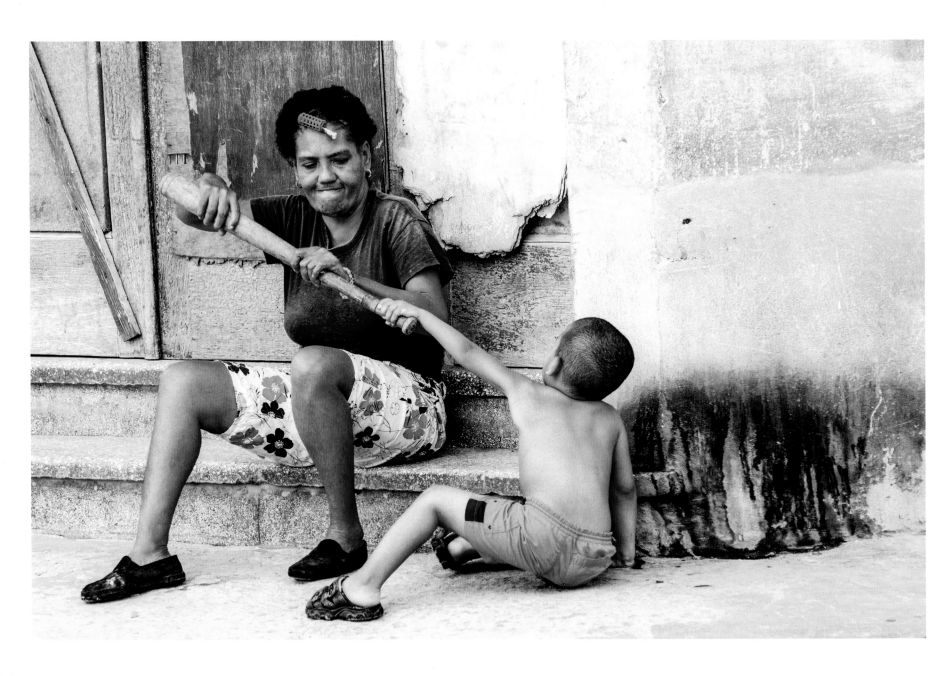

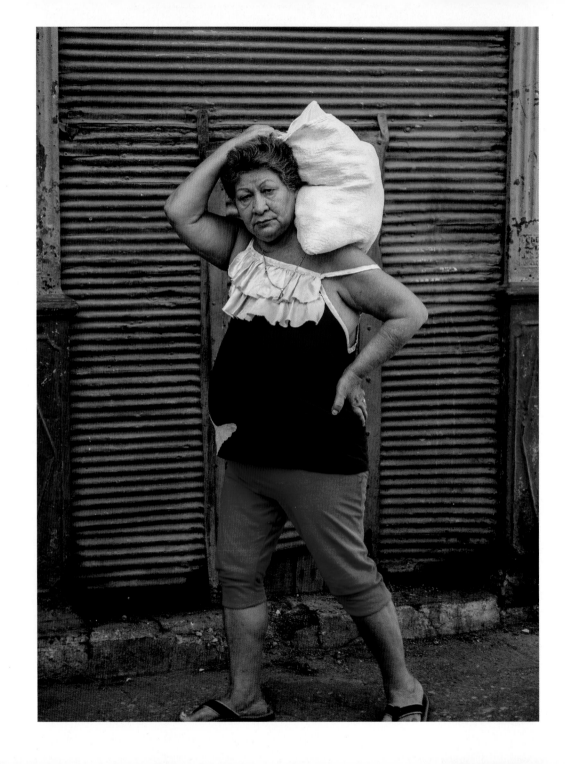

192 | Carrying a Load, Centro Habana, 2011

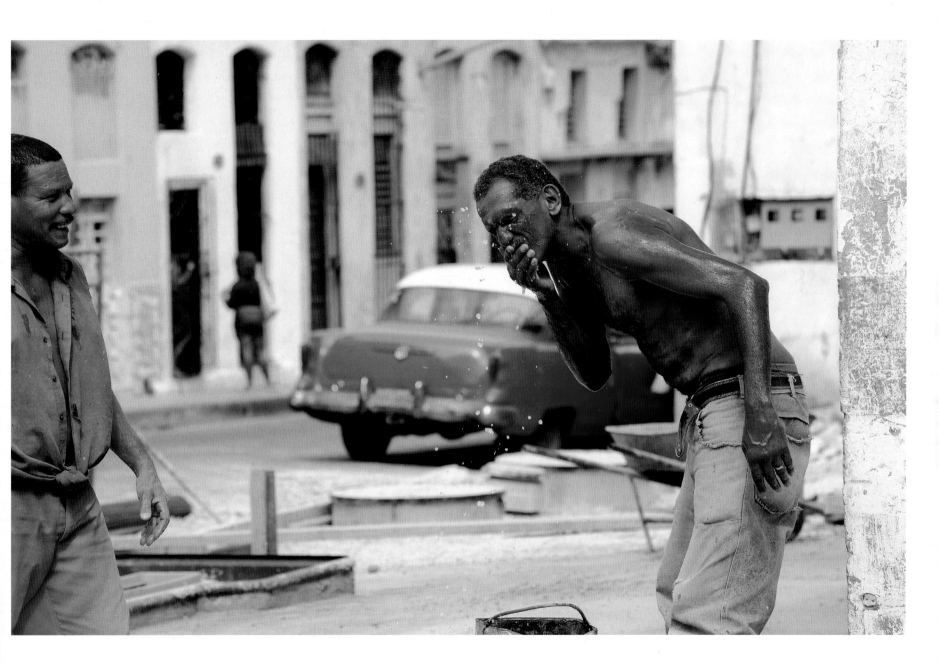

Coolin' on a Hot Day, Centro Habana, 2009 | 193

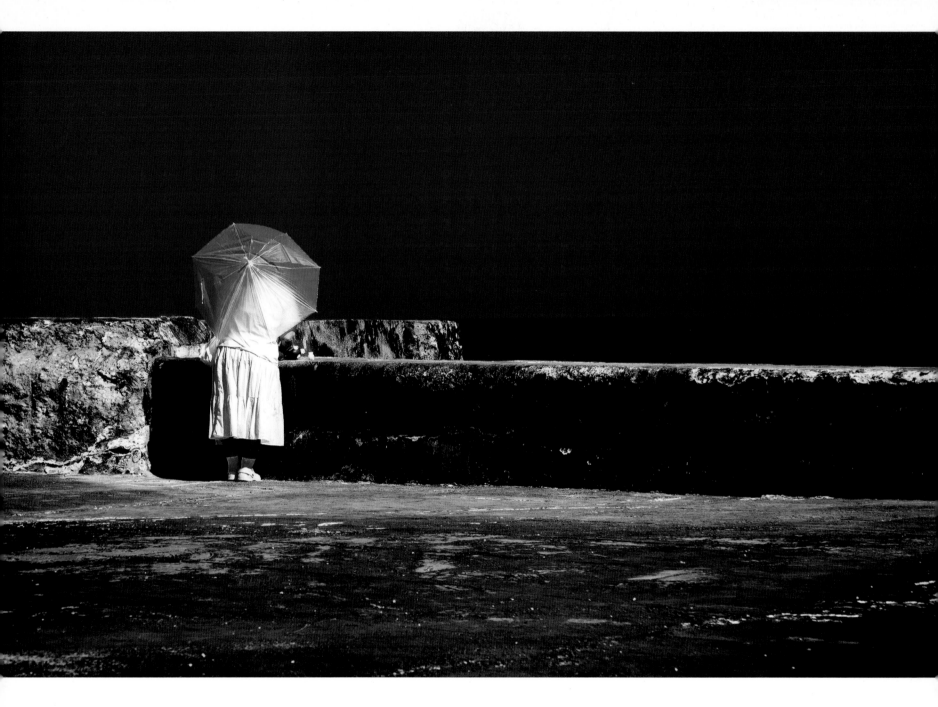

194 | Offerings, El Malecón, 2012

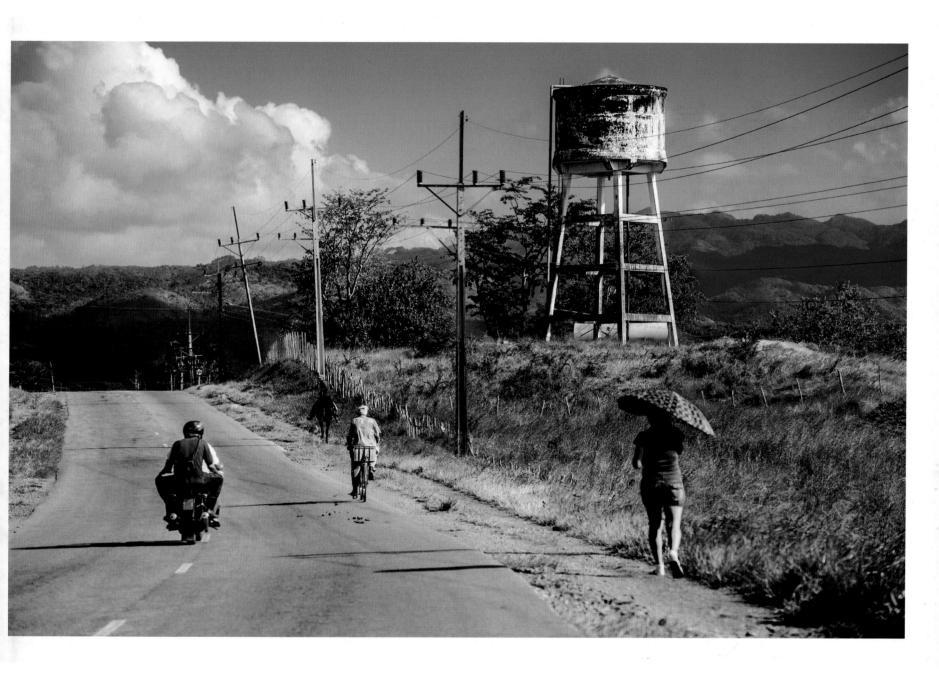

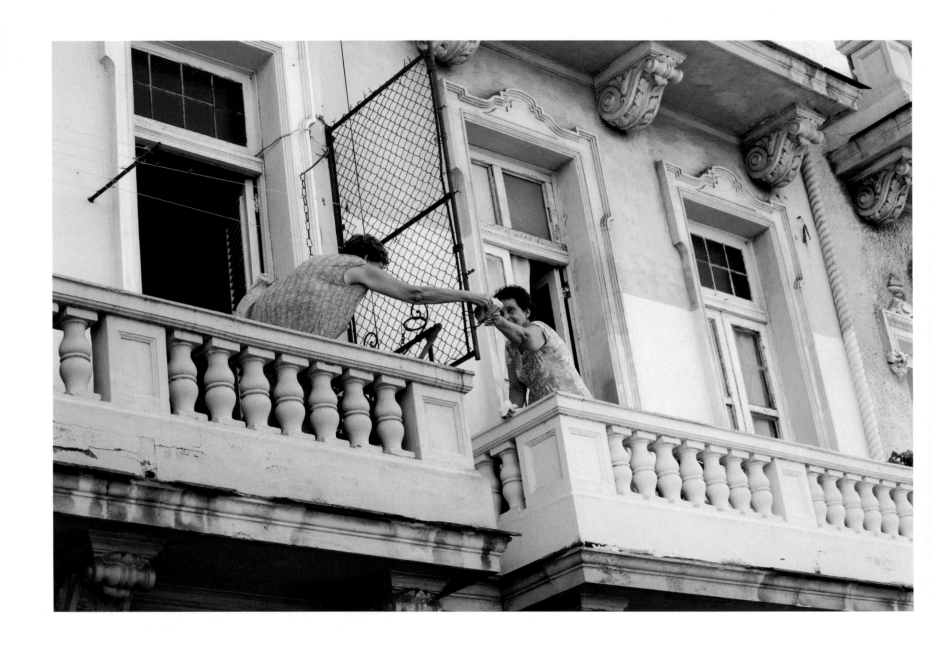

196 | Sharing, Vedado, 2011

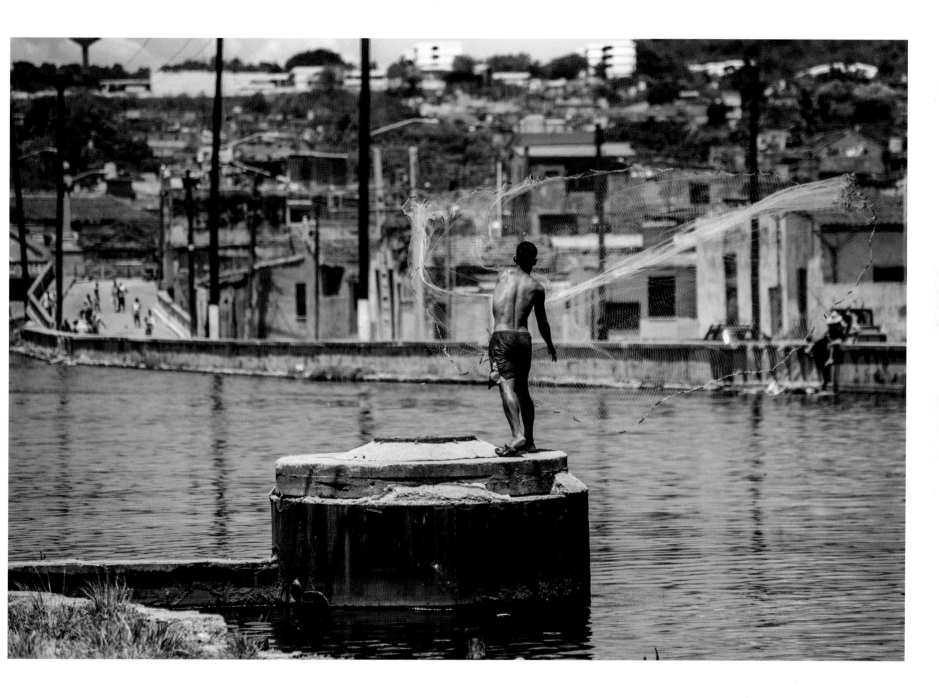

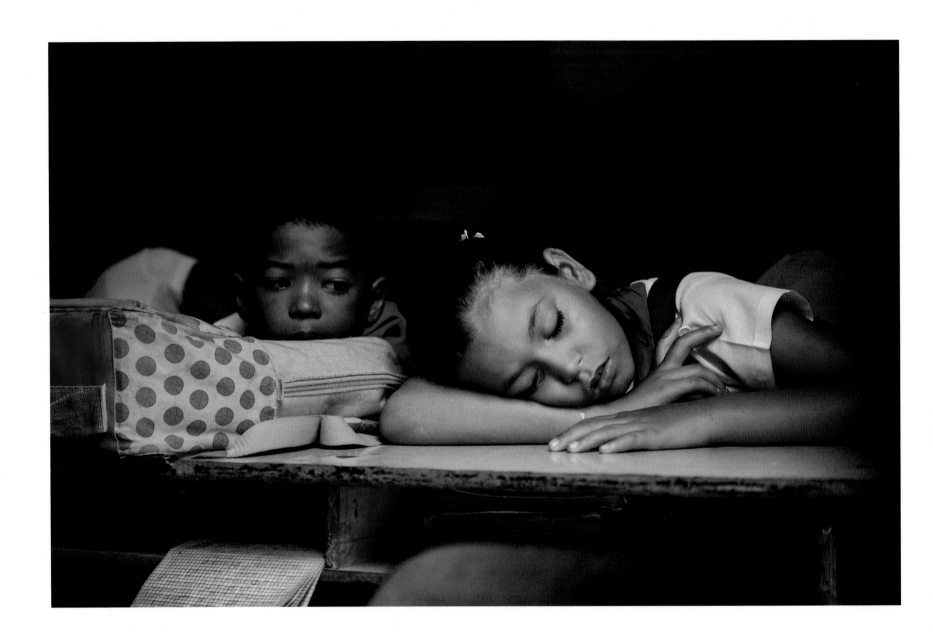

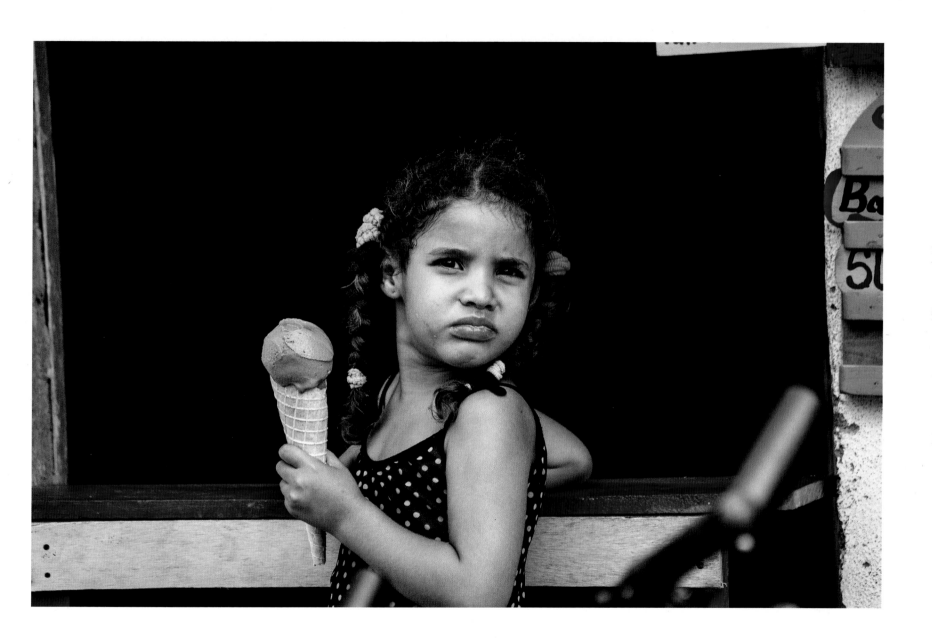

Ice Cream Cone Girl, Trinidad, 2012 | 199

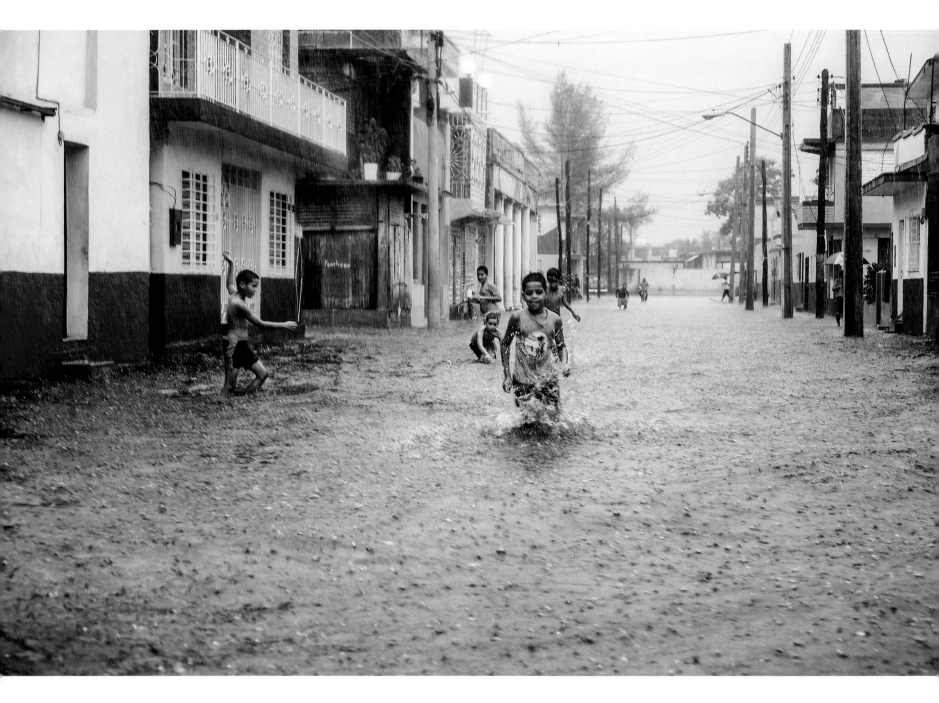

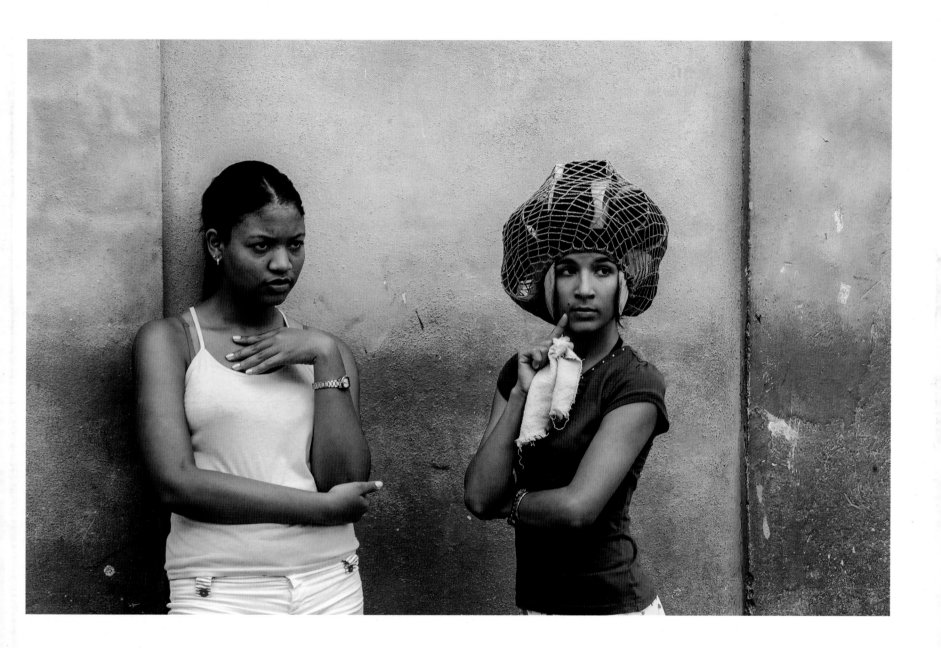

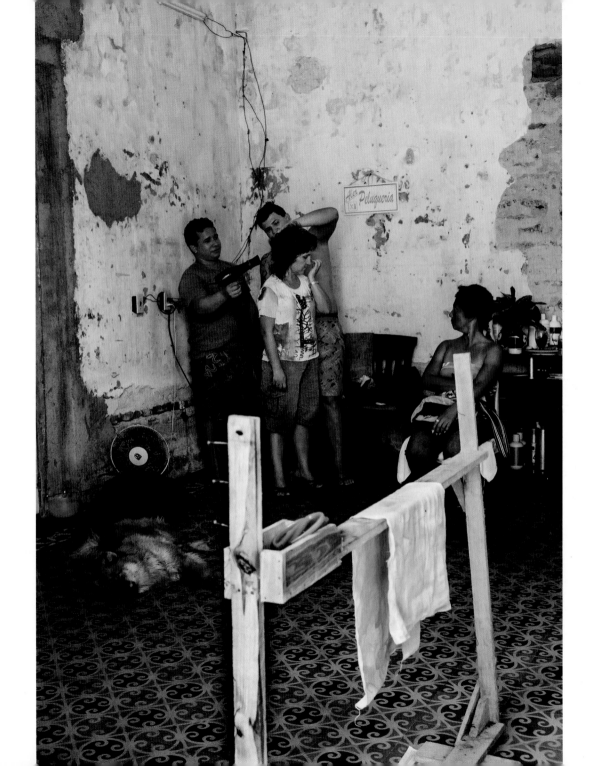

202 | House Salon, Camagüey, 2014

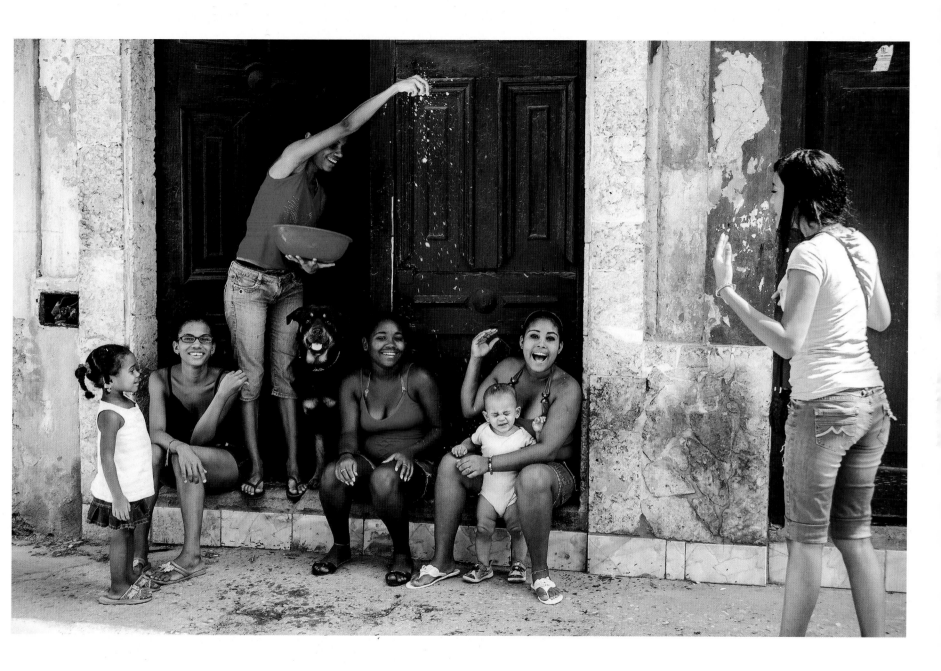

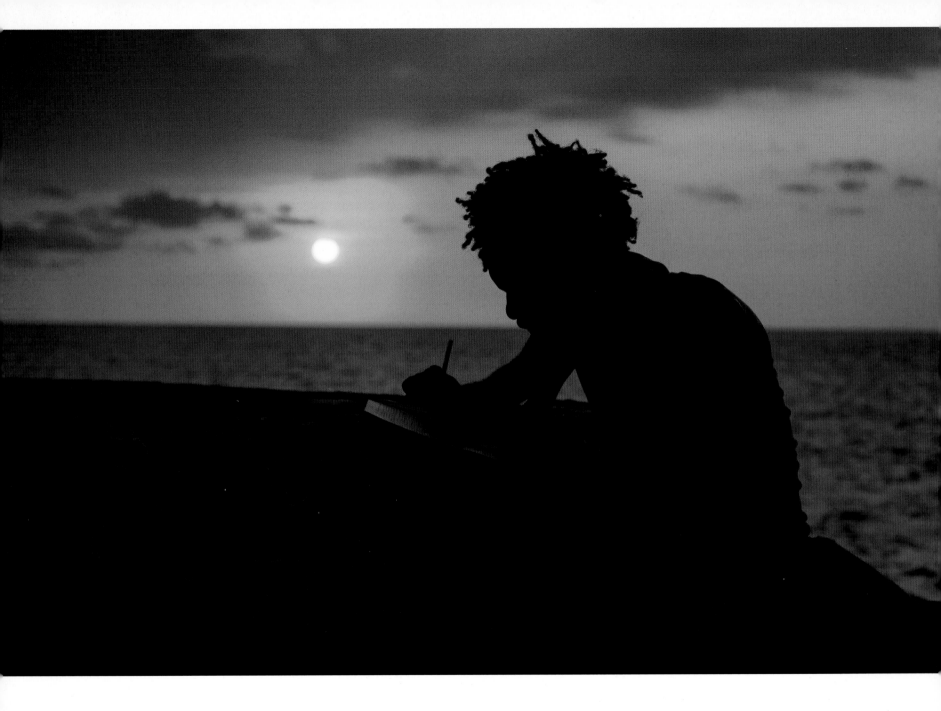

| Writing Prose at Sunset, El Malecón, 2013

ACKNOWLEDGMENTS

*Where the palm trees smile up at the sky, where you do
as you please, there go I. To a land where I long to be, to
Havana, that's calling to me.*

*Oh, it's grand there and dear to my heart, when I land
there, I'll never depart. For a someone as sweet as can be, in
Havana is calling to me.*

*I can't stay I must away, I can't stay I go today.
I'm as happy as can be, Oh, Havana is calling me.*

ELISEO GRENET AND MARION SUNSHINE, 1937

Through the years many people have encouraged my photographic endeavors and for that I am grateful. In relation to this book I am blessed to have had support from both my American family, friends, and colleagues and *mis amigos y familia adoptiva* (my friends and adopted family) in Cuba.

Loyal stateside support directly related to *Embracing Cuba* has come from Bob Ames, Christopher Baker, Roman Barinas, Peter Bjarkman, Anthony Boadle, Jay Brothers, Luisa Crespo, Paul Felix, Jamie Fiffles, Maria Finn, Virginia Fowler, Gil Garcetti, Pico Iyer, Alberto Magnan, Karina Muranaga, Penny Marshall, Ed Nadel, Yasiel Puig, Suzanne Thompson, Corky and Mike Stoller, Dayramir Gonzales Vicet, Kevin DeKimpe, and Tess Vigeland. Many thanks to all of you!

Extra special thanks to Kit Krieger: you and your *Cubaball* trip are to blame for my obsession with Cuba—and boy am I glad and grateful! Your insightful contribution to the baseball section text is greatly appreciated too. *Saludos*, my

friend! My beautiful amiga Lia Chapman, thank you for providing the needed translations. *Besos!* Glenn Camhi, I am grateful to you for lending your time, talent, and brilliance to edit some of my photos. You will be amply rewarded with shrimp 'n' grits and key lime pie! The music of Candi Sosa and Chucho Valdéz provided a soothing backdrop of melodies throughout the writing of the manuscript. To my buddy Bill Martinez, Esq. (even though your Giants bested my Royals in the 2014 World Series), thank you for organizing all the legal documents for my trips and opening the door to valuable contacts in Cuba. *Saludos*, amigo! Thank you to Nikki Giovanni for the beautiful, unique and perfect poetic endorsement. Humbly honored am I!

A very special thanks to everyone at the University Press of Florida. Extra thanks to Sian Hunter for overseeing this project with great passion, enthusiasm, and care.

To my creative partner and partner in life, Jeff Miiller, for supporting my multiple trips to Cuba and encouraging me to follow my heart. Also for combing over every written word and editing the book text to make it oh so much better than it would have been. I often tell people, "*Mi corazón está en Cuba—my heart is in Cuba,*" and that it is—in an ethereal manner. But the ultimate truth is that the core essence and deepest part of my heart is forever and always with you! *Şerefe!*

Thanks to my friends and adopted family in Cuba: to Rafael, for providing comfortable living quarters that allow me to go about my daily routine in Havana; Luisa, for always having a strong and delicious cup of café and hardy breakfast to get me on my way at the start of each day; my brother Manolito Mesa, driver extraordinaire, for always safely getting me to and from the destination of my desire

around the island and for watching out for me every step of the way. To Camilo Garcia and Alberto Roque Guerra for your friendship, delicious pizza dinners, and enlightening lessons about the Revolution and teachings of Martí that have provided me with a more in-depth understanding and respect for Cuban culture. To filmmaker Roberto Chile and my friends at Fototeca de Cuba: Juan Carlos Marrero and Luis Ismael Cardoso Alburquerque. To Alejandro Gómez Pérez and family in Trinidad for welcoming me into your lives and home—amazing music, fantastic artwork, delicious meals, and caring souls—what could be better? I adore you all! To Pedro Monzón Barata and the Cuban Chapter in Defense of Humanity of the Ministry of Culture for helping garner access to all the people I wanted to meet and places I wanted to go. *Muchas, muchas, muchas gracias!* To *everyone* at CENESEX who has been so supportive and welcoming. I love you all!

Mariela Castro-Espín—I can never thank you enough for taking time out of your hectic schedule to write this book's foreword and for your continuing support, appreciation, and respect for my work. The invitations to show my photographs in Havana have been amazing experiences that I will never forget. I am honored and grateful. I treasure your friendship and commend you for the amazing work you are doing in Cuba. *Saludos!*

To my sister-friend Carolina Sanchez—you are the absolute *best*! What haven't you done? You have been instrumental in my successes in Havana in so many ways. Neither this book nor my Cuba experiences would be nearly what they are without your efforts in gaining access for me to the baseball diamonds and beyond. You have richly blessed my life and I am a grateful beyond words! Love you! *Besos y abrazos!*

Gracias en Español a mis amgios Cubanos (Thanks in Spanish to my Cuban friends)

A mis amigos y familia adoptiva en Cuba: a Rafael, por proporcionar un espacio cómodo de residencia que facilita mi vida y mis movimientos en La Habana; a Luisa, por tener siempre una deliciosa cargada taza de café y un potente desayuno al comienzo de cada día para que pueda emprender mi camino diario; a mi hermano Manolito Mesa, conductor extraordinario, por llevarme siempre con seguridad, desde y hasta el destino deseado alrededor de la isla, y por vigilar cada paso del camino. A Camilo García y Alberto Roque Guerra por su amistad, por nuestras cenas y deliciosas pizzas, además esclarecedoras lecciones acerca de la revolución y las enseñanzas de Martí que me han proporcionado con una más profunda comprensión y respeto por la cultura cubana. A productor de cine Roberto Chile, y mis amigos en Fototeca de Cuba: Juan Carlos Marrero y Luis Ismael Cardoso Alburquerque. A Alejandro Gómez Pérez y familia en Trinidad por recibirme en sus vidas y en su hogar—por la música increíble, fantástica obra de arte, deliciosas comidas y cuido del alma—¿qué podría ser mejor? ¡Los adoro a todos! A Pedro Monzón Barata y el Sección Cubano en Defensa de la Humanidad del Ministerio de Cultura quien me ayudó a obtener acceso a toda la gente que quería conocer y a todos los lugares que quería ir, *¡Muchas, muchas, muchas gracias!* A todas las personas en CENESEX que han sido tan solidarios y acogedores conmigo. ¡Los Amo a todos ustedes!

Mariela Castro-Espín—nunca podré agradecerte lo suficiente por haber tomado tiempo de tu apretada agenda para escribir el prólogo de este libro, y por su continuo apoyo, aprecio, y respeto por mi trabajo. Las invitaciones para mostrar mis fotografías en la Habana han sido experiencias

increíbles que nunca olvidaré. Estoy eternamente agradecido y honrado. Tu amistad es un tesoro. También te felicito por el increíble trabajo que estás haciendo en Cuba. *¡Saludos!*

A mi hermana amiga Carolina Sánchez—¡Eres la mejor! ¿Qué has hecho? Has sido instrumento en mis éxitos en la Habana de muchas maneras. Ni este libro, ni mis experiencias en Cuba, serían lo que son sin tus esfuerzos para poder tener acceso a los diamantes de béisbol y más allá. Ricamente has bendecido mi vida y soy un agradecido más allá de palabras. *Te amo! ¡Besos y abrazos!*

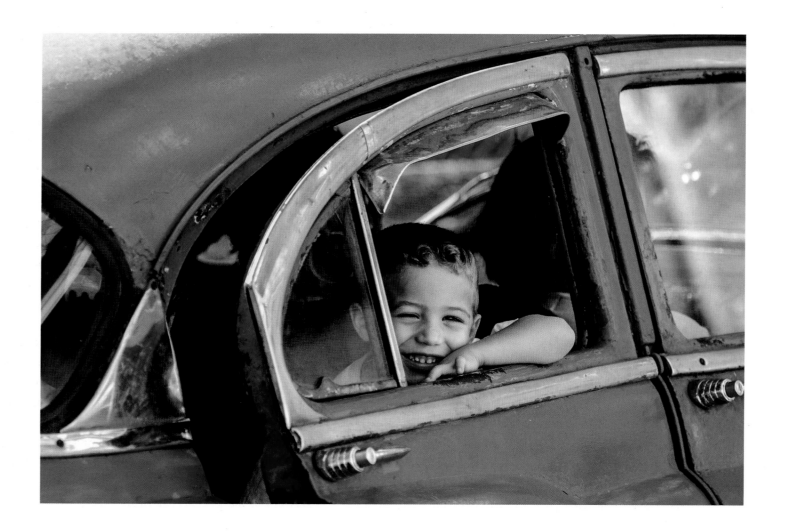

CREDITS

My head buzzed with the sudden recognition of a place that held something for me beyond memory.

ROSA LOWINGER

PERMISSIONS

Robert Ames quote
Used by permission of Robert Ames

Christopher Baker quote
Used by permission of Christopher Baker

Eleanor Early quote
Drawn from Maria Finn's anthology *Cuba in Mind*

Maria Finn quote
Used by permission of Maria Finn, *Cuba in Mind*

Nikki Giovanni poem
Composed as an endorsement for this book

"Havana's Calling Me (La Conga)"
Written by Eliseo Grenet and Marion Sunshine
Used by permission of Edward B. Marks Music Company

Consuelo Hermer and Marjorie May quote
Drawn from Maria Finn's anthology *Cuba in Mind*

Pico Iyer quote
Used by permission of Pico Iyer, *Falling Off the Map*

Sam Lacy quote
Used by permission of *Afro American* newspaper

Lidice López quote
Used by permission of Gil Garcetti, *Dance in Cuba*

Rosa Lowinger quote
Used by permission of Rosa Lowinger

Alberto Magnan Quote
Used by permission of Alberto Magnan

Alcides Sagarra quote
From Reuters interview by Anthony Boadle in Havana, 2004
Used by permission of Anthony Boadle

REFERENCES

Baker, Christopher. *It's a Dog's Life in Havana*. 2012. Web: www.CubaAbsolutely.com

Bos, Harjan, and Henk Van der Leeden. *Cuba: The Billboards*. Raleigh: Lulu Press, 2008.

Castelar, Emilio. "Christopher Columbus." *Century Magazine*, 1892.

Coltman, Leycester. *The Real Fidel Castro*. New Haven: Yale University Press, 2003.

Dibb, Mike, director. *What's Cuba Playing At?* London: BBC Arena, 1985.

Broughton, Simon, and Mark Ellingham, editors. *World Music: The Rough Guide*, Vol. 2: *Latin and North America, Caribbean, India, Asia* and *Pacific*. London: Rough Guides, 2000.

Castro, Fidel Diaz. "Eve Changed the Rules." *OnCuba* 26, December 31, 2013.

Díaz, Ana Niria Albo. "Dancing in Cuba: Past and Present." *Cuba Contemporánea*, November 2, 2013.

Fairly, Jan, and Alexandrine Boudreault-Fournier. "Recording the Revolution: 50 Years of Music Studios in Revolutionary Cuba." In *The Art of Record Production: An Introductory Reader for a New Academic Field*, edited by Simon Frith and Dr. Simon Zagorski-Thomas. Farnham: Ashgate Publishing, 2012.

Finn-Dominguez, Maria. *Cuba in Mind*. New York: Vintage Books, 2004.

Garcetti, Gil. *Dance in Cuba*. Glendale: Balcony Press, 2005.

Gorry, Conner. *Timeless Cool with the Dancers of Santa Amalia*. 2009. Web: www.CubaAbsolutely.com

Harvey, David Alan (photography), and Elizabeth Newhouse (essay). *Cuba*. Washington, D.C.: National Geographic Society, 1999.

Insight Cuba Blog. 2014. Web: http://insightcuba.com/blog/category/cuban-music

Iyer, Pico. "The Island of Waiting." *California Magazine*, July 1, 2007.

Lockwood, Lee. *Castro's Cuba, Cuba's Fidel*. New York: Vintage, 1969.

Perez, Louis. *Cuba: Between Reform and Revolution*, 4th edition. New York: Oxford University Press, 2011.

Ritter, Archibald R. M. *Cuba's Economy during the Special Period, 1990–2010*. Thesis, Carleton University, Ottawa, 2010.

Sainsbury, Brendan, and Luke Waterson. *Cuba*. London: Lonely Planet Publications, 2013.

Stover, Johnnie M. *Rhetoric and Resistance in Black Women's Autobiography*. Gainesville: University Press of Florida, 2003.

Webberley, Helen. *Art and Architecture, Mainly*. 2012. Web: http://melbourneblogger.blogspot.com/2012/01/bacardi-rums-building-resurrected-in.html

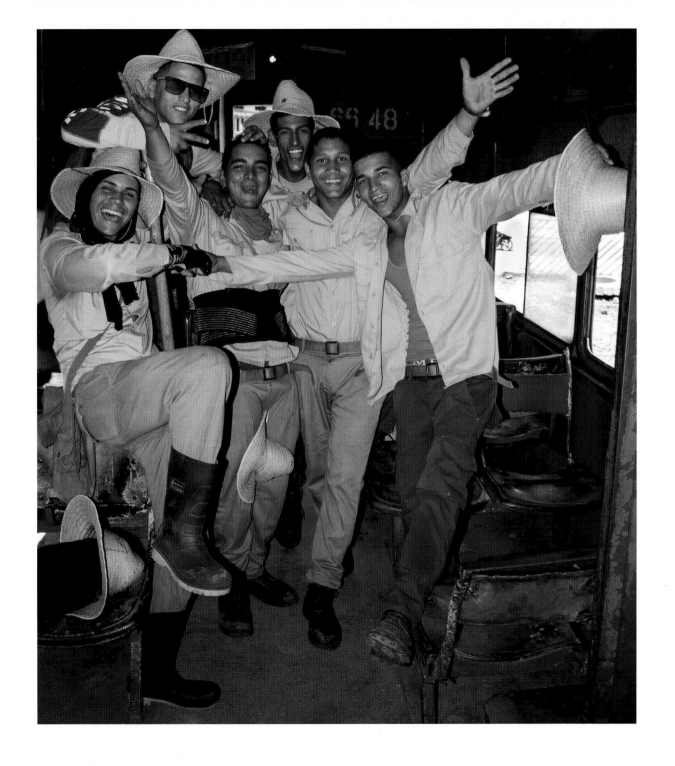

BYRON MOTLEY is an award-winning singer, songwriter, filmmaker, lecturer, and photographer. His photographic work has been featured in *Vanity Fair*, ESPN.com, the *Advocate* magazine, and the *New York Daily News*, as well as in galleries and museums in the United States, Europe, and Cuba. A lifelong and loyal fan of his hometown Kansas City Royals and a Negro League baseball historian, he also has performed on Broadway and with the Boston Pops Orchestra, Celine Dion, Barry Manilow, Natalie Cole, Dionne Warwick, John Legend, and others. He lives in Los Angeles with his partner, Jeff Miiller, and their two rescued mixed-breed terriers, Phoebe and Beasley. This is his second book. www.ByronMotley.com

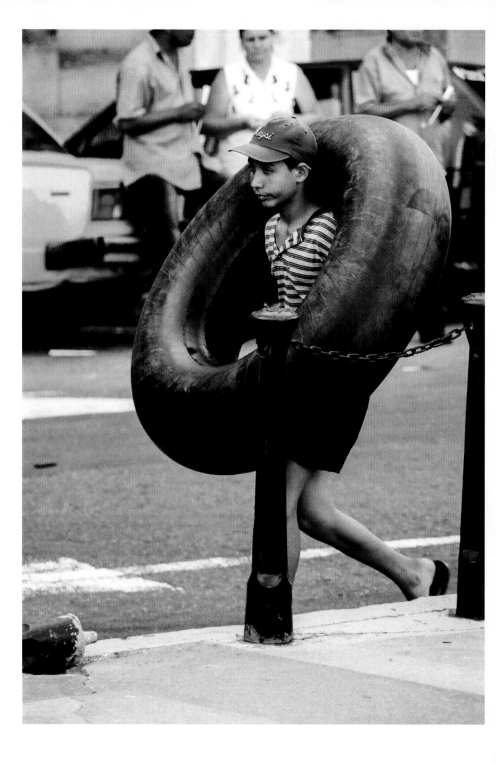